LightConstruction

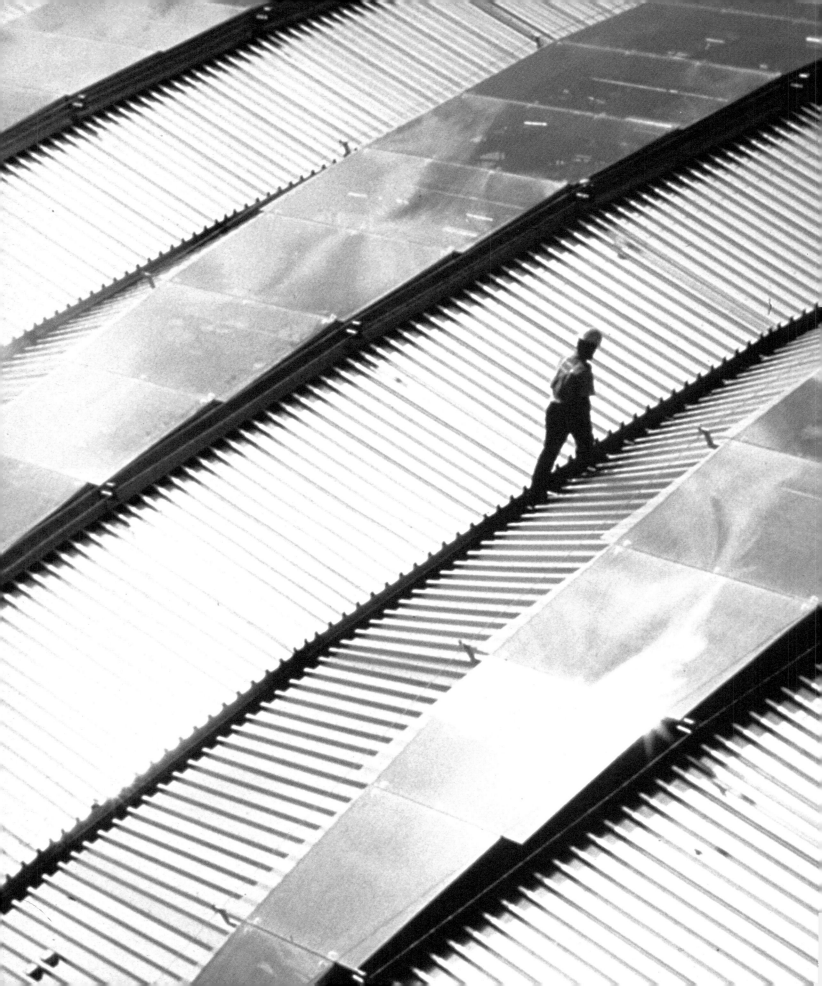

Terence Riley

LightConstruction

The Museum of Modern Art, New York

Distributed by Harry N. Abrams, Inc., New York

Published in conjunction with the exhibition
Light Construction, organized by Terence Riley,
Chief Curator, Department of Architecture and
Design, at The Museum of Modern Art, New York,
September 21, 1995, to January 2, 1996.

The exhibition is supported in part by the
Contemporary Exhibition Fund of The Museum
of Modern Art, established with gifts from Lily
Auchincloss, Agnes Gund and Daniel Shapiro,
and Mr. and Mrs. Ronald S. Lauder.

Produced by the Department of Publications
The Museum of Modern Art, New York
Osa Brown, Director of Publications

Edited by Christopher Lyon
Typeface and book design by Greg Van Alstyne
Production by Amanda W. Freymann
Printed by Hull Printing Company
Bound by Acme Bookbinding Company

Distributed in the United States and Canada
by Harry N. Abrams, Inc., New York,
a Times Mirror Company
Distributed outside the United States and Canada
by Thames and Hudson Ltd., London

Printed in the United States of America

Front cover: Kazuyo Sejima. Saishunkan Seiyaku
Women's Dormitory, Kumamoto, Japan. 1991. Atrium view.
Frontispiece: Nicholas Grimshaw and Partners.
Waterloo International Terminal. 1993. Roof detail.

Photograph credits appear on page 162.

Contents

Foreword

This book accompanies the exhibition *Light Construction*, the latest in a long history of contemporary architecture surveys at The Museum of Modern Art that began with the landmark *Modern Architecture: International Exhibition* of 1932. *Light Construction* presents a broadly-based view of the direction of contemporary architecture in the last decade, cutting across cultural, aesthetic, and technological boundaries. Ignoring what are perceived today as unbridgeable differences, whether geographical or ideological, between groups of architects, Terence Riley, Chief Curator of the Museum's Department of Architecture and Design, has sought to uncover the shared qualities of a diverse group of buildings.

Light Construction is not a style manual but a snapshot of an emergent sensibility. In the thirty-three projects presented, we can perceive a sense of direction, a broad shift away from the architecture of recent decades. While the ultimate definition of this watershed remains elusive, its most distinctive and promising feature is its palpable energy. *Light Construction* is not only an expository analysis of contemporary architecture but an insightful celebration of its vitality on the cusp of the next century.

Glenn D. Lowry, Director, The Museum of Modern Art, New York

Introduction

As we approach the millennium, we naturally look, in architecture as elsewhere, for a culmination, or at any rate a sharp turn in the road. We may also be looking for an architectural standard bearer to lead the way into a new century. Instead we see a coalescing of disparate elements—cultural, technological, aesthetic—and, indistinctly, the gradual emergence of an as yet scarcely definable sensibility, shared among architects and artists of widely divergent practices and positions. This publication and the exhibition it accompanies are meant to contribute to the exploration of this new sensibility.

This project would not have been possible without the cooperation and unfailing assistance of the architects and artists represented and their staffs. In particular, I would like to thank Anna Galeazzi of Olivetti S.p.A. for her loan of the bank model as well as Douglas Walla of the Kent Gallery for the loan of the *Bus Shelter IV* model. The essay has benefitted from the thoughtful advice of a number of colleagues including, within the Museum, Kirk Varnedoe, Chief Curator, Department of Painting and Sculpture, and Christopher Lyon, Department of Publications, whose personal commitment to the project exceeded editorial duties; and, at Columbia University, Kenneth Frampton, Ware Professor of Architecture, and Joan Ockman, Director, The Temple Hoyne Center for the Study of American Architecture.

For his unfailing support of the exhibition, I wish particularly to thank Glenn D. Lowry, Director of the Museum. It was made possible in part by the Museum's Contemporary Exhibition Fund, an expression of generosity and unwavering commitment to the arts of our time on the part of Lily Auchincloss, Agnes Gund and Daniel Shapiro, and Mr. and Mrs. Ronald S. Lauder. I am also deeply grateful to the members of the Trustee Committee on Architecture and Design, chaired by Marshall S. Cogan. Anne Dixon, Supervisor, The Lily Auchincloss Study Center for Architecture and Design, who assisted with many aspects of the exhibition, contributed a number of the texts accompanying project illustrations in this book. My assistant Caren Oestreich shouldered daunting responsibilities with her customary good cheer, as did Bevin Howard, Executive Secretary. The exhibition was organized under the capable eyes of Richard L. Palmer, Coordinator of Exhibitions, Eleni Cocordas, Associate Coordinator of Exhibitions, and Jerry Neuner, Director of Exhibition Design and Production. This book was created with the careful supervision of Osa Brown, Director, Department of Publications, and her staff. I thank Harriet Shoenholz Bee, Managing Editor, for her good counsel; Amanda Freymann, Production Manager, who resourcefully oversaw preparation of illustrations and the book's production, aided by Cynthia Ehrhardt, Production Assistant; and Christopher Lyon, Editor. The book's thoughtful design is due to Greg Van Alstyne, Senior Graphic Designer, whose talents are evident throughout.

Terence Riley, Chief Curator, Department of Architecture and Design

Terence Riley

Light Construction

In recent years a new architectural sensibility has emerged, one that not only reflects the distance of our culture from the machine aesthetic of the early twentieth century but marks a fundamental shift in emphasis after three decades when debate about architecture focused on issues of form. In projects notable for artistic and technical innovation, contemporary designers are investigating the nature and potential of architectural surfaces. They are concerned not only with their visual and material qualities but with the meanings they may convey. Influenced by aspects of our culture including electronic media and the computer, architects and artists are rethinking the interrelationships of architecture, visual perception, and structure.

Represented in this survey are some thirty projects, created in response to commissions and competitions in ten countries. As the majority of the works have been or are being built, they engage their environments on material as well as theoretical levels. This essay situates the projects in a broad, synthetic context, addressing both their cultural and aesthetic dimensions. Priority is given to the visual encounter with a structure, a choice that is not meant to imply a hierarchy of importance but to recognize that the appearance of architecture provides not only the initial but frequently the most defining contribution toward its eventual comprehension.

The sensibility expressed in these projects refers, but does not return, to the visual objectivity embraced by many early modernists, particularly as it is expressed in their fascination with glass structures. Ludwig Hilberseimer's 1929 essay "Glasarchitektur" represents that rationalist outlook and serves as a historical antipode to contemporary attitudes. For him the use of glass in architecture furthers hygienic and economic goals; he discusses its formal properties only insofar as they enable the architect more clearly to express the structural system. Aesthetic concerns are essentially negated: "Glass is all the fashion today. Thus it is used in ways that are frequently preposterous, having nothing to do with functional but only formal and decorative purposes, to call attention to itself; and the result, grotesquely, is that very often glass is combined with the load-bearing structure in such a way that glass's characteristic effects of lightness and transparency become completely lost."[1]

Hilberseimer's *sachlich* approach contains its own understated implications for an aesthetic vision. Describing the Crystal Palace, London (1850–51), which "for the first time showed the possibilities of iron and glass structures," Hilberseimer writes, "It obliterated the old opposition of light and shadow, which had formed the

Opposite: *Fumihiko Maki. Congress Center, Salzburg, Austria. Competition proposal, 1992. Detail of Rainerstraße (principal) facade*

proportions of past architecture. It made a space of evenly distributed brightness; it created a room of shadowless light."[2] The extensive use, in contemporary architecture, of semitransparent glazing materials (such as frosted or mottled glass), translucent plastic sheathings, double layers of glass (which, even if clear, produce enough reflections to function as screens), and an apparently infinite number of perforated materials, results in spaces very different from Hilberseimer's "room of shadowless light." Indeed, recent projects point to the possibility that "transparency" can also express the shadows of architecture.

The literary critic Jean Starobinski begins his essay "Poppaea's Veil": "The hidden fascinates."[3] His title refers to a passage in Montaigne's essay "That difficulty increases desire" (II:15), where the philosopher examines a complicated relationship between Poppaea, who was Nero's mistress, and her admirers: "How did Poppaea hit on the idea of hiding the beauties of her face behind a mask if not to make them more precious to her lovers?"[4] Starobinski analyzes the veil: "Obstacle and interposed sign, Poppaea's veil engenders a perfection that is immediately stolen away, and by its very flight demands to be recaptured by our desire."[5] To describe the action of the viewer, Starobinski rejects the term *vision*, which implies an immediately penetrating certitude, in favor of *gaze*: "If one looks at the etymology, one finds that to denote directed vision French resorts to the word *regard* [gaze], whose root originally referred not to the act of seeing but to expectation, concern, watchfulness, consideration, and safeguard."[6] Starobinski's metaphor is literary, but it easily translates into architectural terms: the facade becomes an interposed veil, triggering a subjective relationship by distancing the viewer of the building from the space or forms within and isolating the viewer within from the outside world.

Created by streams of water running over light-gauge metal fencing in frigid weather, Michael Van Valkenburgh's elegantly simple Radcliffe Ice Walls (Cambridge, Massachusetts, 1988, fig. 1 and pp. 34–35) gives the metaphor substance: like Poppaea's veil, the walls interpose between the viewer and the landscape an ephemeral material (a frozen cloud) and an image (the fence) signifying protection or obstacle. Another germane example is the Ghost House by Philip Johnson (New Canaan, Connecticut, 1985, pp. 36–37), also made of chain-link fencing, which recalls both Frank Gehry's buildings made from off-the-shelf materials and Robert Irwin's diaphanous landscape projects. This minimalist rendition of the archetypal house was designed as a nursery, a latter-day lath house, for growing flowers. The chain-link surfaces not only render the house and its interior as a spectral form but prevent foraging deer or other inquisitive visitors from reaching the flower beds: a most succinct representation of Poppaea's distanced perfection, a literal expression of the watchful and concerned gaze.

A similarly mediated relationship between the viewer and a distanced space within can be seen in larger, more complex projects such as the Saishunkan Seiyaku Women's Dormitory by Kazuyo Sejima (Kumamoto, Japan, 1991, pp. 38–43) and Fumihiko Maki's project for a new Congress Center in Salzburg (1992, pp. 8 and 44–47). The dormitory's heavily screened facades, finely perforated like a sieve,

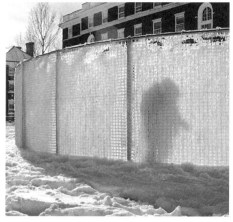

Figure 1: Michael Van Valkenburgh. Radcliffe Ice Walls, Cambridge, Massachusetts. Installation, 1988

Figure 2: Fumihiko Maki. Congress Center, Salzburg, Austria. Competition proposal, 1992. Exploded diagram

provide maximum blockage with the fewest of hints of the interior spaces. Inside, these spaces are relatively free and open, with light filtering through the facades and descending from above. Still, various screened materials used throughout the project impose physical limitations on vision. The Congress Center's facades are more open, but the distance between the viewer and the space within is no less rigorously maintained. As in a Russian doll, the spaces nest one inside another, farther and farther removed from the viewer's grasp (fig. 2).

In these projects and others, the distance created between the viewer and the space within suggests, on some level, a voyeuristic condition made explicit in a gymnasium designed by Charles Thanhauser and Jack Esterson (New York City, 1993, pp. 48–49). In place of typical locker rooms for showering and changing are four freestanding cubicles within the training area, partially enclosed in frosted glass. From various perspectives, the obscured images of athletes dressing and undressing can be observed, accentuating the sensual aspects of physical culture. As in Alfred Hitchcock's *Rear Window*, the anonymity and detachment of the images enhance sensuality; in Montaigne's words, they "entrap our desires and...attract us by keeping us at a distance."[7]

That all of the preceding projects might be referred to as "transparent" suggests a newfound interest in a term long associated with the architecture of the modern movement. Yet the tension between viewer and object implied by the use of the architectural facade as a veiling membrane indicates a departure from past attitudes and a need to reexamine the word *transparency* as it relates to architecture. The presence of a new attitude is confirmed by a brief glance at such projects as the Goetz Collection by Jacques Herzog and Pierre de Meuron (Munich, 1992, pp. 50–53), the Cartier Foundation for Contemporary Art by Jean Nouvel (Paris, 1994, pp. 54–59), or the ITM Building by Toyo Ito (Matsuyama, Japan, 1993, pp. 60–65). The Goetz Collection, whose supporting structure is enclosed between the frosted surfaces of a double-glass facade, appears ghost-like, a complete reversal of the structural clarity of the so-called Miesian glass box (figs. 3 and 4). Seen through a freestanding, partially glazed palisade, the frame structure of the Cartier Foundation is more explicit and the use of clear plate glass more extensive than in the Goetz Collection. Even so, the Cartier Foundation achieves extreme visual complexity—"haze and evanescence" in the words of the architect—due to the overlapping buildup of views and multiple surface reflections. Transparency in the ITM Building and the Cartier Foundation is not created simply by applying a glass curtain wall to the exterior of the building's frame. Rather, the idea of transparency is present deep within the structures; one seems to be suspended within multiple layers of transparency, not only

Figure 3: Jacques Herzog and Pierre de Meuron. Goetz Collection, Munich. 1992

Figure 4: Ludwig Mies van der Rohe. Farnsworth House, Plano, Illinois. 1946–51

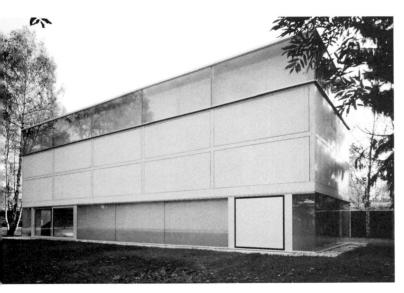

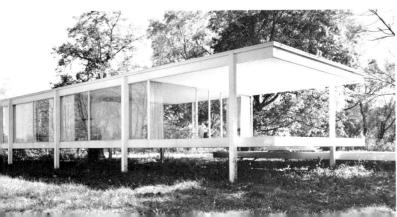

vertical wall surfaces but horizontal surfaces such as the translucent floor panels of Nouvel's project and the reflective floor and ceiling materials of the ITM Building. About the latter, the critic Yoshiharu Tsukamoto has noted: "The result is an interior bleached of all sense we customarily associate with the materials, sublimated into an experience of 'weightlessness,' in Ito's own terminology."[8]

Hilberseimer's ideal of shadowless light is difficult to see in the banal office towers and residential blocks erected in the postwar building boom. The depredations of the debased International Style of those years provided fertile ground for critics of both the modern rationalists and their latter-day followers. The antipathy of the architectural historian Colin Rowe for the kind of architecture proposed by Hilberseimer was buttressed by a distaste for the technological, anticlassical ethos of the glass curtain wall, which he felt was bereft of the intellectual complexities to be found in the traditional facade. In his critique of the purported objectivity of the early modern rationalists, Rowe found an ally in the painter Robert Slutzky, a former student of Josef Albers. Slutzky's interest in Gestalt psychology had led him to question the claims to objectivity of some modern painters. Together, they wrote in 1955–56 the essay "Transparency: Literal and Phenomenal," which was first published in 1963 and was widely read in the 1960s, influencing several generations of American architects. In it they state: "[The observer] may enjoy the sensation of looking through a glass wall and thus be able to see the interior and the exterior of the building simultaneously; but, in doing so, he will be conscious of few of those equivocal emotions which derive from phenomenal transparency."[9] They propose "phenomenal transparency" as an abstract, theoretical sense of transparency derived from skillful formal manipulation of the architectural facade, viewed frontally, as opposed to the more straightforward "literal transparency" that they ascribe to the curtain-wall architecture of the modern rationalists.

Figure 5: Rem Koolhaas–O.M.A.
Bibliothèque Nationale de France,
Paris. Competition proposal, 1989.
Axonometric

Rem Koolhaas's 1989 Bibliothèque Nationale de France project (fig. 5), a massive, glass-enclosed cubic structure, offers a kind of transparency that appears to fall entirely outside Rowe and Slutzky's scheme: a building with the visual complexity they sought, which nevertheless rejects the traditional facade that Rowe ultimately defended. It is a building in which transparency is conceived, in the words of the architectural historian Anthony Vidler, "as a solid, not as a void, with the interior volumes carved out of a crystalline block so as to float within it, in amoebic suspension. These are then represented on the surface of the cube as shadowy presences, their three-dimensionality displayed ambiguously and flattened, superimposed on one another in a play of amorphous densities." Vidler also takes us a step further toward understanding the new direction of contemporary architecture: "The subject is suspended in a difficult moment between knowledge and blockage."[10]

The visual experience described by Vidler is certainly not the type that Rowe and Slutzky disparage as literal. But does the viewer's ambiguous perception of the building's interior volumes evoke those "equivocal emotions" that derive, those authors argue, from phenomenal transparency? The word *ambiguous* plays an important role both in their writings and in the more recent ones of Koolhaas; but it is not enough to think that all things ambiguous are necessarily related. The distinction between

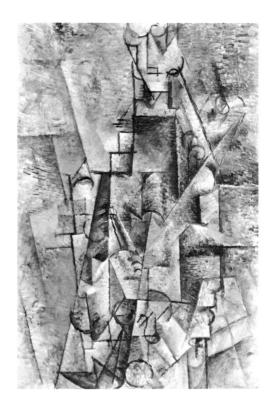

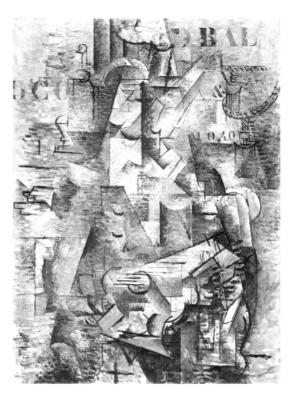

Figure 6: Pablo Picasso. Man with a Clarinet. 1911. Oil on canvas, 41 ³/₈ x 27 ³/₁₆ in. Museo Thyssen-Bornemisza, Madrid

Figure 7: Georges Braque. The Portuguese. 1911–12. Oil on canvas, 46 x 32 in. Öffentliche Kunstsammlung Basel. Kunstmuseum. Gift of Dr. h. c. Raoul La Roche, 1952

the experience of Koolhaas's design, as Vidler describes it, and the terms of analysis proposed by Rowe and Slutzky can best be understood if we look to the passage in which they use paintings by Pablo Picasso and Georges Braque to provide a "prevision," as they call it, of literal and phenomenal transparency.[11] They see Picasso's *Man with a Clarinet* of 1911 (fig. 6) as an example of literal transparency, "a positively transparent figure standing in a relatively deep space"; only gradually does the observer "redefine this sensation to allow for the real shallowness of the space." Braque's *The Portuguese* of the same year (fig. 7) reverses this experience: the painting's "highly developed interlacing of horizontal and vertical gridding…establishes a primarily shallow space"; only then does the viewer "become able to invest this space with a depth."

At this point it seems necessary to separate Rowe from Slutzky, whose concerns led him into a deep investigation of the relationship between the fine arts and the psychology of perception.[12] While admiring Slutzky's analysis, Rowe ultimately is concerned with how the cubist paintings might support his conviction that modern architecture represents nothing more than a formal evolution out of, rather than a break with, the architecture of the classical past. Disregarding the fundamental differences between traditional perspectival construction and synthetic cubism, and setting aside for the moment the differences between *Man with a Clarinet* and *The Portuguese* on which Rowe and Slutzky focus, we can identify three aspects of the paintings that made them useful to Rowe for architectural analysis: their frontality, analogous to that of the traditional facade; their figure-ground relationships, which privileged formal discernment; and their synthetic spatial depth, which suggested to Rowe an affinity with the compositional elements of the classical orders. Thus, the analytical tools developed by Slutzky to undermine rationalist objectivity in painting

ironically serve Rowe to defend the objective viewpoint of the architectural connoisseur. In an extended comparison of Gropius's Bauhaus workshop wing, displaying literal transparency, and Le Corbusier's Villa Garches, representing phenomenal transparency, Rowe and Slutzky even criticize Gropius for "relying on the diagonal viewpoint," rather than the fixed, orthogonal viewpoint of Le Corbusier's work and, for that matter, the canvases of Picasso and Braque.[13] In so doing, they continue, Gropius "has exteriorized the opposed movements of his space, has allowed them to flow away into infinity."

Figure 8: Marcel Duchamp. The Bride Stripped Bare by Her Bachelors, Even (The Large Glass). 1915–23. Oil, varnish, lead foil, lead wire, and dust on two glass panels (cracked), each mounted between two glass panels, with five glass strips, aluminum foil, and a wood and steel frame, 109 1/2 x 69 1/4 in. Philadelphia Museum of Art, Bequest of Katherine S. Dreier, 1953

Regardless of their ultimate positions, Rowe and Slutzky's ideas about transparency rest on the premise that the viewer has visual access to the object, either by penetrating to it directly or by constructing a visual path through the shallow space of the Cubist grid. Vidler's term *blockage* has no function in a discussion of penetrating the spaces created by Picasso and Braque (or Rowe's architectural exemplar, Le Corbusier), but the term strongly resonates with the work of Marcel Duchamp, particularly his *Large Glass* of 1915–23 (fig. 8). For Duchamp the surface of the *Large Glass* is a kind of threshold, distinct from the object itself, suggesting a subjective tension between the viewer and the object like that created by Poppaea's veil; it is to be "looked at rather than through," in the words of the architecture critic Kenneth Frampton.[14] Another way of describing the effect on the viewer is suggested by Octavio Paz; whereas Picasso's work represents "movement before painting," Paz explains that "right from the start Duchamp set up a vertigo of delay in opposition to the vertigo of acceleration. In one of the notes in the celebrated *Green Box* he writes, 'use *delay* instead of "picture" or "painting"; "picture on glass" becomes "delay in glass."'"[15]

Frampton's comments on the *Large Glass* are made in an essay in which he compares Duchamp's great work to Pierre Chareau's 1932 Maison de Verre, a long-neglected masterpiece of prewar architecture, which ran completely against the grain of modern rationalist thought (fig. 9). It was sheathed in layers of transparent and translucent materials, which alternately obscured and revealed a sequence of views—"ambiguous characteristics," Frampton notes, which "would surely have been anathema to the fresh air and hygiene cult of the mainstream Modern Movement."[16] Though the glass architecture of the Maison de Verre might have been dismissed by the rationalist Hilberseimer, it remains resistant to the visual delectation espoused by Rowe. Frampton points out that it served as both a private residence and gynecologist's office, a combination of functions richly analogous to the division of the *Large Glass* into the Bride's domain above and that of the eroticized Bachelor Apparatus below. Frampton writes, "The works are unclassifiable in any conventional sense; they are 'other' in the deepest sense of the word and this 'strangeness' is a consequence of their opposition to the mainstream of Western art after the Renaissance."[17] Frampton's writings, which underpin many of the thoughts expressed here by myself

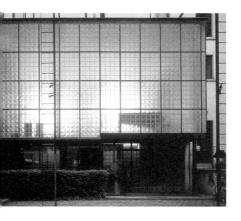

Figure 9: Pierre Chareau. Maison de Verre, Paris. 1932. Facade

Figure 10: Rem Koolhaas–O.M.A. Bibliothèque Nationale de France, Paris. Competition proposal, 1989. Périphérique facade

and others, point to the relationship between delay in glass and a potential delay in architecture that this essay attempts to establish.

These modes of delay resist the kind of classification that inevitably results from visual objectivity's fixed point of reference. Herzog and de Meuron's 1989 project for a Greek Orthodox Church in Basel and Ben van Berkel's ACOM Office Building renovation (Amersfoort, the Netherlands, 1993, pp. 66–67) provide examples of "delay in architecture." The church is a volume of glass and translucent marble enclosing a second volume of translucent alabaster, which is the sanctuary. On the alabaster are ghostlike photo-etched images of ancient icons, which act as filters, interposing faith, history, and memory, "delaying" the headlong rush of visual perception into the interior. The new facades surrounding the ACOM Office Building similarly provide a visual threshold, revealing the "memory" of the preexisting structure, built in the 1960s and now subsumed. Van Berkel employs translucent materials and perforated screens to hinder visual penetration, creating the greatest possible distance between the interior and exterior membranes.

Like Poppaea's veil, these facades have a positive presence and, in distancing the viewer, a specific function: they are something inserted *between*. The facades of Koolhaas's library not only transmit the shadowy presences of forms within but acknowledge equally amorphous forms *without*, specifically clouds, whose generic shapes are etched on the Paris and Périphérique facades (fig. 10). In this respect as well as in acting as thresholds, Koolhaas's facades have a certain affinity with the *Large Glass*, whose upper panel is dominated by the image of a cloud. The cloud is an appropriate symbol of the new definition of transparency: translucent but dense, substantial but without definite form, eternally positioned between the viewer and the distant horizon. Koolhaas describes the library's facades: "transparent, sometimes translucent, sometimes opaque; mysterious, revealing, or mute.... Almost natural—like a cloudy sky at night, like an eclipse."[18]

The "mysterious" facades mentioned by Koolhaas and the "haze and evanescence" that Nouvel sees in the Cartier Foundation originate in conditions Rowe and Slutzky somewhat derisively refer to as the "haphazard superimpositions provided by the accidental reflections of light playing upon a translucent or polished surface."[19] But the architects' words are not simply poetic, and the effect they describe is not haphazard, as a brief excursion into quantum electrodynamics may suggest. Transparent and translucent materials allow some photons (particles of light) to pass through them while they partially reflect others. This activity in the surface of the transparent membrane can account for the reflection of as much as 16 percent of the light particles that strike it, creating visible reflections and, frequently, a palpable luminescence.[20] The doubling of the glass found in many of the projects here increases the potential for the glass surface to cast back photons: up to 10 percent of those that pass through the outer layer are reflected by the inner one; still others ricochet between the two. The dynamics of light passing through transparent surfaces is described as a "slowing" of light by the physicist Richard Feynman.[21] The similarity of his term to Duchamp's "delay in glass" provides a striking bridge between the languages of the physicist and the artist.

While Feynman's writings apply specifically to the passing of light through materials, the D. E. Shaw and Company Offices by Steven Holl (New York City, 1991, pp. 68–69) demonstrate a "slowing of light" as it reflects off opaque surfaces. In this project, natural light enters through the building's windows, strikes screen walls back-painted in various colors, and ricochets into the interiors, suffusing them with reflected colored light recalling the soft, pervasive glow of James Turrell's sculptures.

The contrast between a classic modernist project and recent works illustrates the difference between today's attitudes toward the architectural surface and earlier conceptions of transparent and translucent skins. While capable of creating a remarkably complex surface, Mies van der Rohe intended in his Tugendhat House (Brno, Czechoslovakia, 1929) to achieve the greatest transparency (fig. 11). To realize this aim, Mies employed the simplest kind of skin. The house was sheathed floor to ceiling by the largest sheets of plate glass produced in Europe up to that time. Ironically, given its expense, he hoped that the glazing would be essentially nonmaterial; in fact, a mechanism allowed the glass walls to be lowered into the basement, removing them altogether.

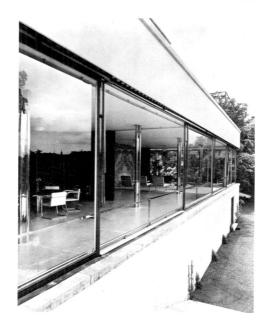

Figure 11: Ludwig Mies van der Rohe. Tugendhat House, Brno, Czechoslovakia. 1930. Exterior view of retractable windows.

The projects presented here rarely display a skin that could be called nonmaterial; instead, they exploit the positive physical characteristics of glass and other substances. As opposed to the fraction of an inch by which the windows of the Tugendhat House separated its interior from the exterior, these newer projects frequently have very complex sections comprising a variety of materials, with discrete spaces between. This gives the surfaces a depth that is sometimes slight, as in the tightly bound sheathing of the Signal Box auf dem Wolf by Herzog and de Meuron (Basel, 1994, pp. 72–73), and sometimes more pronounced, as in Peter Zumthor's Kunsthaus Bregenz (Bregenz, Austria, pp. 74–77), currently under construction, whose interior and exterior are separated by layers of translucent shingles, a passable air space, and an interior wall. Such built-up sections increase emphasis on the architectural surface and reveal a desire for greater complexity, visual and otherwise, in the structure's skin. The reasons for multiple layers of material frequently include reducing the transmission of heat and cold, but the aim of insulating the structure is not solely a technical one. As does Poppaea's veil, layers of transparency define the viewer's relationship to the world, creating not only insulation but a notable isolation—removal from the continuum of space and experience implied by the nonmaterial surfaces of the Tugendhat House.

Architecture—though it may be read as a text with definite relationships to literature, philosophy, the fine arts, and so on—is a specific kind of text with its own critical tools. The section, a conceptual device with little application outside architecture, can be used to develop details, like the elements of a structure's surface, or even the building as a whole. The section on page 78 of Harry Wolf's proposed ABN-AMRO Head Office Building (Amsterdam, 1992) is analogous to details of the structure's curtain wall: each represents a volume of space suspended between glazed surfaces. Section views of the Leisure Studio (Espoo, Finland, 1992, pp. 82–85) by Kaako, Laine, Liimatainen, and Tirkkonen, the Neues Museum extension (Berlin,

1994, see fig. 26) proposed by David Chipperfield, and other projects all show a dense volume surrounded by open, unprogrammed space, itself enclosed by a glazed skin. Analogous to thermally efficient double-glazed walls, these designs isolate activities from light, sound, or heat. Yet the extravagance of these efficiencies reminds us that isolation is not simply a functional goal in these structures, but a visual and ultimately cultural one.

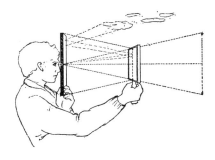

Figure 12: Reconstruction of Brunelleschi's perspective experiment, 1417. After Alessandro Parronchi, Studi su la dolce prospettiva (Milan: A. Martello, 1964), fig. 91

The tension between viewer and object engendered by the use of veil-like built-up membranes parallels a tension between architectural surface and architectural form that is evident in many of the works presented here. The art historian Hubert Damisch has written at length about the invention of perspective drawing, one of the principal design tools since the Renaissance, and its inherent bias toward form: "Perspective is able to comprehend only what its system can accommodate: things that occupy a place and have a shape that can be described by lines."[22] Damisch further notes that the limitations of perspective's ability to describe visual experience were apparent even at its inception. He cites Brunelleschi's 1417 experiment in which he tested the accuracy of his perspective drawing of the Baptistery of San Giovanni, seen from the door of the Cathedral in Florence. The drawing on a panel was held by the observer, who peered through a small hole in the back of it toward the Baptistery while holding at arm's length a mirror that reflected the right half of the panel, thus allowing him to compare the actual view of the structure with the reflection of Brunelleschi's drawing of it (fig. 12). Damisch notes that the architect attempted to compensate for the limitations he clearly saw in his drawing system: having rendered the Baptistery and the surrounding square, Brunelleschi added a layer of silver leaf to the upper area of the panel to mirror the sky and the clouds, those aspects of the actual view that escaped his system of perspective. Brunelleschi's addition of silver leaf not only "manifests perspective as a structure of exclusion, the coherence of which is based upon a set of refusals," but, by reflecting the formlessness of the clouds, must "make room...for even those things which it excludes from its system."[23]

Many of the projects presented here exhibit a similarly compensatory attitude, an attempt to "make room" for that which neither perspective nor Cartesian space can describe. Dan Graham, in *Two-Way Mirror Cylinder inside Cube*, a component of his Rooftop Urban Park Project at the Dia Center for the Arts, New York (1991, see fig. 27 and pp. 86–87), recognizes the usefulness of geometry, plan organization, and systemization of the structure while refusing to assign them a transcendent, defining role. The environment, endlessly reflected, literally superimposes formlessness on the structure's architectural surfaces, easily overcoming the certitude of the structurally framed view and the idealized abstraction of the circle and the square that create its plan, dissolving their Platonic forms in contingent perceptions. Similarly, the transparent surfaces, flickering video screens, and tilted volume of the Glass Video Gallery by Bernard Tschumi (Groningen, the Netherlands, 1990, see fig. 14 and pp. 88–91) counteract the ability of a structural grid and perspective vision to determine the overall image of architecture. As Tschumi explains, "The appearance of permanence (buildings are solid; they are made of steel, concrete, bricks, etc.) is increasingly challenged by the immaterial representation of abstract systems (television and electronic images)."[24]

Rosalind Krauss has recently described a phenomenological reading of minimalist sculpture, on the part of certain architecture critics, which effects a shift in meaning that closely parallels the shift from form to surface evident in the projects presented here. She writes, "Far from having what we could call the fixed and enduring centers of a kind of formulaic geometry, Minimalism produces the paradox of a centerless, because shifting, geometry.... Because of this demonstrable attack on the idea that works achieve their meaning by becoming manifestations or expressions of a hidden center, Minimalism was read as lodging meaning in the surface of the object, hence its interest in reflective materials, in exploiting the play of natural light."[25] This interpretation of minimalist sculpture's tendency to shift the meaning of the object from its form to its surface has broad implications for architecture. Jean Nouvel expresses a similar idea when he describes the architecture of his Cartier Foundation as one whose rules consist in "rendering superfluous the reading of solid volumes in a poetry of haze and evanescence."[26]

The position that Krauss describes need not be limited to a building with polished, reflective surfaces that record "actual, contingent particularities of its moment of being experienced."[27] For example, the "contingent particularities" of the Goetz Collection do not lie solely in the subtle reflections of the birch trees surrounding it. The project achieves a specific rather than universal character in its construction as well: it "reflects" its site in the laminated birch veneer panels of the facade. And even though the surfaces of the minimalist gymnasium by Iñaki Abalos and Juan Herreros (1991, pp. 98–101) are much less transparent or translucent, that project also resists being perceived as an abstract formal exercise, insisting on its site-specificity, reflecting the character of the walled Spanish hill town of Simancas.

In telling contrast to the ultimate importance given to architectural form in both historicist postmodernism and deconstructivism, many of these projects exhibit a remarkable lack of concern for, if not antipathy toward, formal considerations. In fact, most of the projects could be described by a phrase no more complicated than "rectangular volume." Commenting on one of his recent projects, Koolhaas explains the logic of this formal restraint: "It is not a building that defines a clear architectural identity; but a building that creates and triggers potential."[28] The tension between surface and form in contemporary architecture is not limited to relatively simple forms: the overall silhouettes of Renzo Piano's Kansai International Airport (Osaka, Japan, 1994, pp. 110–17), Frank Gehry's Frederick R. Weisman Art Museum (Minneapolis, 1993, pp. 106–9), and Nicholas Grimshaw and Partners' Waterloo International Terminal (London, 1994, pp. 92–98), for example, are far too complex to be characterized as minimalist. Kansai Airport's sheer scale prevents us from grasping its form, and the extent of the new Waterloo terminal can only be seen from the air. Yet even when experiencing parts of Kansai Airport, we realize that its silvery, undulating skin is more critical to its design than is its formal composition; equally, the form of the Waterloo International Terminal reflects peculiarities of the lot lines of existing rail yards rather than any preconceived formal conceit. In both projects, the overall form is complex but indefinable, specific but nonrepresentational.

None of the above projects, nor any of the less articulated ones previously considered, displays interest in "timeless, unchanging geometries," and all of them complement the diminished importance of overall form by an increased sensitivity to the skin. And while the large projects may seem not just indifferent to but fundamentally estranged from the geometric rigors of perspectival construction, what impresses the viewer of a project such as Toyo Ito's Shimosuwa Municipal Museum (Shimosuwa, Japan, 1993, pp. 118–23) is not that its form is difficult to grasp, which it is, but that it simultaneously appears so precise. In effect, it suggests a new conception of measure and order. Brunelleschi perceived an unbridgeable gap between the measurable (the Baptistery) and the immeasurable (such as a cloud). Similarly, Leonardo identified two kinds of visible bodies, "of which the first is without shape or any distinct or definite extremities...The second kind of visible bodies is that of which the surface defines and distinguishes the shape."[29] Leonardo's distinction is essentially false, however, determined by the inability of Renaissance mathematics to describe complex surfaces. Fractal geometry has shown that there is no such fundamental distinction between the Baptistery and the cloud, only a difference in the manner of calculating their physical characteristics.

The computer has diminished the realm of the immeasurable in architectural design. In describing the uniquely shaped panels that compose the skin of the Shimosuwa Museum, Ito noted that without computer technology their cost, relative to that of standardized panels, would have been prohibitive. The use of extensive computer modeling in the design of Kansai Airport (fig. 13) and Waterloo Terminal further demonstrates the extent to which technology has overcome the "problem" of structure, once a primary focus of design, whose "solution" subsequently defined, visually and otherwise, all other aspects of a project. This relativization of structure can be seen in various ways in the projects presented here; for example, Nagisa Kidosaki, writing about the Shimosuwa Museum, explains: "Thin membranes meant a thin structural system."[30]

Figure 13: Renzo Piano Building Workshop, Japan. Kansai International Airport, Osaka. 1994. Diagram showing top-bottom chord axial forces under vertical loading

The use of sophisticated computer modeling is only one sign of the impact of technology on the architectural surface. The incorporation of electronic media into contemporary structures may result in the transformation of a building's skin, which literally becomes a screen for projection in Herzog and de Meuron's 1993 Olivetti Bank project (see fig. 15). A more architectonic synthesis of the electronic media can be seen in those projects in which electronic technology is not simply grafted to the structure but transformed into material and spatial qualities. The flattening of objects and activities projected onto translucent glazing gives a facade or interior surface the aura of a flickering electronic screen. On a small scale, this phenomenon is evident in the Thanhauser and Esterson gymnasium, where the athletes' silhouettes are projected onto the surfaces of dressing room cubicles (each cubicle has splayed walls, as if to suggest projection). On a larger scale, the farmhouses and elements of the natural landscape outside Ito's ITM

Building collapse, in effect, as they are projected onto the surface glazing of the triple-height atrium. In Tod Williams and Billie Tsien's portable translucent set for the play *The World Upside Down* (Amsterdam and New York, 1990–91, pp. 104–5), projections actually became part of the performance as actors' silhouettes were cast onto screens and magnified by manipulation of the lighting. Jacques Herzog writes of "these surfaces for projection, these levels of overlapping, the almost-identity of architecture."[31]

Despite the ambiguous, equivocal, and at times even erotic undertones of many of the projects discussed here, it would be incorrect to assign them to a world of smoke and mirrors, where all is illusion, indecipherable and unattainable. Rather, they realign or rethink a nexus of ideas that has fueled much of architectural development since the Renaissance: perspectival vision, Cartesian space, and, by inference, the structural grid. Inherent in the works presented here, particularly Joel Sanders's studied Kyle Residence project (1991, pp. 124–25), is the possibility of a position that includes the certitude of objective vision and the equivocal nature of the gaze; these works recognize the efficacy and the utility of perspectival construction without subordinating all else to its language of measure and order. The fusion of the two might be best understood in the designers' attitude toward structure, for centuries the most evident expression of the theoretical coincidence of perspectival vision and Cartesian thinking. Many of these projects share a common approach to the relationship between the structure and the skin: the structural members, rather than framing and therefore defining the point of view, are lapped over by single and double layers of translucent sheathing, as in the interior partitions of the Cartier Foundation, the clerestory of the Goetz Collection, and Annette Gigon and Mike Guyer's Kirchner Museum Davos (Davos, Switzerland, 1992, pp. 126–29). The structure, while providing support in a straightforward manner, has a diminished potential to determine the appearance of the building. Other projects here virtually erase the boundary between support and surface: the Glass Video Gallery makes no material distinction between the glass ribs that give it stability and the glass sheathing that encloses the space (fig. 14). The monocoque design of the Phoenix Art Museum Sculpture Pavilion by Williams and Tsien (Phoenix, Arizona, pp. 130–31) similarly merges structure and sheathing. The Pavilion's translucent resin panels, ranging from one-half to one inch thick and connected only with stainless steel clips, are self-supporting and stabilizing.

Figure 14: Bernard Tschumi. Glass Video Gallery, Groningen, the Netherlands. 1990. Exploded axonometric diagram

It could be argued that these self-effacing but critical details relativize the role of the structure in a more self-confident way than deconstructivist ploys such as tilted columns, destabilized surfaces, and structural redundancies, which, though meant to undermine the role of structure, frequently achieve the opposite: the specter of the displaced rises up endlessly to haunt the architecture. More fundamentally, such

Figure 15: Jacques Herzog and Pierre de Meuron. Olivetti Bank Project. 1993 (prototype)

detailing can be unambiguous about creating ambiguity. Italo Calvino expresses this idea well: "Lightness for me goes with precision and determination, not vagueness and the haphazard."[32] In "Lightness," one of Calvino's *Six Memos for the Next Millennium*, he writes, "I look to science to nourish my visions in which all heaviness disappears"; and further, "the iron machines still exist, but they obey the orders of weightless bits."[33] Calvino reminds us that just as the current conception of transparency is distant from that held by early modern rationalists, these contemporary expressions of lightness are distinct from earlier conceptions of lightweight architecture: they imply a seeming weightlessness rather than a calculation of relative weight.[34] Calvino's balance between iron machines and weightless bits is also seen in Starobinski's prescription for the "reflexive gaze," which incorporates the wisdom associated with vision, yet "trusts in the senses and in the world the senses reveal."[35]

The subject of Starobinski and Calvino is literature, but their observations have numerous implications for understanding the aesthetics of the architecture presented here, as well as its broader cultural context.[36] Calvino refers to Guido Cavalcanti as a poet of "lightness," which he defines as follows: "(1) it is to the highest degree light; (2) it is in motion; (3) it is a vector of information."[37] Ito's Tower of the Winds (Yokohama, 1986–95, pp. 132–33) practically begs to be analyzed in these terms. Relatively nondescript in daylight, the structure was brought to life at night by thousands of computer-controlled light sources whose constantly changing patterns responded to sounds and wind. In the architect's words, "The intention was to extract the flow of air (wind) and noise (sound) from the general flow of things in the environment of the project and to transform them into light signals, that is, visual information. Simply put, it was an attempt to convert the environment into information."[38]

It is not surprising that the pervasive presence in contemporary culture of film, television, video, and computer screens, representing a unique sensibility of light, movement, and information, should find its way into architecture. Koolhaas's composition for the Karlsruhe Zentrum für Kunst and Medientechnologie is perhaps the most provocative configuration of the electronic screen and the architectural facade, but the proposed display of financial quotations on the facade of Herzog and de Meuron's Olivetti Bank project is no less explicit and equally convincing, given its program (fig. 15). Among built projects, Ito's Egg of the Winds (fig. 16), Tschumi's Glass Video Gallery, and Mehrdad Yazdani's CineMania Theatre (1994, pp. 102–3) represent more restrained uses of electronic imagery but still demonstrate the ability of the architectural object to be transformed by the dull glow and flickering image of the electronic media. The effect, as Ito has described it, is to render urban space as a "phenomenal city of lights, sounds, and images...superimposed on the tangible urban space of buildings and civil engineering works."[39]

Figure 16: Toyo Ito. Egg of the Winds, Tokyo. 1991

The architects' interest in electronic media is neither an expression of technological fantasy nor simply a fascination with the aesthetic allure of low-voltage luminescence. It is rooted in the ability of these electronic modes of communication to portray the immediacy and the poignant transience of contemporary life. Their works bring to mind Ludwig Wittgenstein's observation, "It seems as though there is nothing intangible about the chair or the table, but there is about the fleeting human experience."[40] Dennis Adams's installation *Bus Shelter IV* (Münster, Germany, 1987, pp. 134–35) narrows the gap between the tangible and the intangible. Adams transforms an ordinary bus shelter into the setting for an urban drama in which commuters find themselves both observers and observed. Interposed between enlarged backlit transparencies, they find their own image projected and reflected by a highly manipulative visual environment.

The many images here that portray the architecture at night, lit from within, suggest that Ito is not alone in seeking an architecture that "is to the highest degree light." In Zaha Hadid's 1994 proposal for the Cardiff Bay Opera House, the nocturnal view is not simply the inverse of the building's daylight appearance. Indeed, the drawings prepared for the competition indicate that the design was conceived as a nighttime phenomenon. *Floor Plan*, an installation by Melissa Gould (Linz, Austria, 1991, pp. 136–37), equally depends on darkness, literally and metaphorically, to convey its message. The project consisted of a nearly full-scale outline of the plan of a Berlin synagogue destroyed during the Nazi terror. The ghost building was evoked by lights in shallow trenches, which traced the configuration of the synagogue's walls and columns. Photographs document the poignant dramatic character of the project: we see eerily lit faces of visitors moving through the installation. More tragically, the work can disappear at the flick of a switch. Gould's project demonstrates unequivocally that "lightness" should not be confused with frivolity.

The current fascination with the architecture of lightness in many ways depends on recent technological developments. It also manifests a persistent theme in Western culture. Describing his proposed ABN-AMRO Head Office Building, Harry Wolf refers to the "longstanding concern for light in the Netherlands; that is, the association of luminosity, precision, and probity in all matters." However, notwithstanding the philosophical associations of light with the Enlightenment, illumination, and so on, the attempt to magnify the presence of natural light in northern European projects is primarily a response to the immediate setting—also a longstanding concern. Wolf recalls "Vermeer's preoccupation with subtle modulations of light through a window."[41] Jan Vermeer's emphasis on ambient light is, among other things, an attempt to magnify its diminished presence in northern latitudes (fig. 17); a similar motive led to the gilding of architectural features, from the cupolas of New Haven's churches and the Goldene Dachel of Munich's imperial residence to the reflective sheathing of Gehry's Weisman Art Museum. The Kirchner Museum's principal galleries are lit by a clerestory level, capturing light from all directions in a plenum and diffusing it through the galleries' frosted glass ceilings. This sensitivity to low levels of natural light also may be a response to the flattening of the shadowless landscape, particularly during the winter months.

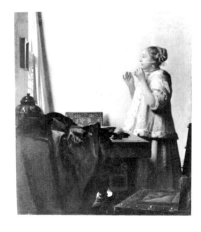

Figure 17: Jan Vermeer. Woman with a Pearl Necklace. C. 1662–65. Oil on canvas, 21 11/16 x 17 3/4 in. (55 x 45cm). Staatliche Museen zu Berlin–Preußischer Kulturbesitz Gemäldegalerie

Herzog usefully observes: "Le Corbusier…wrote, 'Architecture is the scientific, correct, and wonderful game of volumes assembled under light.' What, however, if architecture is not a game at all, especially not a scientific and correct one and if the light is often clouded over, diffuse, not so radiant as it is in the ideal southern landscape?"[42] Holl's Helsinki Museum of Contemporary Art (under construction, pp. 138–43) traps this diffuse northern light within its section in order to introduce it, both directly and by reflection, into the lower parts of the building—suggesting, perhaps, an architectural antithesis of Le Corbusier's *brise-soleil*, a shield from Mediterranean sunlight. Oriented to maximize exposure to the sun, which is low on the horizon most of the year, the museum incorporates a reflecting pool as an extension of nearby Töölo Bay. In Holl's words, "The horizontal light of northern latitudes is enhanced by a waterscape that would serve as an urban mirror, thereby linking the new museum to Helsinki's Töölo heart, which on a clear day, in [Alvar] Aalto's words, 'extends to Lapland.'"[43]

In climates far removed from the idealized, sun-filled landscape of the Mediterranean, which Le Corbusier encountered in his youthful *voyage en Orient*, the longing for light may conflict with another more recent cultural concern. The past two decades have seen an increasing consciousness of architecture's environmental implications, particularly the energy consumption of buildings. Two approaches, both of which avoid or minimize mechanical heating and cooling systems dependent on fuel consumption, attempt to balance environmental concerns with the widespread use of glass and other thermally inefficient materials.

The first approach is essentially passive, in the technical sense of employing nonmechanical systems to heat and cool structures and often electing to forgo optimal climate control. Williams and Tsien's Phoenix Art Museum Sculpture Pavilion is to have no mechanical air-conditioning system; instead, it will employ a low-technology cooling device based on commonsense thermodynamics. Approximately twenty feet above the viewing area, scores of nozzles emit a fine mist of cool water, which evaporates before reaching ground level. The heat exchange that occurs during the evaporation process lowers the air temperature by ten to twenty degrees, and this heavier air then descends to cool visitors in the open pavilion. The simple principles behind this low-technology approach are equally useful in the colder climate of Munich, where the Goetz Collection is enclosed by a double layer of glass that not only contributes to the "slowing" of light but acts as a sort of a duct, like a chimney. As heat accumulates in the lower floor (which is below grade and therefore has a more stable temperature), it escapes into the space between the layers of glass and rises to the upper floor, providing a secondary source of heat. The Leisure Studio and Glass Video Gallery reject systems requiring high energy consumption to compensate for low thermal efficiency; users must simply accept constraints imposed by the climate: diminished comfort or restricted use when temperatures reach seasonal extremes. This attitude should not be perceived as a kind of obliviousness to the reality of climatic conditions but as a value judgment: a conscious decision reflecting a deep-rooted preference for the enhancement of available light, for one particular kind of comfort instead of another.

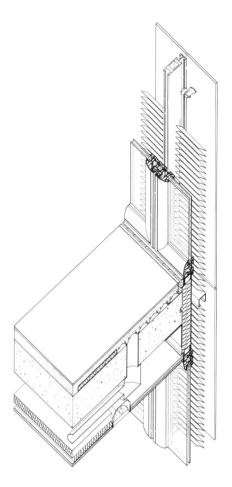

Figure 18: Sir Norman Foster and Partners. Business Promotion Center, Duisburg, Germany. 1993. Axonometric cutaway of layered glass cladding and floor slab

The second approach uses higher technology to achieve energy efficiency. Just as the computer has rendered the problem of structure less fundamental, limitations on the efficiency of mechanical heating and cooling are being overcome by technological advancements. Norman Foster's Business Promotion Center (Duisburg, Germany, 1993, pp. 144–47) is a building with an insulated glass facade wrapped in another layer of glass (fig. 18). A continuous air space between the two layers rises from the ground to the top of the structure. Large buildings, in contrast to smaller ones such as the Goetz Collection, absorb too much heat. To control heat intake, the air space in the Duisburg project has translucent louvers that can admit light but deflect heat, which can then be exhausted upward before entering the interior glazing. Within this system, there is an attempt to address microenvironmental differences between interior spaces. Even though the louvers adjust themselves automatically to the position of the sun, office workers can readjust them. Occupants may also open windows in the inner glazing to ventilate offices from the air moving through the twenty-centimeter gap between the inner and outer glazing.

Just as lightness offers a way to understand much of contemporary architecture in terms other than formal ones, cultural concerns with light and the environment are not limited to glass structures. The shimmering skin of metal tiles that covers Kansai Airport not only evokes the architect's stated goal of "lightness," but acts as a huge umbrella, protecting the structure from heat gain as well as rain. The building's undulating wave shape is, borrowing Calvino's words, "to the highest degree light," but it also interestingly embodies his emphasis on movement. Its shape expresses the flow of passengers across the structure from the "landside" to the "airside," as they move from check-in to departure, and it is also calculated to channel streams of air. The voluptuous interior ceiling carries ribbonlike channels, their shape derived from computer models of the flow of air, which guide heated and cooled air through the length of the building without the use of enclosed air ducts.

Such applications of innovative solutions to environmental problems bespeak a confidence in technology that has become discredited in some quarters. But the dismissal of a technological approach as evidence of an unjustified faith in the myth of progress is refuted by the successes of Foster, Piano, Peter Rice, and many other architects and engineers. Much of their research seeks to justify the ongoing use of glazed structures, so it is not surprising that their attention often focuses on glazing materials. While this research, like that devoted to conversion of solar energy, has limited application today, new glazing materials are on the edge of wide use. "Superwindows" with various coatings and gas-filled cavities have already proven to have better insulation properties than today's thermally efficient opaque materials.

Perhaps more intriguing than this new class of high-performance but essentially static systems are what Stephen Selkowitz and Stephen LaSourd call "smart" glazings, which react to changing conditions. These include "photochromic glass, which reversibly changes optical density when exposed to light," and "thermochromic glazings,

which become translucent when a preset thermal threshold is reached."[44] The former, used in sunglasses, is not yet sold for architectural use, but the latter, according to the authors, will become more widely available in the near future. A third type of smart glazings, called electrochromic, consists of multilayer assemblies through which a low-voltage electric current can be passed, causing ions to move to the outer layer where they may reflect heat-producing ultraviolet light but transmit visible wavelengths.

To speak of the technological attitudes of the projects discussed here as cultural phenomena requires further scrutiny, particularly given the prominence of glass structures over the course of this century. Glass architecture is not, however, unique to our time; a centuries-long fascination with it is evident in Jewish, Arabic, and European literature and mythology. As the architectural historian Rosemarie Haag Bletter has demonstrated, the "glass dream" that inspired these cultures has ancient roots, traceable to the biblical accounts of King Solomon's temple having reflective floors made of gold.[45] The glass dream was sustained through the Mozarabic culture of medieval Spain, principally in literary form, but it also found built expression in small metaphorical structures such as garden pavilions. "Because an actual glass or crystal palace was not technically feasible, the semblance of such a building was attained through allusion: water and light were used to suggest a dissolution of solid materials into a fleeting vision of disembodied, mobile architecture."[46] In the Gothic period, the glass dream found greater expression in built form, in the soaring cathedrals with their expansive walls of colored glass, as well as in literary sources, particularly the legends of the Holy Grail. In Wolfram von Eschenbach's *Parzifal*, the sought-for Grail is symbolized by a glowing crystal hidden in a cave. The association between the image of a crystal or jewel and glass architecture is enduring. Zaha Hadid, describing her design for the Cardiff Bay Opera House, refers to the overall organization as an "inverted necklace" that strings together the various service elements, which she calls the "jewels" of the program.[47] Similarly, Harry Wolf speaks of his attempts to "create a heightened sense of transparency, just as light reflected and refracted in a gem seems more compelling and brilliant."[48]

This literary and architectural motive continued through the Renaissance, emerging as a central theme of Francesco Colonna's widely read *Hypnerotomachia Poliphili* of 1499. An expression of the romantic aspect of the Renaissance fascination with the ruins of classical antiquity, it invokes images of structures with transparent alabaster walls and floors of highly polished obsidian, so mirrorlike that viewers thought they were walking through the reflected sky. While the Enlightenment was characterized by a fascination with light and the scientific investigation of optics, its architectural expressions were not as poetic. The Crystal Palace might seem equally rationalist, though it is hard for us to imagine the impact of this first extensively glazed large structure, envisioned as the stage for a global event, and the spectacle created by its construction and dismantling. Furthermore, the glass fountain at its crossing was an understated but direct reference to the fantastic Mozarabic structures described by Bletter.[49]

As Bletter has demonstrated, the association of crystalline architecture with the transcendent (and its counterpart, the association of opaque materials with the profane) is central to the glass dream in all of its manifestations. The expressionist

Figure 19: Bruno Taut. Glass Pavilion, Cologne. 1914 (demolished)

movement in the twentieth century added to the spirituality, fantasy, transformation, and utopianism with which glass architecture had historically been identified. In the aftermath of the First World War, expressionists such as architect Bruno Taut were seeking not only new forms but a new society. Bletter notes, "The crystalline glass house [fig. 19]...concretizes for Taut the kind of unstructured society he envisions. Glass is here no longer the carrier of spiritual or personal transformation but of a political metamorphosis."[50]

In an essay published ten years ago, K. Michael Hays proposes the possibility of a "critical architecture" that is perceived as a cultural phenomenon, as a readable text, without forgetting that it is a particular kind of text with specific references to its own history, "a critical architecture that claims for itself a place between the efficient representation of preexisting cultural values and the wholly detached autonomy of an abstract formal system."[51] If the architecture presented here can claim to occupy such a position, one might ask, Where is that place? Of what exactly is this contemporary architecture critical?

First and foremost, it is a critique of the canonical history of modern architecture. The historian Reyner Banham writes: "The official history of the Modern Movement, as laid out in the late Twenties and codified in the Thirties, is a view through the marrow-hole of a dry bone...The choice of a skeletal history of the movement with all the Futurists, Romantics, Expressionists, Elementarists and pure aesthetes omitted, though it is most fully expressed in [Siegfried] Giedion's *Bauen in Frankreich*, is not to be laid to Giedion's charge, for it was the choice of the movement as a whole. Quite suddenly modern architects decided to cut off half their grandparents without a farthing."[52]

The modern past is reconfigured by many of the projects discussed here in that they offer a chance to reconsider the reputations of certain figures whose work was largely ignored in the postwar period. Fritz Neumeyer uses terms strikingly similar to Starobinski's when describing Otto Wagner's 1904–6 Postal Savings Bank in Vienna: "Like the then floating garment that clothes the female body in ancient Greek sculpture, revealing as much beauty as it conceals, Wagner's treatment of the structure and construction exploits a similar kind of delicate, sensuous play that was probably only evident to a connoisseur of a certain age and experience. Exactly this principle gives the interior of the [Postal Savings Bank] its quality of silk-like

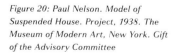

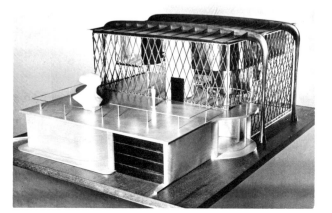

Figure 20: Paul Nelson. Model of Suspended House. Project, 1938. The Museum of Modern Art, New York. Gift of the Advisory Committee

transparency. The glass veil is lifted up on iron stilts that carefully cut into its skin and gently disappear."[53]

Paul Nelson's "technosurrealist"[54] Suspended House (fig. 20), a glazed volume with free-floating forms suspended within, provides a model for a

number of projects, from Sejima's Women's Dormitory to Maki's Congress Center project and Manfred and Laurids Ortner's proposed Museum of Modern Art for Vienna's Museum Quarter (1990, fig. 21 and pp. 148–51). Describing his unbuilt project of 1935, Nelson said, "Suspension in space...heightens the sense of isolation from the outside world."[55]

The Maison de Verre by Pierre Chareau, largely ignored by modern historians until the publication of Kenneth Frampton's monograph on Chareau in 1969, looms large in any discussion of lightness.[56] Recognized in its time as having transcended the then ossifying parameters of the International Style, it was referred to as having a "cinematographic sense of space," a description that invokes much of the imagery employed here to describe contemporary architectural synergy.[57] In its visual complexity, the coyness with which it reveals its interior space, and its willful subordination of structural clarity, the facade of the Maison de Verre could serve as a précis for Starobinski's notion of the gaze as a reflexive act. Vidler's description of facades that reveal "shadowy presences" could equally be applied to Chareau's masterwork or

Figure 21: Manfred and Laurids Ortner. The Museum of Modern Art, Museumsquartier Vienna. Competition proposal, 1990. Diagram of component structures

the Johnson Research Laboratory Tower (fig. 22) by Frank Lloyd Wright, the great American architect whose contribution to modern architecture was frequently marginalized by European historians.

Oscar Nitzchke's seminal project of 1935, La Maison de la Publicité (fig. 23), was similarly neglected by modern historians, whose interests were more focused on the machine metaphor than on populist expressions of modern culture such as cinema and advertising.[58] Yet the project offers an early example of the current fascination with electronic media and the nocturnal transformation of architecture. Recalling Calvino's triad of light, movement, and information, Nitzchke's project assumes a prophetic aura. Louis Kahn's decision to use glass for its specific material qualities in his projected Memorial to the Six Million Jewish Martyrs (1966–72), instead of regarding it as a nonmaterial, is unusual for its time, and dECOi's 1991 Another Glass House (fig. 24) is a recent project that transforms its inspiration, Philip Johnson's 1949 Glass House, by emphasizing glass's materiality, which Johnson implicitly denied.

In postmodernism's caricature (ironically based largely on Giedion) of modern history, the wholesale devaluation of buildings such as Gordon Bunshaft's 1963 Beinecke Rare Book and Manuscript Library at Yale University (fig. 25) has further obscured the roots of a number of works presented here. The Beinecke's section within a section—an outer layer of translucent alabaster enclosing a glazed, climate-controlled rare books library—is revived in various ways

Figure 22: Frank Lloyd Wright. S. C. Johnson & Son, Inc. Research Laboratory Tower, Racine, Wisconsin. 1943–50. Exterior

Figure 23: Oscar Nitzchke. Maison de la Publicité, Paris. 1934–36. Perspective. Gouache and photomontage, 28 x 20 1/2". The Museum of Modern Art, New York. Gift of Lily Auchincloss, Barbara Jakobson, and Walter Randel

Figure 24: dECOi. Another Glass House. Competition proposal, 1991. Axonometric

in Peter Zumthor's Kunsthaus Bregenz, David Chipperfield's proposed extension of the Neues Museum in Berlin (fig. 26), and the Herzog and de Meuron Greek Orthodox Church project.

Besides representing an attempt to recapture lost figures in modern architectural history, the projects here also reflect the current reevaluation of the canonical masters. As a result of the historical parody of "glass boxes" offered by postmodern critics, a new generation is rediscovering an architecture of the not so recent past. Charles Jencks's dismissal of the work of Mies van der Rohe exemplifies postmodernist criticism: "For the general aspect of an architecture created around one (or a few) simplified values, I will use the term univalence. No doubt in terms of expression the architecture of Mies van der Rohe and his followers is the most univalent formal system we have, because it makes use of few materials and a single, right-angled geometry."[59] Detlef Mertins's writings are among recent, less hostile appraisals: "Could it be that this seemingly familiar architecture is still in many ways unknown, and that the monolithic Miesian edifice refracts the light of interpretation, multiplying its potential implications for contemporary architectural practices?"[60] Mertins could well be speaking of Koolhaas's Two Patio Villas (Rotterdam, 1988, pp. 152–55), in which the use of clear, frosted, green-tinted, and armored glass recalls not the nonmaterial of the Tugendhat House but the rich surfaces and the multiplicity of perceptions evident in Mies's Barcelona Pavilion.

Although the expressionists were rejected by rationalist architects such as Hilberseimer and effectively written out of the history of modern architecture by Giedion and others, the influence of Taut and his followers, referred to as the Glass Chain, is evident in the work of a number of canonical modern masters, including Mies's glass skyscrapers of about 1920. Walter Gropius, in his manifesto for the Bauhaus, was influenced by Taut's expressionist utopianism: "Together let us desire, conceive, and create the new structure of the future, which will embrace architecture and sculpture and painting in one unity and which will one day rise toward heaven from the hands of a million workers like the crystal symbol of a new faith."[61] Frampton, Banham, and others have noted that standard modern histories frequently underestimate the important relationships between what have come to be perceived as irreconcilably opposed tendencies.

The success of Rowe and Slutzky in awakening a generation of American, and to a lesser extent European, architects from the "glass dream" over the course of four decades depended on establishing a more narrow dialectic than the fundamental one between transparency and opacity described by

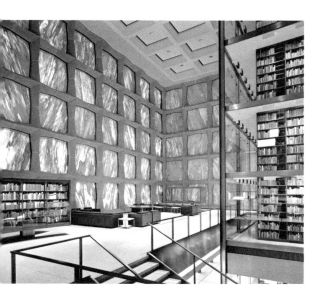

*Figure 25: Gordon Bunshaft–
Skidmore, Owings & Merrill. Beinecke
Rare Book and Manuscript Library, Yale
University, New Haven, Connecticut.
1963. Interior view*

Bletter. Given Rowe's nostalgia for the classical facade and his antipathy toward technological imagery, that longstanding relationship was enormously inconvenient. Rowe and Slutzky inverted the dichotomy by equating the literal transparency of glass structures with materiality and the phenomenal transparency of Le Corbusier with the higher functions of intellectual abstraction: "A basic distinction must perhaps be established. Transparency may be an inherent quality of substance—as in a wire mesh or glass curtain wall, or it may be an inherent quality of organization...a phenomenal or seeming transparency."[62]

If much of the architecture herein can be seen as a critical response to Giedion and the "room of shadowless light" that he helped canonize, it also represents a critique of the formalism espoused by Rowe in the course of devaluing glass architecture. The facades seen here express not only a post-Rovian sense of transparency but the rejection of the frontally viewed classical facade and its "structure of exclusion," its "set of refusals." While there is a common interest in maintaining a level of ambiguity, in limiting the overreaching certitude of architectural expression, this recent architecture goes beyond evoking the "equivocal emotions" that Rowe and Slutzky found in the presence of architectural form, investigating the possibility of rethinking, and investing with meaning, the architectural skin. As membranes, screens, and filters, the surfaces of this architecture establish a vertigo of delay, blockage, and slowness, upending the "vertigo of acceleration" that has dominated architectural design since the invention of perspectival drawing.

In a contemporary context, the critique of Rowe's Epicureanism represented by the projects here need not be taken as endorsement of a new *sachlich* architecture of shadowless light, an expression of the renewed puritanism of our time. Just the opposite: this recent architecture, trusting in "the senses and in the world the senses reveal," can be described as beautiful—a word infrequently heard in architectural debates. Indeed, academic rationalists enjoyed such success in establishing the basis for architectural discussions that architects have been called "secret agents for beauty." As a group, the projects here have a compelling visual attraction, undiminished by close reflection, that implicitly criticizes Hilberseimer's rejection of the aesthetic dimension. They likewise reject the strictures of postmodernism, which have alternated between invoking, as inspirations for architecture, a suffocating supremacy of historical form and arid philosophical speculation. Of the latter Koolhaas writes, "Our amalgamated wisdom can be caricatured: according to Derrida we cannot be Whole, according to Baudrillard we cannot be Real, according to Virilio we cannot be There—inconvenient repertoire for a profession helplessly about being Whole, Real, and There."[63]

*Figure 26: David Chipperfield.
Neues Museum Extension, Berlin.
Competition proposal, 1994.
Computer-generated light study
of interior of the Temple Hall*

In Tony Kushner's play *Angels in America*, part two opens with Aleksii Antedilluvianovich Prelapsarianov, the World's Oldest Living Bolshevik, haranguing the audience: "What System of Thought have these Reformers to present to this mad swirling planetary disorganization, to the Inevident Welter of fact, event, phenomenon, calamity?"[64] Prelapsarianov's taunts remind us that the already muddied waters

of the postmodern debate, played out over the last thirty years, are further roiled by the approaching millennium, with its own set of critical references. Even so, without claiming an overreaching system of thought, it is possible to see in the current architectural synergy further evidence of a renewed adherence to the spirit of the century, a spirit that most often expressed itself as one of invention and idealism. In response to the "inconvenient repertoire" of poststructuralism, Koolhaas imagines a "potential to reconstruct the Whole, resurrect the Real, reinvent the collective, reclaim maximum possibility."[65]

Beyond his own work, Koolhaas's words resonate in projects at vastly different scales, though, as is often the case, they can be most distinctly seen in smaller projects, where simpler programs allow for more direct expression. Despite its modest scale, the Leisure Studio eloquently fits Hays's definition of a critical architecture, but it is also an expression of an idealism too easily dismissed in a cynical age. Designed by an architectural collaborative as a *contre-projet* in response to an official housing

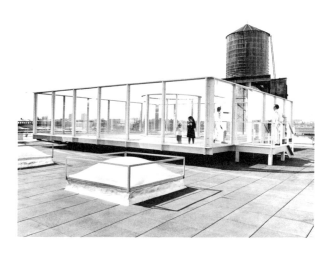

Figure 27: Dan Graham. Two-Way Mirror Cylinder inside Cube. *1991. The Rooftop Urban Park Project, Dia Center for the Arts, New York City*

exhibition, it is currently used as an informal meeting place where artists and architects socialize and exchange ideas. In contrast to standard professional practice, the structure was built and paid for by the architects themselves. Tod Williams and Billie Tsien's mobile, translucent stage set evokes the choreographer's theme of societal transformation, and in doing so reminds us that the realm of the aesthetic has social dimensions. Graham's *Two-Way Mirror Cylinder inside Cube*, a work which clearly occupies a position "in between," consciously refers to the history of glass architecture. (Bletter's commentary on expressionist design could well be applied to it: "Those very aspects...that appear on first glance to be its most revolutionary ones—transparency, instability, and flexibility—on closer examination turn out to be its most richly traditional features."[66]) But Graham's work, too, transcends a purely aesthetic approach. By incorporating it into his Rooftop Urban Park Project, which he characterizes as a "utopian presence" in the city, he elevates the work from the status of mere formal abstraction (fig. 27). His contemporary urban park—which, like its traditional counterparts, seeks to reintegrate alienated city dwellers with their environment while providing a contemplative place apart—restores the aesthetic dimension of the glass dream and points toward the idealism that sustained it.

Notes

I would like to thank Kenneth Frampton, Michael Hays, Rem Koolhaas, Guy Nordenson, Joan Ockman, Jean Starobinski, Bernard Tschumi, and Kirk Varnedoe for their suggestions and comments. I also thank Christopher Lyon for his dedication and insights during the editorial process, and Pierre Adler, Bevin Howard, Lucy Maulsby, Vera Neukirchen, and Heather Urban for research and translation assistance.

1. Ludwig Hilberseimer, "Glasarchitektur," *Die Form* 4 (1929): 522. Translated by Vera Neukirchen.

2. Ibid., 521.

3. Jean Starobinski, "Poppaea's Veil," in *The Living Eye* (Cambridge: Harvard University Press, 1989), 1.

4. Michel de Montaigne, *The Essays of Michel de Montaigne*, trans. and ed. M. A. Screech (London: Allen Lane, Penguin Press, 1991), 697. The passage continues: "Why do women now cover up those beauties—right down below their heels—which every woman wants to display and every man wants to see? Why do they clothe with so many obstacles, layer upon layer, those parts which are the principal seat of our desires—and of theirs? And what use are those defence-works with which our women have started to arm their thighs, if not to entrap our desires and to attract us by keeping us at a distance?"

5. Starobinski, "Poppaea's Veil," 1–2.

6. Ibid., 2.

7. See note 4.

8. Yoshiharu Tsukamoto, "Toyo Ito: An Opaque 'Transparency,'" in *JA Library* 2, special issue of *The Japan Architect* (Summer 1993): 154.

9. Colin Rowe and Robert Slutzky, "Transparency: Literal and Phenomenal," in Rowe, *The Mathematics of the Ideal Villa and Other Essays* (Cambridge: MIT Press, 1976), 171.

10. Anthony Vidler, *The Architectural Uncanny: Essays in the Modern Unhomely* (Cambridge: MIT Press, 1992), 221.

11. Rowe and Slutzky, "Transparency," 163–64.

12. In a recent communication with the author, the architectural historian Joan Ockman summarized the elements of phenomenal transparency as "free play in the object, the extension of 'aesthetic time,' and oscillating readings or meanings that are ultimately unresolvable." Her description clearly shows that a foundation of Gestalt psychology, provided by her husband Robert Slutzky, supported the concept of phenomenal transparency.

13. Rowe and Slutzky, "Transparency," 171.

14. Kenneth Frampton, "Pierre Chareau, an Eclectic Architect," in Marc Vellay and Frampton, *Pierre Chareau, Architect and Craftsman, 1883–1950* (New York: Rizzoli, 1985), 243.

15. Octavio Paz, *Marcel Duchamp, or The Castle of Purity*, trans. D. Gardner (London: Cape Goliard Press, 1970), 1–2. I am indebted to Peter Eisenman for suggesting that I look at Paz's discussion of transparency.

16. Frampton, "Pierre Chareau, an Eclectic Architect," 242.

17. Ibid.

18. Rem Koolhaas and Bruce Mau, *S,M,L,XL* (New York: Monacelli Press, 1995 [prepublication copy]), 654.

19. Rowe and Slutzky, "Transparency," 166.

20. Richard P. Feynman, *QED: The Strange Theory of Light and Matter* (Princeton: Princeton University Press, 1985), 69. I thank Guy Nordenson for suggesting Feynman's writings.

21. Ibid., 109.

22. Hubert Damisch, *Théorie du nuage* (Paris: Editions du Seuil, 1972), 170. Translated by Pierre Adler. I owe to Rosalind Krauss my introduction to Damisch's book, to which she refers in the essay cited in note 25.

23. Ibid.

24. Bernard Tschumi, "Groningen, Glass Video Gallery, 1990," in *Event-Cities* (Cambridge: MIT Press, 1994), 559.

25. Krauss, "Minimalism: The Grid, The/Cloud/, and the Detail," in Detlef Mertins, ed., *The Presence of Mies* (Princeton: Princeton Architectural Press, 1994), 133–34.

26. Jean Nouvel, "The Cartier Building," architect's statement, n.d.

27. Krauss, "Minimalism," 133.

28. Koolhaas and Mau, *S,M,L,XL*, 1261.

29. Leonardo da Vinci, *The Notebooks of Leonardo da Vinci*, arr., trans., and intro. E. MacCurdy (New York: George Braziller, 1939), 986–87.

30. Nagisa Kidosaki, "Shimosuwa Municipal Museum," in *JA Library* 2, special issue of *The Japan Architect* (Summer 1993): 27.

31. Jacques Herzog, architect's statement, n.d.

32. Italo Calvino, "Lightness," in *Six Memos for*

the Next Millennium (New York: Vintage International, 1993), 16.

33. Ibid., 8.

34. The linguistic relationship between lightness and lightweight exists principally in English.

35. Starobinski, "Poppaea's Veil," 6.

36. For further analysis of Calvino and lightness in architecture, see Cynthia Davidson and John Rajchman, eds., Any Magazine 5 (March/April 1994).

37. Calvino, "Lightness," 13.

38. Toyo Ito, "A Garden of Microchips: The Architectural Image of the Microelectronic Age," in JA Library 2, special issue of The Japan Architect (Summer 1993): 11–13.

39. Ibid., 11.

40. Quoted in Ray Monk, Ludwig Wittgenstein: The Duty of Genius (New York: Penguin Books, 1990), 355. The passage is from notes taken by Rush Rhees of Wittgenstein's 1936 lecture "The Language of Sense Data and Private Experience — I."

41. Harry Wolf, "ABN-AMRO Head Office Building," architect's statement, n.d.

42. Jacques Herzog, "The Hidden Geometry of Nature," Quaderns, no. 181–82 (1989): 104.

43. Steven Holl, "Museum of Contemporary Art, Helsinki," architect's statement, n.d.

44. Stephen Selkowitz and Stephen LaSourd, "Amazing Glass," Progressive Architecture 6 (June 1994), 109.

45. Rosemarie Haag Bletter, "The Interpretation of the Glass Dream — Expressionist Architecture and the History of the Crystal Metaphor," Journal of the Society of Architectural Historians 40, no.1 (March 1981): 20.

46. Bletter, "Glass Dream," 25.

47. Zaha Hadid, "Cardiff Bay Opera House Architectural Competition," architect's statement, n.d.

48. Wolf, "ABN-AMRO Head Office Building."

49. Prince Albert Saxe-Coburg, the royal patron of the Crystal Palace, commissioned Edward Lorenzo Percy to design a centerpiece based on literary accounts of a fountain in the Alhambra. See Hermione Hobhouse, Prince Albert: His Life and Work (London: Hamish Hamilton Limited/ The Observer, 1983), 103 (caption).

50. Bletter, "Glass Dream," 37.

51. Michael Hays, "Critical Architecture: Between Culture and Form," Perspecta (The Yale Architectural Journal) 21 (1984): 15.

52. Reyner Banham, "The Glass Paradise," Architectural Review 125, no. 745 (February 1959): 88.

53. Fritz Neumeyer, "Iron and Stone: The Architecture of the Großstadt," in H. F. Mallgrave, ed., Otto Wagner: Reflections on the Raiment of Modernity (Santa Monica, Calif.: Getty Center for the History of Art and the Humanities, 1993), 134f.

54. Kenneth Frampton, "Paul Nelson and the School of Paris," in Joseph Abram and Terence Riley, eds., The Filter of Reason: Work of Paul Nelson (New York: Rizzoli, 1990), 12.

55. Judith Applegate, interview with Paul Nelson, Perspecta 13/14 (April 1971): 75–129.

56. Kenneth Frampton, "Maison de Verre," Perspecta (The Yale Architectural Journal) 12 (1968): 77–126. For further discussion of the relationship between Nelson and Chareau, see Abram and Riley, eds., The Filter of Reason: Work of Paul Nelson (New York: Rizzoli, 1990).

57. Paul Nelson, "La Maison de la Rue Saint-Guillaume," L'Architecture d'aujourd'hui 4me année, ser. 3, vol. 9 (Nov.–Dec. 1933): 9.

58. For an interesting but somewhat incomplete account of the relationship between Nitzchke, Nelson, and Chareau, see Sean Daly, "Composite Modernism: The Architectural Strategies of Paul Nelson and Oscar Nitzchke," Basilisk [journal online] 1, no. 1 (1995), available at http://swerve.basilisk.com.

59. Charles Jencks, The Language of Post-Modern Architecture (New York: Rizzoli, 1977), 15.

60. Detlef Mertins, "New Mies," in Mertins, ed., The Presence of Mies (New York: Princeton Architectural Press, 1994), 23.

61. Bletter, "Glass Dream," 38.

62. Rowe and Slutzky, "Transparency," 161.

63. Koolhaas and Mau, S,M,L,XL, 969.

64. Tony Kushner, Angels in America: A Gay Fantasia on National Themes, Part II: Perestroika, (New York: Theater Communications Group, 1994), 13–14.

65. Koolhaas and Mau, S,M,L,XL, 510.

66. Bletter, "Glass Dream," 43.

Projects

Michael Van Valkenburgh # Radcliffe Ice Walls Harvard University, 1988 (installation)

Installed on a frequently traversed quadrangle at Harvard University, landscape architect Michael Van Valkenburgh's Radcliffe Ice Walls consisted of three curved screens of metal fencing, each fifty feet long and seven feet high, constructed of fine galvanized metal mesh. A mist of water emitted from a plastic pipe along the top of the fence caused ice to form on the screens. Over a three-week period in February 1988, the screens were misted six times; the differences in the resulting patterns of ice were due to variations in temperature, wind speed, and wind direction. The project developed out of Van Valkenburgh's prior experimental studies of how climate affects ice formation, a technical issue, for which data was frustratingly absent, that he found relevant to his landscape design work.

Though technologically simple, this project is, like all ice sculpture, fascinating because the medium seems immaterial. The ice walls were a sort of slow-motion kinetic art, alternately melting and freezing, dissipating and reappearing. Making ice has an inherently alchemical aspect, as if something were being created from nothing. As an isolated natural phenomenon, the ice was offered as a subject for close study, while it also acted as a barrier between the viewer and the landscape, curved to better block the panorama. Covered with frozen water, the ice screens were so diaphanous and evanescent as to be almost air; glistening, they were almost light. —*Anne Dixon*

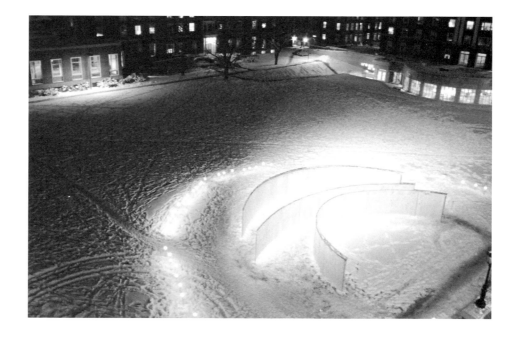

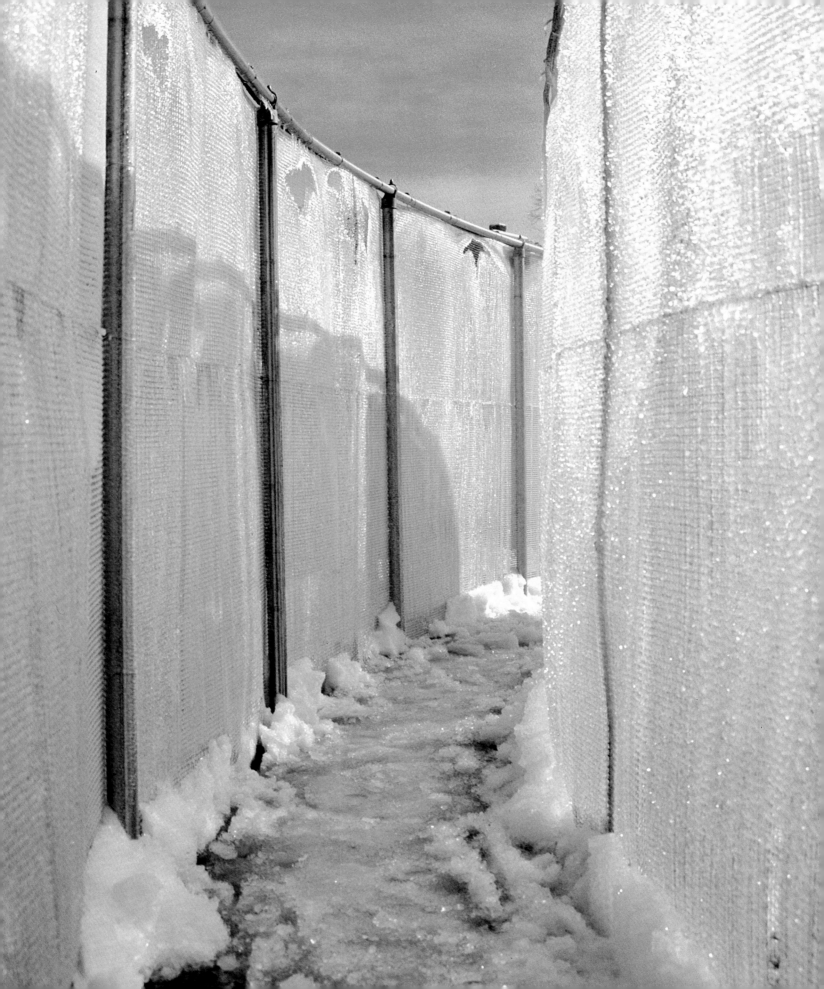

Philip Johnson **Ghost House** New Canaan, Connecticut, 1985

Built thirty-five years after the architect's famed Glass House, the galvanized steel pipe Ghost House, clad in chain-link fencing, serves as a nursery where flowers may be grown, safe from the foraging deer that roam Philip Johnson's Connecticut estate. Set in a wooded area, the small structure was built on the stone foundation of a former outbuilding. It is one of seven designs by Johnson constructed on the property since the Glass House and Guest House were completed in 1949.

Despite its simple conception, the nursery is replete with material and historical references. The form of a traditional house recalls the 1972 Benjamin Franklin Memorial in Philadelphia, by Venturi, Rauch and Scott Brown, a painted steel frame outline of a house once occupied by Franklin. The chain-link fencing refers to Johnson's long friendship with the architect Frank Gehry, whose use of off-the-shelf materials in such projects as his house in Santa Monica became a hallmark. The chain-link fencing—woven, ephemeral, and tensile—also contrasts eloquently with the masonry foundation, solid, dense, and compressive.

The Ghost House has a specific relationship with the Glass House, as do all the structures on his estate that followed it. Both are set on a plinth, are nominally transparent, and are conceived as objects in the landscape. The differences are more evident: the Glass House expresses the principles of high modernism; the Ghost House, its form made mannerist by the slight disengagement of the structure down its center line, is a study in postmodernism. Furthermore, the objective vision suggested by the Glass House, whose steel structure frames views of the horizon, is not apparent in the more recent project. The chain-link fencing reveals but distances the flowers within, creating a more subjective relationship between the beheld and the beholder. —*Terence Riley*

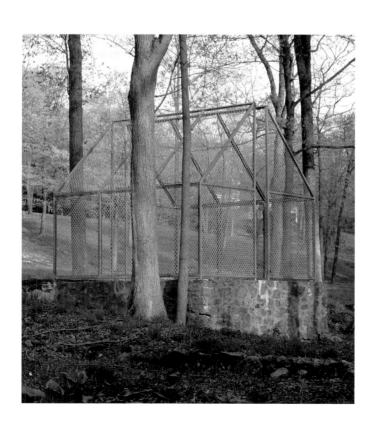

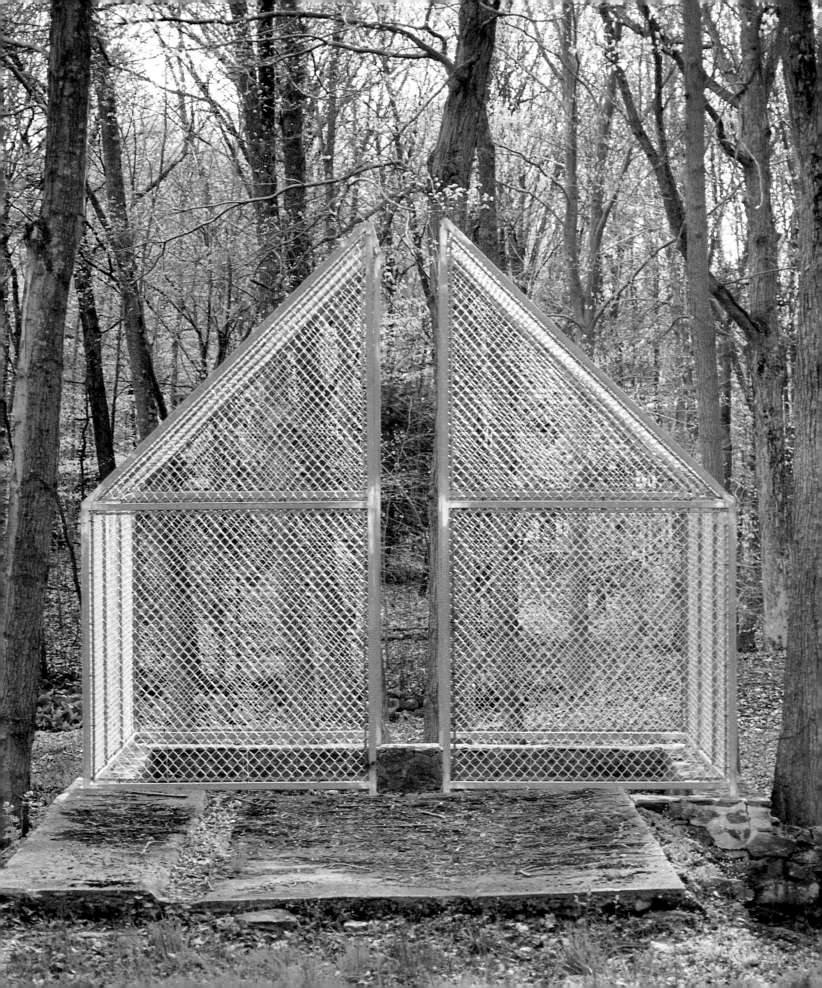

Saishunkan Seiyaku Women's Dormitory

Built for the Saishunkan Company in Kumamoto, on the southern island of the Japanese archipelago, this dormitory houses in twenty shared rooms up to eighty women participating in the company's six-month training courses. Classes are conducted in adjacent facilities, but the dormitory's program includes a traditional tatami room and garden that are used for instruction on the arts of ikebana (flower arranging) and the tea ceremony, as part of a comprehensive cultural education.

To provide maximum privacy within an open setting, the bedrooms, which are on the ground level, are arranged in rows along both lengths of the steel-frame building. Each bedroom opens onto the enclosed central atrium and the walled, open-air courts on either side of the building. The atrium, lit by skylights and through the heavily screened curtain walls that surround the upper-level spaces, serves as a shared living area. Its communal character contrasts with the minimal private spaces. The lofty atrium is punctuated by towerlike structures containing the building's mechanical, electrical, and plumbing systems; screened with perforated metal, these towers provide lateral support against earthquake damage.

An elliptical volume housing the caretaker's apartment hovers above the ground-level communal space as well as the building's entrance, which opens into the upper level. On the opposite end of the building, a bridge connects the upper levels on either side of the atrium; on one side is the tatami room, a Japanese garden, and a foyer/lounge; on the other side are communal baths, a laundry, a terrace, and a television room. Despite its cloistered quality, the building reveals unexpected open vistas, juxtaposing hard or glossy surfaces with landscaped green spaces.

Sejima's division of the program into minimal private areas and larger communal ones is a typically Japanese use of space, emphasizing group identity and socialization. Her dormitory is also a contemporary expression of a traditional Japanese type, the *soudou* of the Zen monastery, in which the student's personal space is peripheral to a larger communal space. —*T.R.*

Road 6m

Top light

Top light

Top light

Road 4m

Left: site plan showing location on roof of top lights
Opposite: aerial view from north

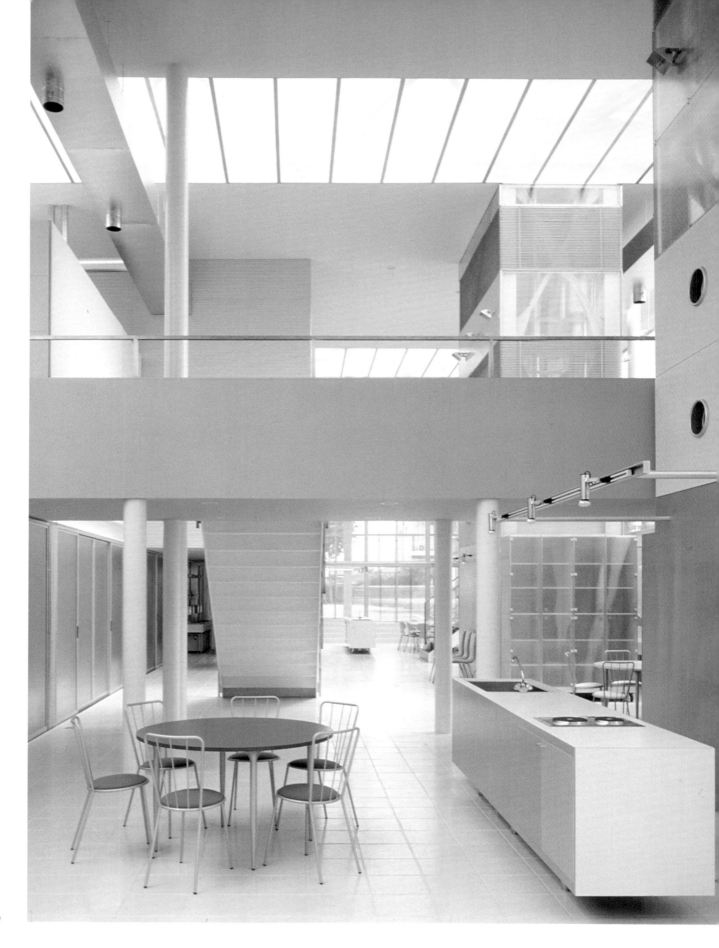

*Atrium view
(looking north)*

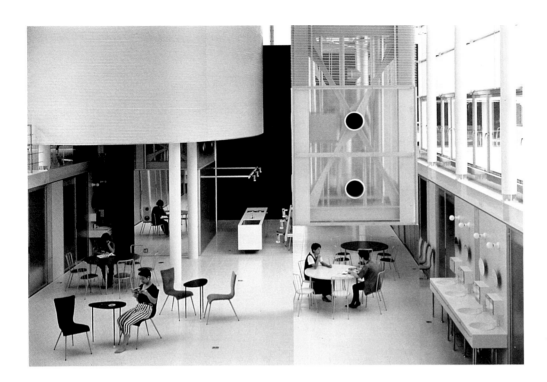

*Atrium view from upper
level, looking toward
caretaker's apartment*

Upper level plan

Ground level plan

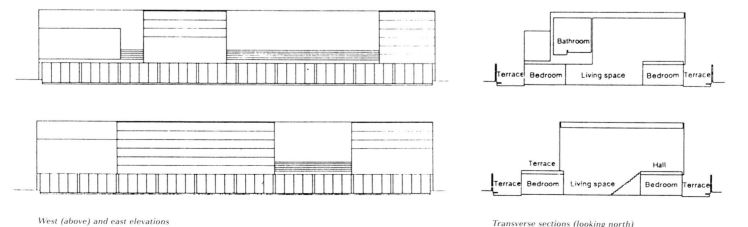

West (above) and east elevations

Transverse sections (looking north)

Left: view through curtain wall from west terrace; below: view from north

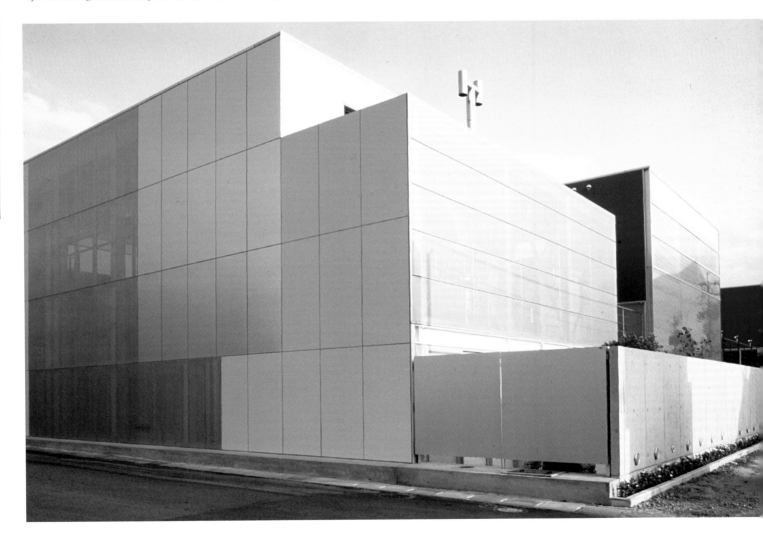

Fumihiko Maki # Congress Center Salzburg, Austria, 1992 (competition proposal)

In his design submitted to a limited international competition for a new Congress Center in Salzburg, Fumihiko Maki proposed replacing the existing meeting facility with an eleven-story concrete and steel frame structure at the edge of the Kurpark, just north of St. Andrew's Church and the historic Mirabell Palace. Linked to the adjacent Sheraton Hotel both in construction and function, the proposed Congress Center's complex program includes a main hall suitable for a variety of functions, an entry foyer, boutiques, meeting halls, offices, and a new wing of guest rooms for the hotel.

Maki conceived an airy cube, 158 feet square in plan and 119 feet high, sheathed in glass, louvers, and perforated metal, and with a skeleton frame. Maki's proposed structure reveals through its transparent facades the abstract and architectural forms within as well as the activities that animate them, giving the Congress Center a visibly public dimension,

which resonates with Salzburg's historic urban center. Various programmatic elements are contained within the simple form, interlocking spatially in the horizontal and vertical dimensions. Despite its straightforward functional arrangement in plan, Maki's proposal is fluid when viewed in section: an elliptical volume containing small meeting rooms is suspended between the upper levels of the triple-height main meeting hall and the enclosed roof terrace above.

Throughout much of the twentieth century, the exterior expression of internal functions has been taken as axiomatic. Yet in Maki's proposal the revelations are exceedingly complex, the efficient floor plan and fluid section being seen simultaneously through transparent layers reaching deep within the structure. The building becomes an expression of what Maki's proposal calls the Ideal City, "a crucible in which the memories and aspirations of its citizens are continuously amalgamated." Like

Munich's Izar Büro Park, which he also designed, the proposed Congress Center for Salzburg exploits the inherent tensility of metals. This quality is expressed most directly in the curtain wall wrapping the ellipsoidal volume; unlike a conventional curtain wall's rectilinear grid, which implies that the wall is self-supporting, a diagonally-patterned wall reflects its true structural character—that it is, in fact, hanging from the actual frame. Maki's appreciation for the qualities of metals is further evident in the exploitation of their lightness, malleability, and reflectivity, seen in his Tokyo Church of Christ as well as the proposed Congress Center. —T.R.

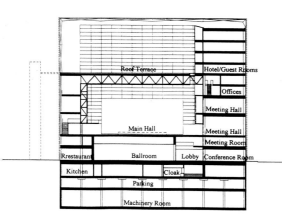

North-south section

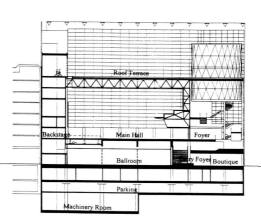

East-west section

Rainerstraße (principal) facade, entrance at left

Kurpark (south) facade

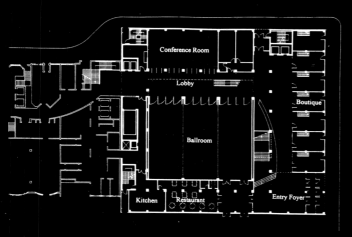

Ground floor (hotel at left)

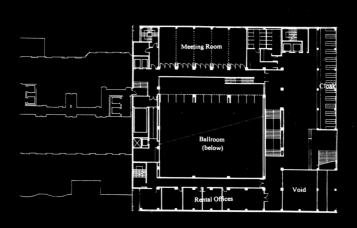

Second level

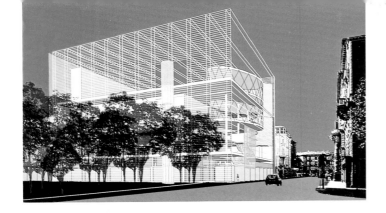

Perspective views: southeast corner seen from Rainerstraße (top) and entry foyer

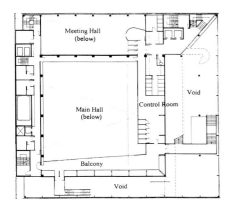

Third floor

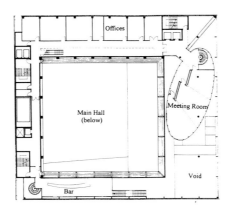

Fifth floor

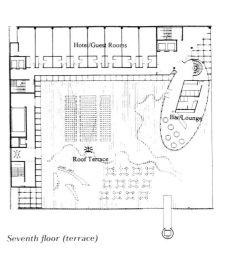

Seventh floor (terrace)

Definitions Fitness Center 2 New York City, 1993

Definitions Fitness Center 2 is a four-thousand-square-foot loft space containing an area with exercise machines, floor workout space, and massage rooms. The most distinctive feature of the design, by New York–based architects Charles Thanhauser and Jack Esterson, is a set of four shower and changing enclosures. These aluminum-clad cubicles radiate in an arc defined by a copper-clad curved wall, which they penetrate. Extending farthest, the rear walls of the shower stalls tilt outward, as if responding to centrifugal force.

Water and electricity supply lines and exhaust ducts are exposed above each of the structures, which formally reiterate the dynamism of the exercise equipment.

The walls of the changing rooms are made of etched glass panels set in an aluminum grid. The translucent panels make visible the silhouette of someone dressing or undressing, although the cubicles are deceptively private when one is inside, since light bounces off the etched glass, making it seem opaque. At the inner end of the loft, a discreet door leads to the

massage rooms. This intimate sanctuary was conceived as an antipode to the activity and extroversion at the other end of the space. The walls of the massage rooms are paneled in maple and cherry woods, and fluorescent lights reflect from copper panels set in the ceiling, transforming cold light into warm. —*A.D.*

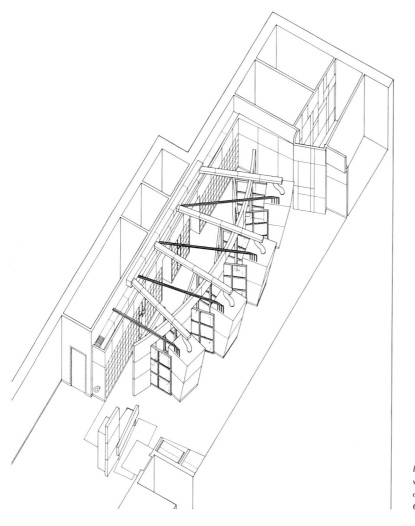

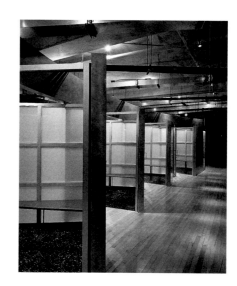

Left: axonometric view; right:
view past entries to shower and
changing enclosures
Opposite: views of changing area

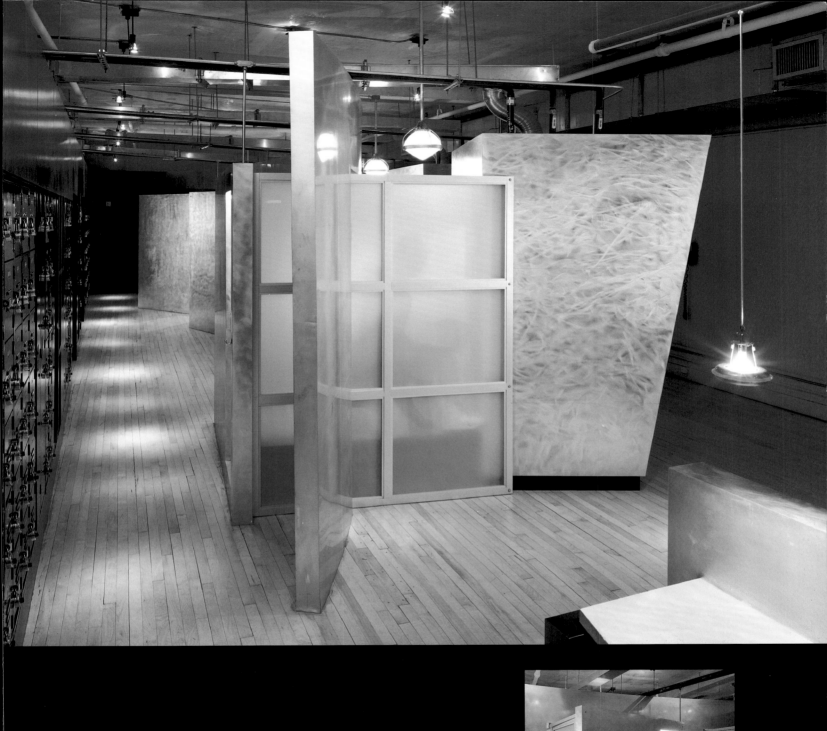

Goetz Collection Munich, 1992

The Goetz Collection, designed by the Swiss architects Jacques Herzog and Pierre de Meuron, is a 3,180-square-foot private gallery built on the same lot as the owner's house in a residential neighborhood of Munich. It not only contains the owner's collection of artworks but serves as a space for temporary exhibitions. At first glance, the gallery appears to reiterate the functional and structural clarity associated with the work of Mies van der Rohe, yet closer examination reveals a complex and ambiguous condition.

While the facades suggest three stories, there are in fact only two; what appears to be the ground level is actually part mezzanine and part clerestory lighting the lower level. A discontinuity between appearance and reality is equally evident in the expression of the structure. The diagrammatic clarity of modern rationalism is recalled in the rhythmic division of the upper clerestory by vertical supports. Yet it is only the pale shadows of those supports that are visible; instead of framing and, by implication, dominating the surface, they are contained within the frosted glass sheathing. Furthermore, a supposition that the vertical supports extend to the ground would also be wrong; rather than being columns, the supports are members of a truss which is itself supported by two unequal, asymmetrically placed concrete volumes that bridge the lower gallery. The expression of the truss's structure in the birch laminate panels that clad the midsection of the building also suggests a familiar modernist belief, the universal validity of technology. Yet the material is also a reference to the site, which is surrounded by birch trees. Ultimately the gallery, like much of Herzog and de Meuron's work, suggests a minimalism that encompasses subtle ambiguities and contingent perceptions rather than one that reductively distills classical principles. —*T.R.*

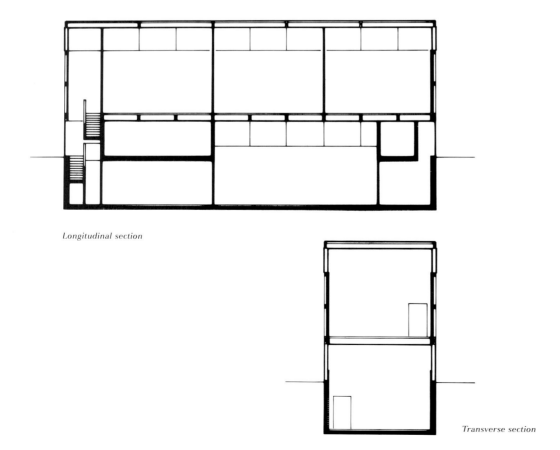

Longitudinal section

Transverse section

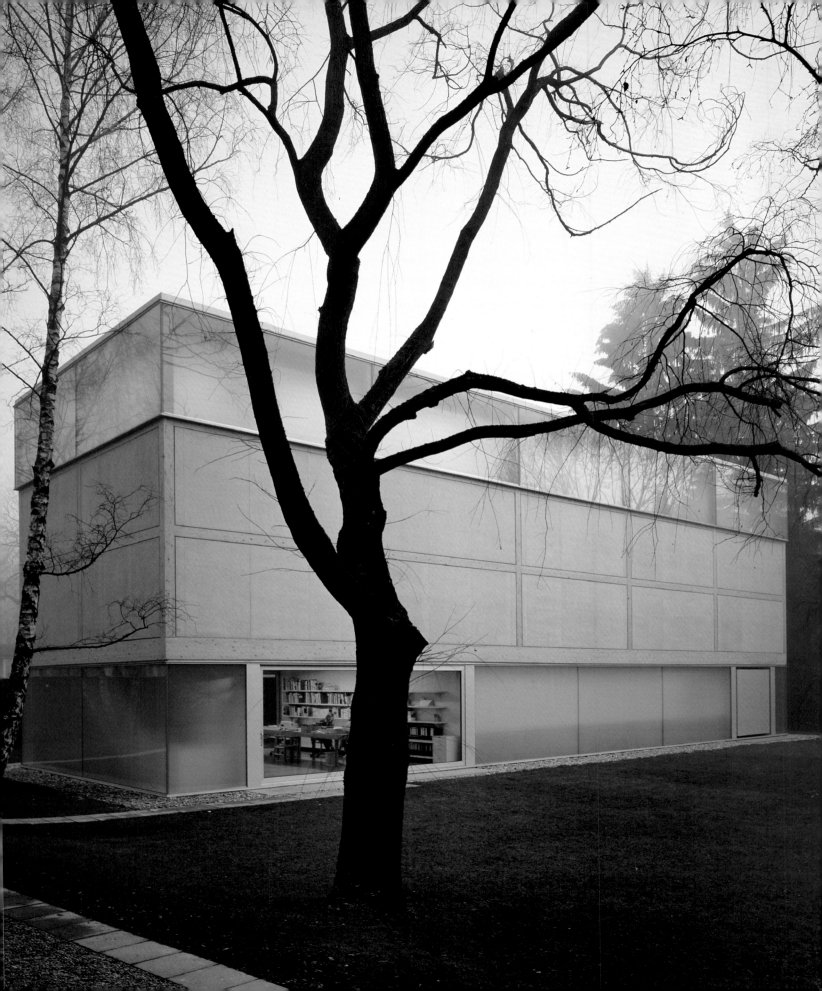

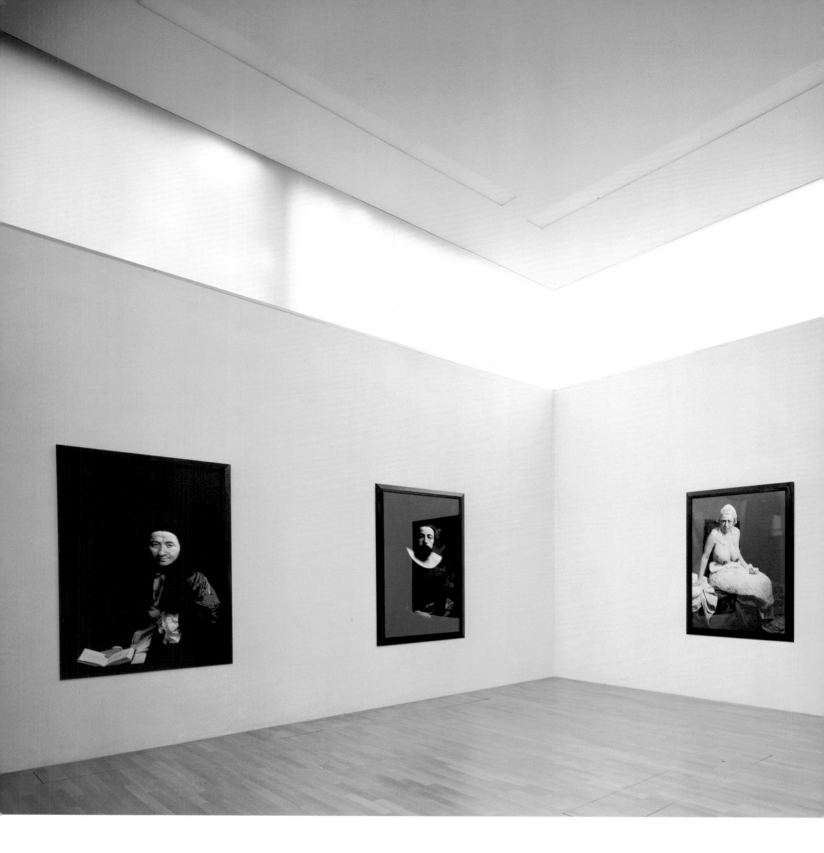

View of upper gallery during the 1994–95 exhibition Jürgen Klauke — Cindy Sherman, *with three works by Sherman (left to right):* Untitled No. 218 (History Portrait) *(1990),* Untitled No. 220 (History Portrait) *(1990), and* Untitled No. 222 (History Portrait) *(1990)*

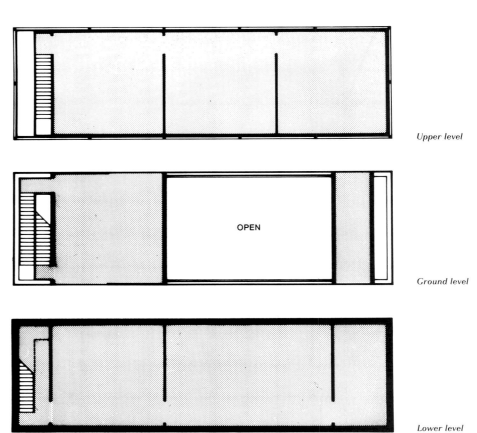

Upper level

OPEN

Ground level

Lower level

Jean Nouvel # Cartier Foundation for Contemporary Art Paris, 1994

The Cartier Foundation in Paris, designed by Jean Nouvel, houses gallery spaces as well as corporate offices for the international jewelry producer. Its site, on the Boulevard Raspail in the city's historic center, was previously occupied by an early-nineteenth-century villa surrounded by an acre of gardens with mature trees, including a giant cedar of Lebanon planted by Chateaubriand, one of the villa's more illustrious occupants. Most recently, it housed the American Center of Paris.

A consideration of the site's history is critical for understanding the basic design elements. Because neighbors objected to the loss of open space if the entire site were developed, the architect was required to keep the new structure within the footprint of the old villa. This restriction meant that the building had to be organized in a vertical fashion, rather than spread out, as a building with about 113,000 square feet of usable space typically would be. The steel frame structure rises 102 feet, with seven floors of offices above exhibition space on the ground level. The floors are connected by internal circulation as well as two flanking exterior stairways. Eight floors below ground accommodate additional exhibition space, support services, and parking for 123 cars, accessed by streetside elevators.

Nouvel's design does not simply represent a functional response to daunting restrictions. The project's success is due to the extent to which he was able to neutralize and effectively exploit the limitations. At the property line in the front, a six-story partially glazed palisade provides an introduction to the visual language of the project and also, perhaps, echoes the garden wall that hid the villa from passersby. From the street one sees the garden behind the structure through the palisade and through the ground floor's ten-by-twenty-six-foot sliding glass walls. In his use of glass Nouvel does not seek absolute transparency but exploits glass's inherent physical qualities to evoke a subjective visual response: "By laying out three parallel glass surfaces, I created an ambiguity which will have visitors wondering if the park has been built on, if it has been enclosed, or if—because of the series of reflections—the trees are inside or outside,

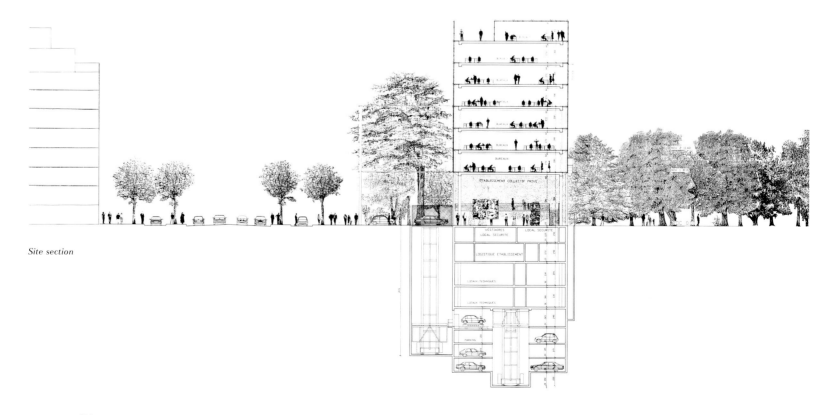

Site section

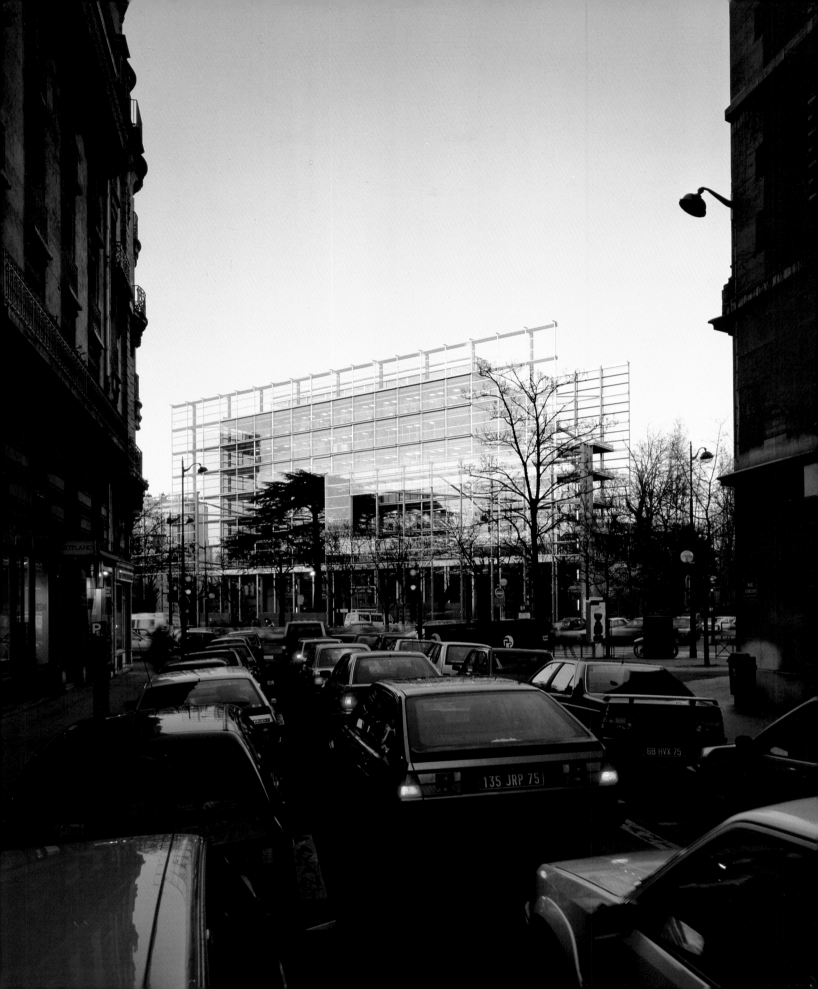

Terrace level, with executive offices. Flanking exterior stairways are seen on this plan and the two below

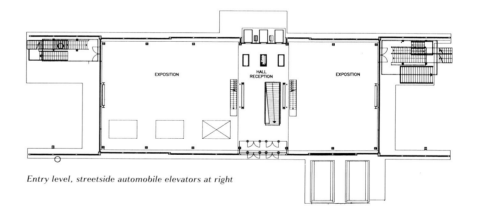

Typical office level

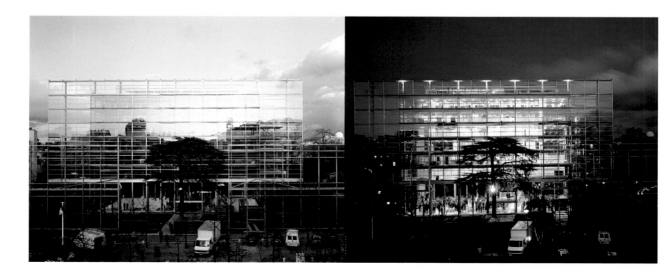

Entry level, streetside automobile elevators at right

if what they see through this depth is a reflection or something real."

The ambiguous depth Nouvel creates on the ground level is continued through the building in both horizontal and vertical dimensions. Light filters into the lower-level exhibition space through cast glass panels in the ceiling. In the upper-level offices, the city can be glimpsed through partially matte glass partitions, adjustable semi-transparent sun shades, and scrims of perforated metal. Nouvel's use of transparent or translucent materials in the Cartier Foundation, and in his Centre du le Monde Arabe, has little affinity with the use of glass in the commercially developed office buildings that dominate new construction. Nouvel is attracted to glass's "fabulous solidity" rather than its transparency, and with it he achieves a level of extreme visual complexity, an architecture of light and shadow, which had been principally associated with solid masonry structures, such as the villa that this building replaces. —*T.R.*

Right: dusk and night views
Opposite: view toward garden
through ground-level galleries

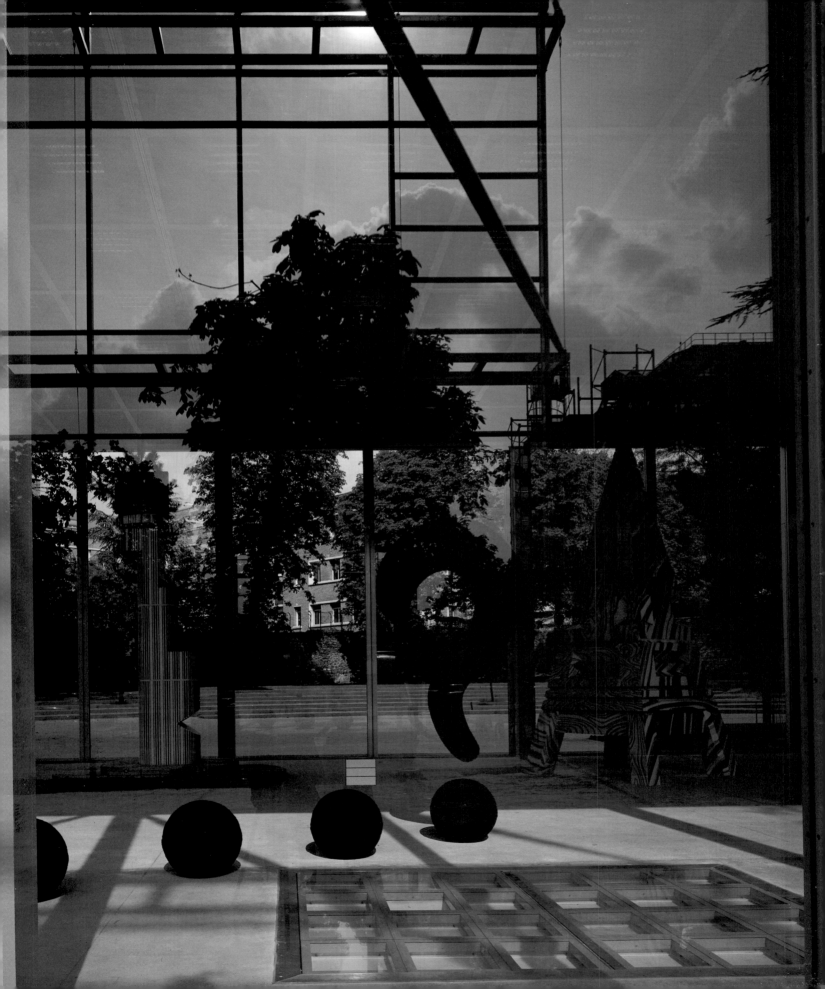

Terrace view

View toward garden past exterior stairway

Views of typical office level

Toyo Ito **ITM Building** Matsuyama, Japan, 1993

A regional office building for the sales and marketing division of a Japanese confectionery manufacturer, the three-story, steel frame ITM Building is located on the eastern island of Shikoku. The structure houses open plan offices and a computing center on the first two levels, with a ninety-six-seat presentation room and a board room on the upper level. The building is sited on two dissimilar parcels of land with adjacent rear property lines, each parcel fronting on opposing sides of a residential block. On the smaller (northerly) parcel is a parking lot and a long, narrow

volume serving as the entrance to the building and extending to the fan-shaped second parcel. On this larger parcel is the bulk of the building, built to the property lines. A faceted curtain wall wraps the southern facade, which is bounded by a curving roadway. Despite these restrictions, Ito's design achieves a remarkable sense of expansiveness, effectively neutralizing the compressed conditions of the site. The narrowness of the entry hall is mitigated by mirror-backed frosted glass on one side and finely perforated metal panels on the other, masking storage and mechanical equipment.

The use of reflective and translucent materials in the flooring and ceiling render the entire space, like much of the building, ethereal.

At the reception desk, the space opens up both vertically, into a triple-height atrium housing the lobby and staircase, and horizontally, as vistas radiate through the faceted facade. The verticality of the atrium is accentuated both by the uninterrupted rise of the frosted glass facade, which reveals the shadowy presences of adjacent buildings, and the continuous vertical core housing the building systems and kitchenettes for each floor, which are sheathed in curved perforated metal panels. Equally, the horizontality of the expansive views through the open office plan to the distant mountains is emphasized by the lateral striations of the radial facade, banded by opaque panels, frosted glass panels, fixed wire-mesh glass, and operable clear glass jalousies. —T.R.

Left: site plan
Opposite: view (from upper level) of atrium with vertical services core

Upper level:
1. Presentation room
2. Board room

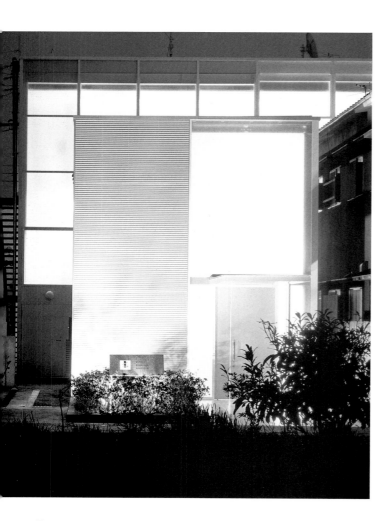

Entry

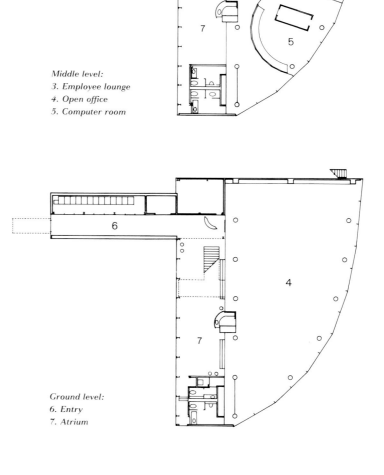

Middle level:
3. Employee lounge
4. Open office
5. Computer room

Ground level:
6. Entry
7. Atrium

Above and right: views of rear facade

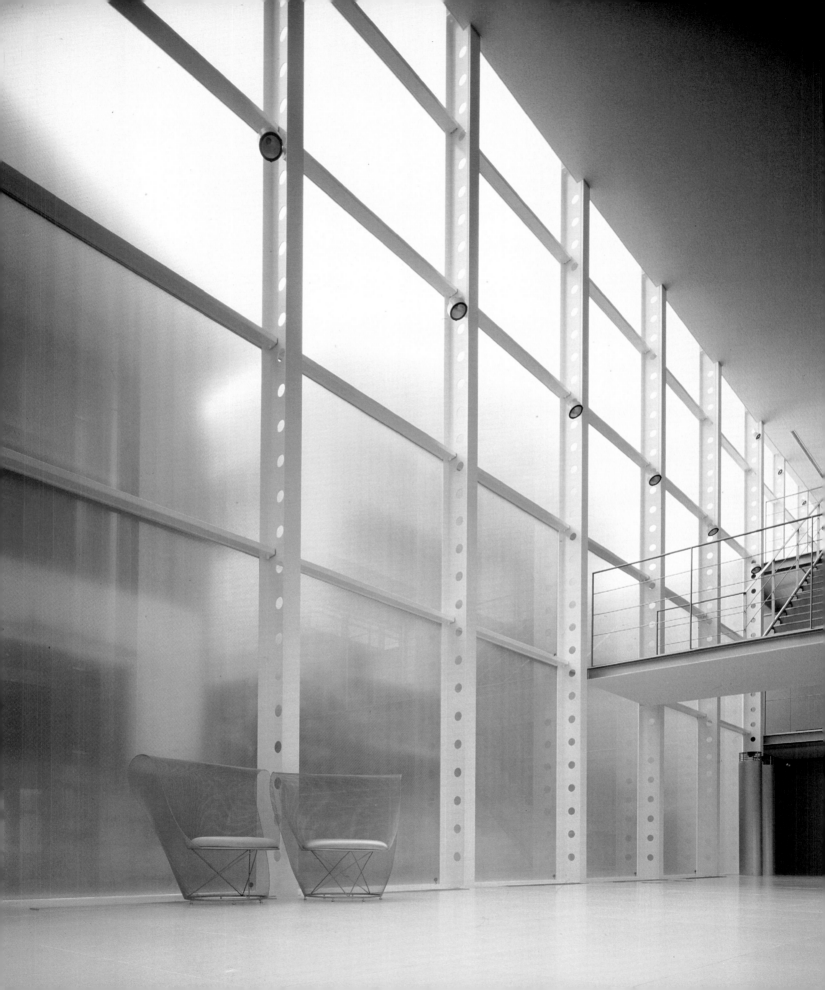

Middle level, view from employees' lounge

Upper level, view from top of stairs

Opposite: view of atrium; above: section through atrium.

ACOM Office Building

Ben van Berkels's renovation was intended to transform the appearance of an undistinguished three-story structure, dating from the 1960s, which is situated amid the heavy traffic of the Stadsring at its intersection with Viandenstraat in Amersfoort, the Netherlands. Rather than strip away the existing facades, consisting of plastered brick with strip windows on the upper two levels and plate glass between the structural columns at the ground level, the Rotterdam-based architect proposed enveloping the existing building in a semitransparent skin of surface-modified, tempered glass panels and horizontal slats of dark red meranti wood. The new work incorporates the previous facades' obscured, and now cap-

tured, image behind semitransparent screens, which tilt outward at the parapet. At ground level, the screen work is principally of the dark wood, creating a horizontal plinth mimicking the overall composition of the original facades. Along the Stadsring the ground-level wooden screens project towards the street and splay in the direction of the entry. In combination with a similar extension of the Viandenstraat facade's new screen walls, they frame a spatial threshold for the building.

Van Berkel's project achieves the principal goal of altering the appearance of the rather drab preexisting structure, and it does so not simply by substituting a new form for an outmoded one, but by investigating

the visual nature of the architectural object. Instead of actually being removed, as would typically have happened, the original facades *become* removed: present but distanced from the immediate visual grasp implied by the modernist architectural language they express. —*T.R.*

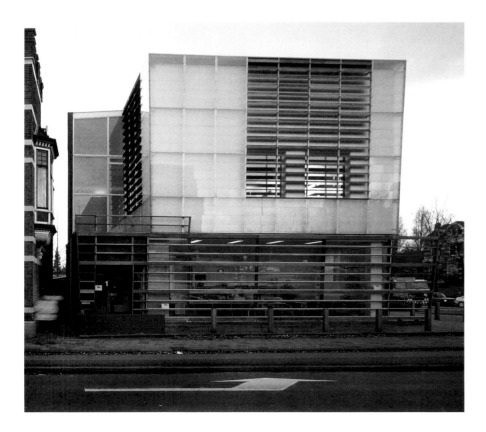

Viandenstraat facade

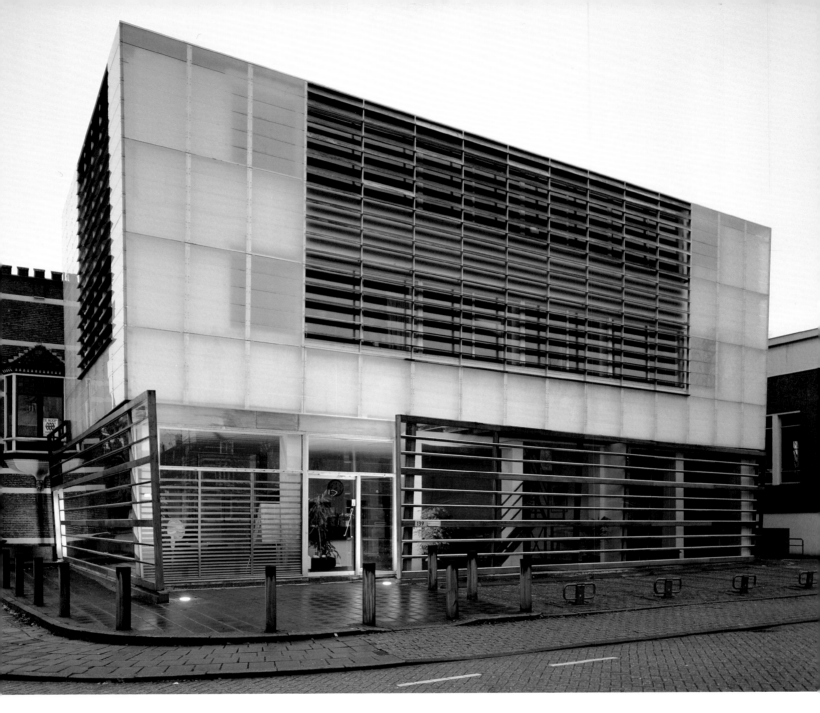

Stadsring facade

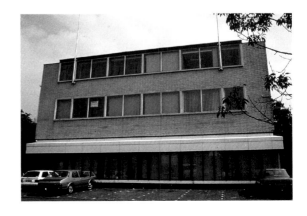

Original facade

Steven Holl **D. E. Shaw and Company Offices** New York City, 1991

At the center of the offices designed by New York–based architect Steven Holl for a financial trading firm, one that is active in global markets almost around the clock, is a tranquil, double-height reception area. The floor is glossy black and the walls are cool, plaster-coated white, perforated by rectilinear openings. Natural and artificial light enter the space from concealed windows and fixtures, after being reflected from surfaces painted in brilliant colors. The painted surfaces themselves are invisible to an occupant of the space, so the diffusive colored light is rendered mystical in its sourcelessness, and the effect is of a cloistral anteroom to the realm of high finance.

The reflective floor continues throughout the offices, which occupy the top two stories of a midtown Manhattan high-rise building, so

there is always light underfoot. Off the reception area, a skyline view is disclosed, emerging more palpably than if it had been immediately apparent. In the corner conference room, the midtown view is starkly unimpeded. A hint of green emanates from the backside of the corner column, reflecting off the window glass. A group of translucent glass hanging lamps, an assemblage that seems to echo the collection of buildings outside the window, is reflected in the paneled metal conference table. This room, in contrast to the reception area, conveys the ideas of clarity and congregation.

Holl's design uses light in some of its many manifestations: as projected diffused color and as an agent of lucidity, to impart the intangible nature of the client's business, which relies on computer links to telephone

lines and satellites. Here, behind a fluorescent green facade in the sky, computer scientists and mathematicians monitor and respond day and night to electronic transmissions of minutely fluctuating numbers. —A.D.

Above: cutaway axonometric view
Opposite: view toward reception area

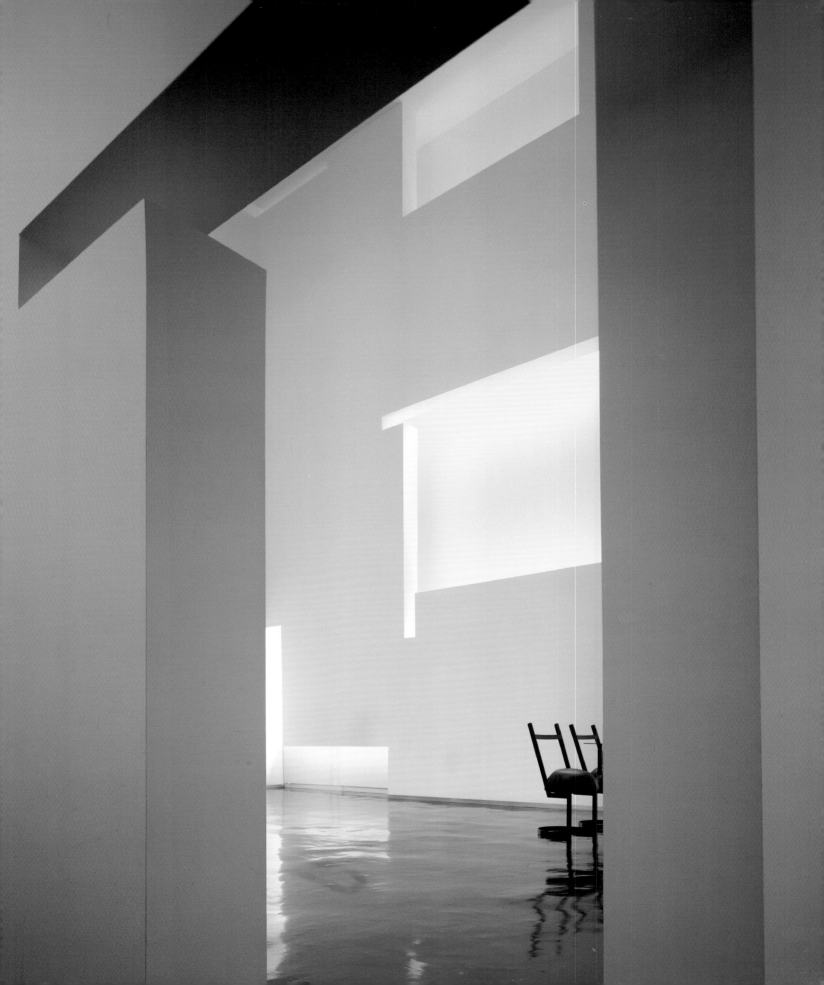

Corner of conference room

Above: diagram showing daylight infiltration
Right and opposite: views into reception area

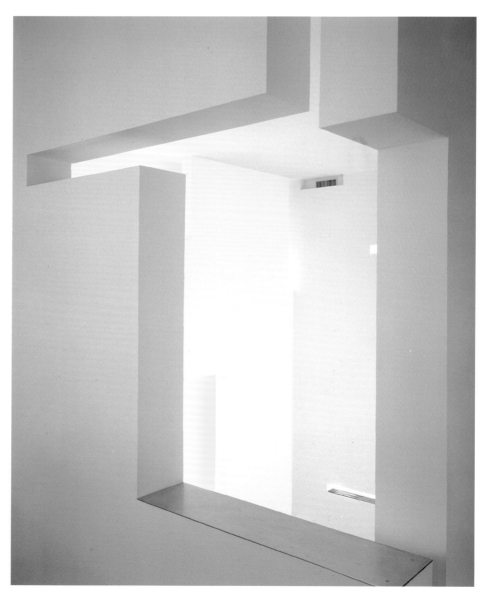

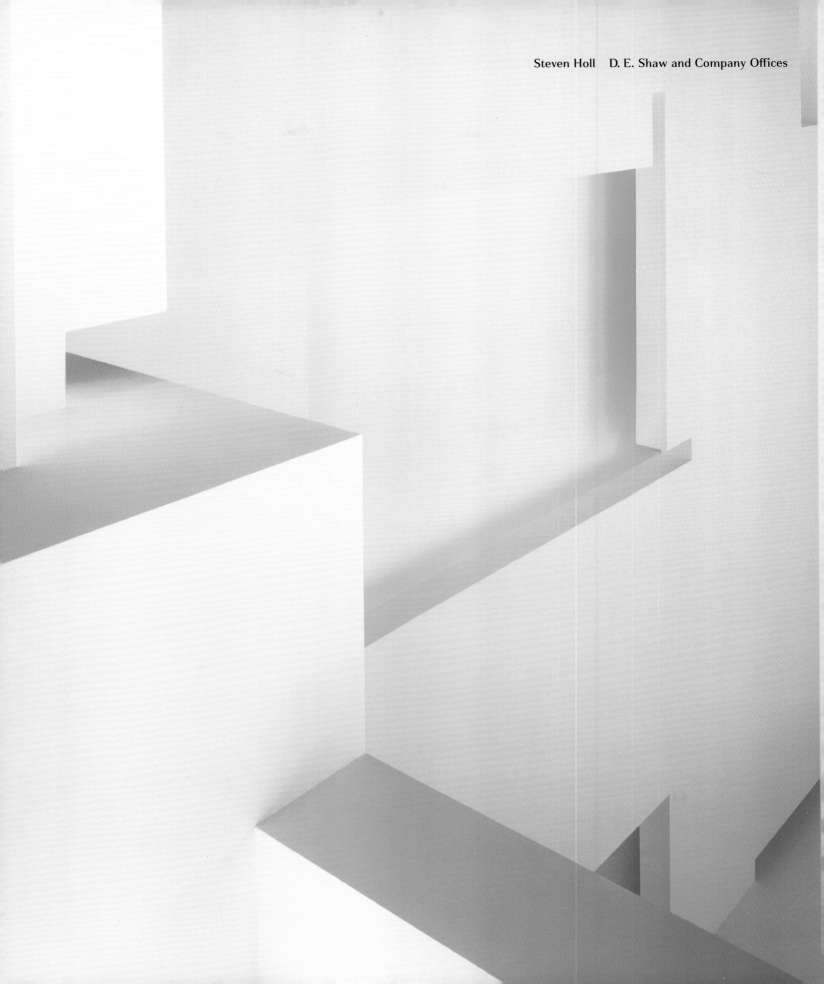

Signal Box auf dem Wolf _{Basel, 1995}

Situated on the edge of the main rail yard of the city of Basel and beside the old Wolf-Gottesacker cemetery, the six-story Signal Box auf dem Wolf by Jacques Herzog and Pierre de Meuron serves to monitor and guide the complex movement of freight trains in and out of the depot, which they also designed. From the upper level, the rail yard can be visually surveyed, but the actual control of the trains' movements is largely computerized, with miles of cable arranged in multilevel racks throughout most of the structure.

As with the automated warehouse they designed, built in 1987 for the Ricola manufacturing company, the Signal Box's considerable size seems disproportionate to the relatively small number of workers meant to occupy it. Their fewness is reflected in the paucity of windows and other openings; hence, the visual appearance of the structure is determined less by literally revealing the interior functions, an axiomatic principle of modern design, than by suggesting them with a metaphorical skin, in this case a series of twenty-centimeter-wide copper bands that bind the structure. Twisted upward in places to allow light into the few windows, the copper alludes to the electrical cable winding through the building. Aside from creating a striking and somewhat mysterious visual presence, the copper also has a functional goal, creating an electrostatic shield. In the words of the architects, "As a result of the copper coiling, the building acts as a Faraday cage protecting the electronic equipment inside from unexpected external effects."

Herzog and de Meuron's investigation of the potential meanings to be found in the architectural skin is also seen in a second warehouse they designed for Ricola in Mulhouse, France. Like the Signal Box, it fuses aesthetic and functional concerns: the building's polycarbonate sheathing reduces the amount of sunlight entering the structure, while images of plants silkscreened onto the sheathing allude to the sources of the medicinal products stored within, which are extracted from herbs. —T.R.

Left, top to bottom: section; ground level plan with entry at right; typical floor plan
Opposite: view from rail yard

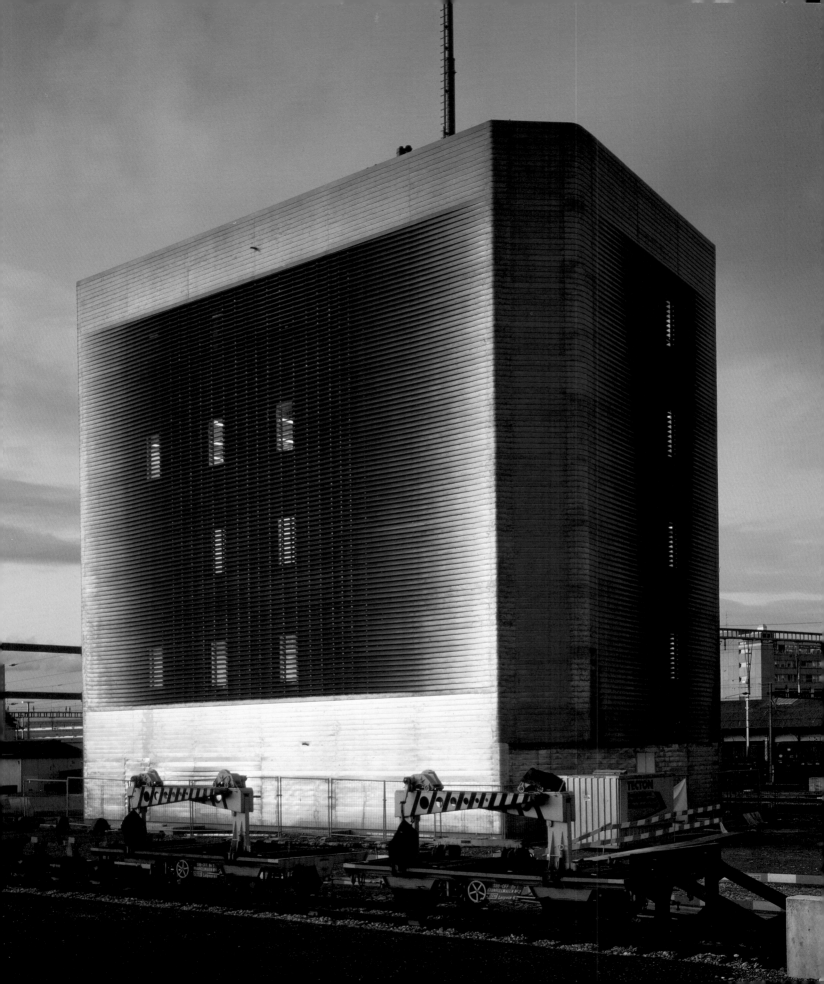

Peter Zumthor # Kunsthaus Bregenz Bregenz, Austria, 1991 (competition proposal)

The Kunsthaus Bregenz, designed by the Swiss architect Peter Zumthor and currently under construction, appears as a rather enigmatic cubic volume, rising slightly above the rooflines of Bregenz's old town. Chosen in a competition, Zumthor's design also calls for a separate structure, housing the museum's administrative offices, a bookstore, and a cafe, to be built across a new square to the southwest, leaving the Kunsthaus strictly as a place to show art.

A membrane of frosted glass, reaching from street level to the parapet, defines the building's simple profile. Complex interstitial spaces are woven between the membrane and the three levels of austere galleries within. The supporting structure consists of three massive, asymmetrical concrete walls, continuous from two levels below grade to the roof, which act as spines. Fixed to these spines, and floating one above another, are the galleries. These discreet rectangular volumes— "concrete shells," in the architect's words—are separated by a gap of approximately seven feet between the floor of one and the ceiling of the one just below. This gap allows light into the center of the multistory building, to be diffused through each gallery's matte glass ceiling. The spines serve as screen walls; behind them are narrow slots for stairways and freight and passenger elevators. The exhibition spaces thus remain open and remarkably light within a comparatively dense mass.

The entire inner volume of the structure is enveloped by a semi-transparent facade of matte glass panes, assembled like shingles, which allow air to pass through to the four-foot-wide space that separates the inner and outer skins. While achieving the functional goals of limiting direct sunlight and heat gain within the museum, this discreet isolation contributes significantly to the striking appearance of the building: shadows of spaces within are revealed through the building's facades. The massive concrete elements also realize both functional and aesthetic goals: since the lower part of the structure is below the water table, ground water can be fed directly into heat pumps, which circulate hot or cool water through pipes in the museum's walls and floors to control the temperature in the galleries. In the architect's words, "What may at first appear not to be a very energy-friendly glass house is really a building which, in keeping with its function, captures much daylight, guarantees a constant climate to protect the works of art, and nevertheless, as is shown by the calculations, makes do with little energy thanks to its 'soft' climate technology." —T.R.

Entrance facade

Typical gallery floor plan

*four gallery levels above,
support spaces below*

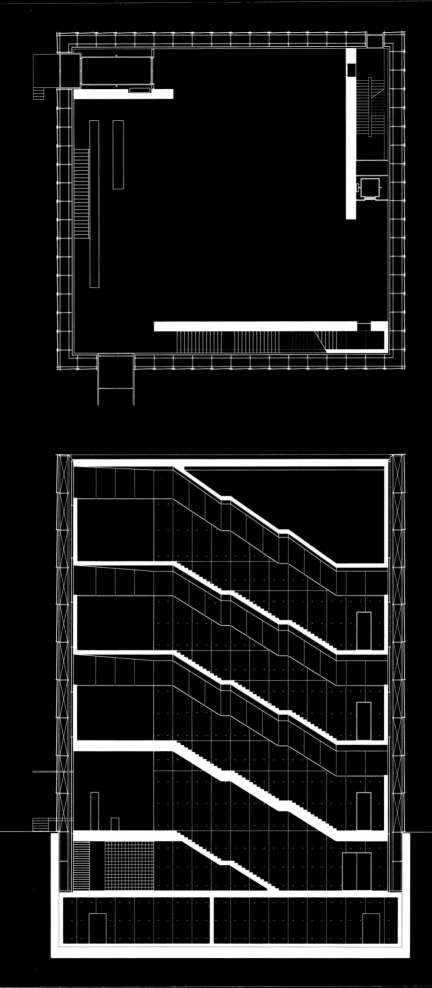

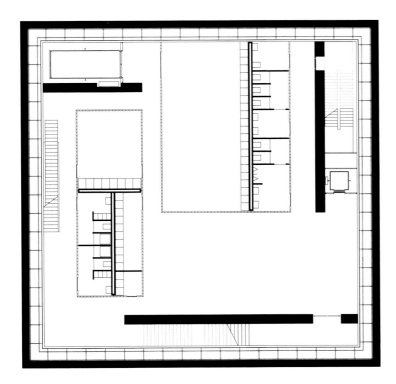

Plan of lower level, indicating spaces for support functions, separated by glass block partitions

Views of model in urban context

Harry C. Wolf **ABN-AMRO Head Office Building** Amsterdam, 1992 (competition proposal)

This design for the head office of the ABN-AMRO banking corporation, submitted in a limited competition by Los Angeles–based architect Harry Wolf, was proposed for a site in Amsterdam South, a peripheral area. The design features a cylindrical thirty-story tower at the eastern end of a long esplanade, an arcing five-level parking structure behind it, and a ten-story structure grafted tangentially to the midpoint of the tower's principal elevation, facing the esplanade. An extension, with one story above and one below grade, connects the tower and the parking structure and acts as the principal entry for employees and visitors to the circular trading room, 125 feet in diameter.

Facing the esplanade, a ten-story slot between the cylindrical volume and the tangent slab would make the principal pedestrian entry visible from a great distance. Upon entering,

visitors would look down over the trading floor before ascending to the seventeen-story atrium above. Besides being skylit, the atrium has a south-facing eight-story "window" that would bring light directly into it and, through its glass floor, into the trading room below. At the level of the atrium's skylight is a terrace, planted with trees, adjacent to the building's dining facilities. Above this level, one quadrant of the tower is cut away, leaving a view of the city from the open-air terrace, which is protected by the remaining three-quarters of the tower, rising another eleven stories. The double-height concrete structural frame, enclosed by double layers of transparent, translucent, and etched glass, provides a system whereby every other floor, suspended from the one above, can extend the full forty-seven feet between the atrium and the outer surface of the

building, or some subdivision thereof, allowing for a variety of mezzanine-like spaces throughout the tower.

While the golden section and the Platonic geometries of the cylinder and the square underlie much of the tower's conception, the architect's intentions are far from the notion of a timeless, unchanging geometry. In his words: "Irradiated by its crystalline appearance during the day and constantly changing with the sun and with the fluctuations of the ambient light, this building is intended to embody the longstanding concern for light in the Netherlands; that is the association of luminosity, precision and probity in all matters." —*T.R.*

Opposite: computer-manipulated photographs of model showing views of atrium from southeast (left) and southwest (right), and simulating effects of light entering atrium at different times of day and year. Clockwise from upper left: 21 June, 11:00 a.m.; 21 June, 6:30 p.m.; 8 March, 2:00 p.m.; 22 December, 11:00 a.m.

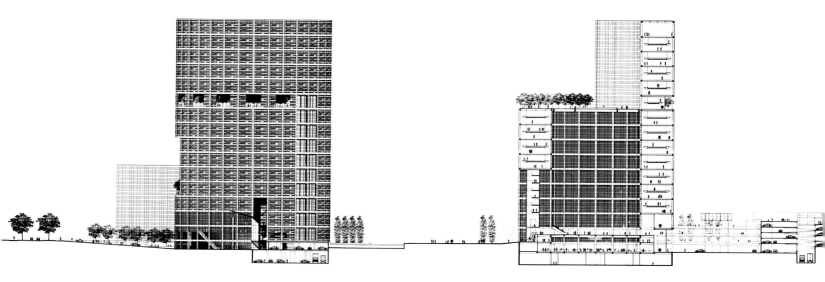

Elevation facing west, section through main visitors' entrance

East-west section

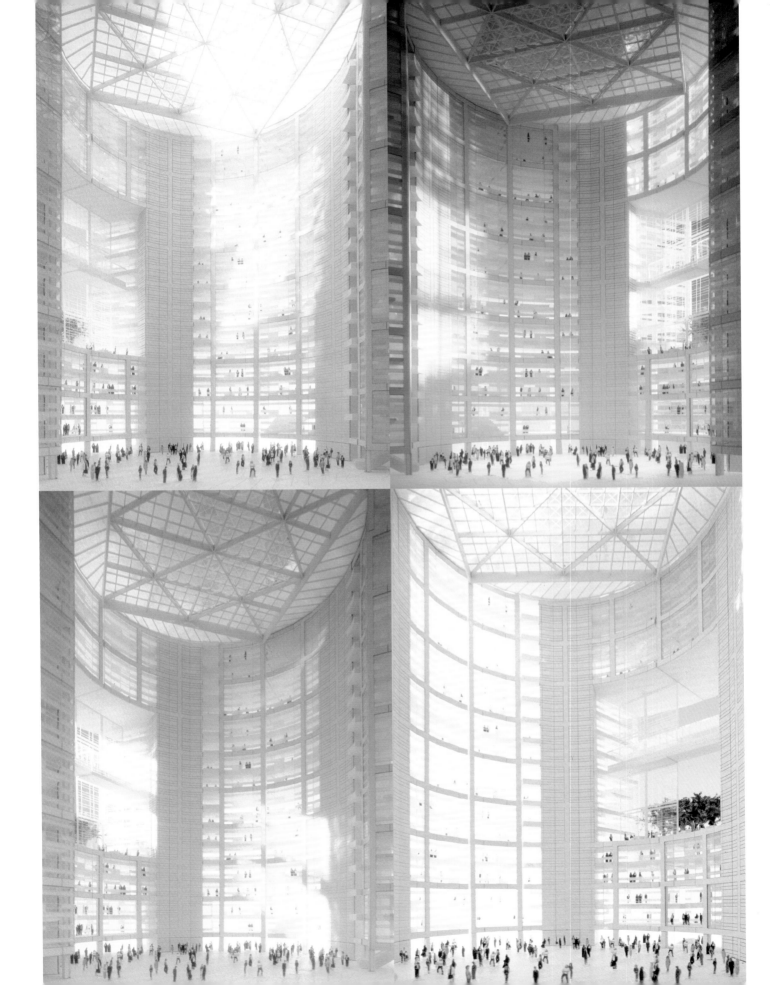

Clockwise from left: trading room level, esplanade level, atrium level

Key:
1. *Principal vehicular entry and drop-off*
2. *Trading floor*
3. *Parking structure*
4. *Visitors' pedestrian entry*
5. *Trading room below*
6. *Office space*
7. *Atrium*

*Typical office floor plan showing a variety
of sample workspace arrangements*

Aerial view of model, seen from the northwest

Leisure Studio

Conceived as a summer house for an artist to live and work in, this small (488-square-foot) structure was built as a *contre-projet* on a rented site to coincide with a leisure housing fair near Espoo's new Puolarmaari Garden. Within an otherwise open space, a volume of rendered brick contains a small kitchen, a bathroom, and a sauna, and supports a platform for sleeping. In this minimalist space, there is no need for furniture: the floor panels can removed to reveal storage space and create seating ledges; the panels themselves can be used as tables. The entire wood frame structure, including the roof, is clad with single sheets of semi-transparent triple-wall polycarbonate so that in the dark the building glows like a lantern. The shadowy presences of the volume of brick and persons inside can be seen through the cladding material.

The studio begs comparison with Mies van der Rohe's Farnsworth House, both in the rhetorical emphasis on transparency and in the other-worldly manner in which both structures hover above the ground. Beyond aesthetic concerns, however, the Leisure Studio resonates with the spirit of prewar modernist idealism. Evoking the credo that less for each means more for all, the structure embodies a frugal, anticonsumption ethic. Crossing the boundary between professional and tradesman, the four collaborating architects helped construct the building and covered half the expenses: "The willingness to exert maximum influence on the result—by building with one's own hands—was one of the driving forces" behind the project. Since the housing fair closed, the structure has been used as a place for artists and architects to meet informally, achieving a public dimension which reflects its idealistic conception. —*T.R.*

Plan of studio and loft above

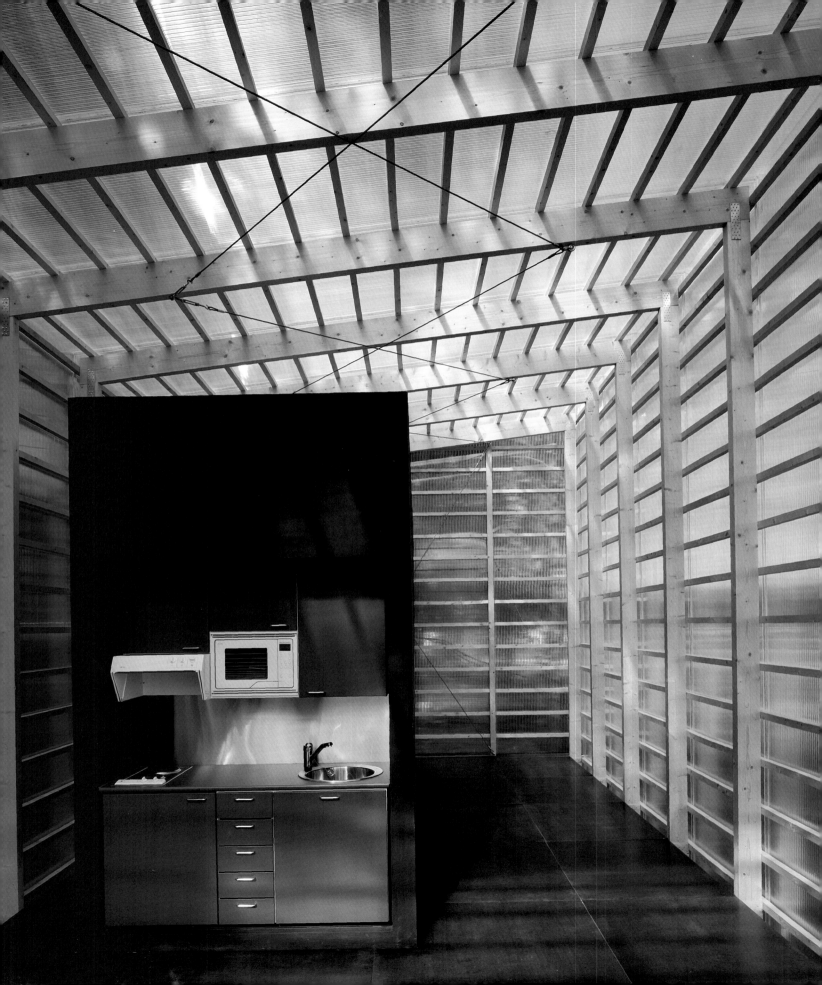

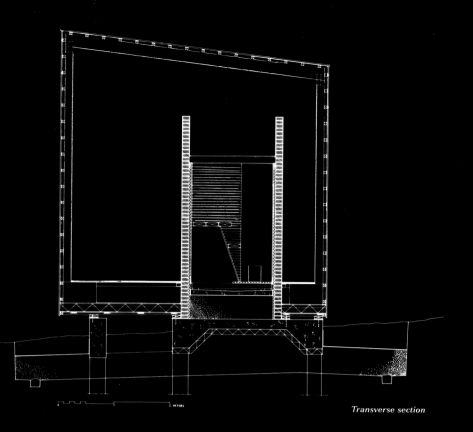

Transverse section

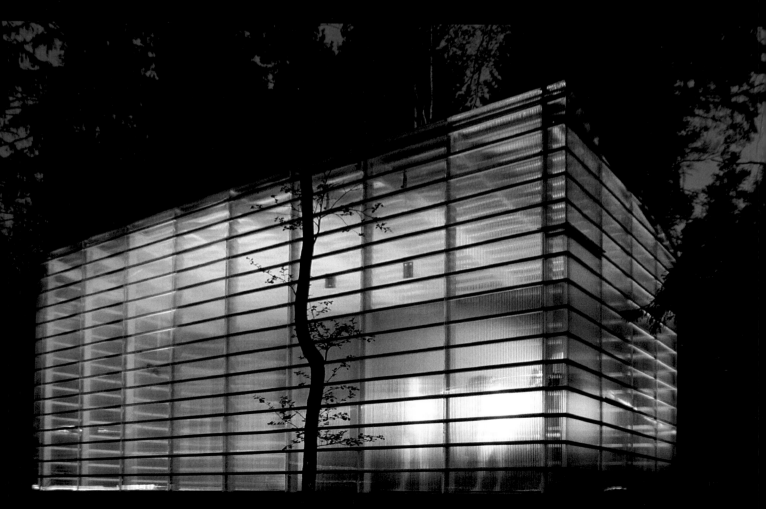

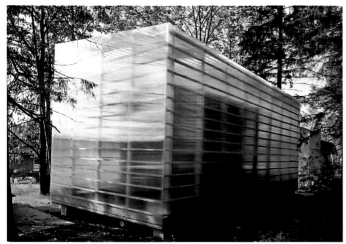

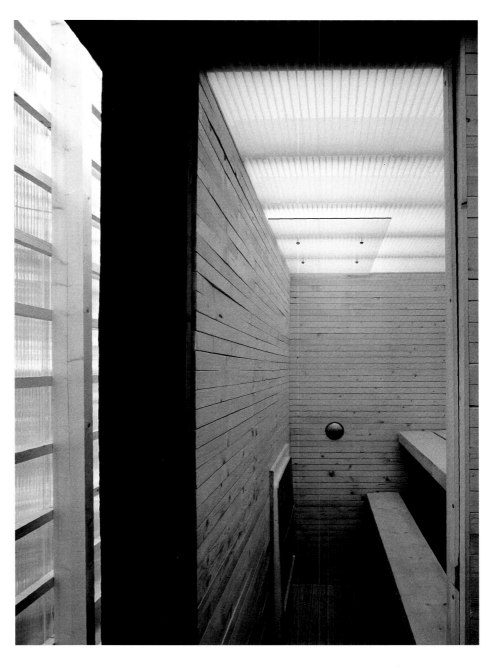

View of sauna

Dan Graham Two-Way Mirror Cylinder inside Cube New York City, 1991

Dan Graham's sculpture installation for the roof of the Dia Center for the Arts in New York City uses an architectural vocabulary to provoke reconsideration of the urban environment and the idea of neutral space. His walk-in sculptural pavilion is composed of simple geometric forms; the plan describes a circle ten feet in diameter at the center of a thirty-six-foot square. A painted steel framework supports walls of reflective transparent glass; one segment of the cylinder wall pivots to permit entry. The wood platform floor cantilevers over a steel base, raising the pavilion above the roof level and imparting to it the character of a stage. Viewing the artwork, one becomes a part of the piece, a performer whose image is repeated as reflections in the glass.

As architecture the pavilion is clearly related to Philip Johnson's Glass House of 1949, a rectangular glass-walled structure with an interior cylindrical form. The Glass House, situated within a large landscaped private estate, is a modern rendition of the eighteenth-century belvedere: a small structure in a park that serves as a protected place in which one may observe and be immersed in nature that is pleasingly framed by the architecture. From within Graham's pavilion, one surveys not landscape but cityscape. The view is framed two-dimensionally (as in a picture) by the steel framework, and the clear geometry of the roofless structure also visually and conceptually orders the metropolis into simple shapes: rectangular buildings, cylindrical water towers, round clocks, gridded city plan. The undifferentiated mass of the city is reindividuated so that buildings are seen as independent forms, distinguished from their collective context, and as invented forms, not unlike the manipulated "natural" landscape viewed from the belvedere. Entering the cylindrical space intensifies conspicuousness as its surfaces compound distorted reflections. According to the artist, "The spectators are self-consciously aware of themselves as perceivers. The superimposition of spectators' body surfaces and gazes creates an inter-subjective intimacy." Graham's work counters the idea of space designed for the unobserved viewer and blurs the clear distinction between subject and object as it is expressed in the belvedere on private property or in the typical art gallery. He fuses the artwork with the urban space it occupies and with the active presence of the viewers. —A.D.

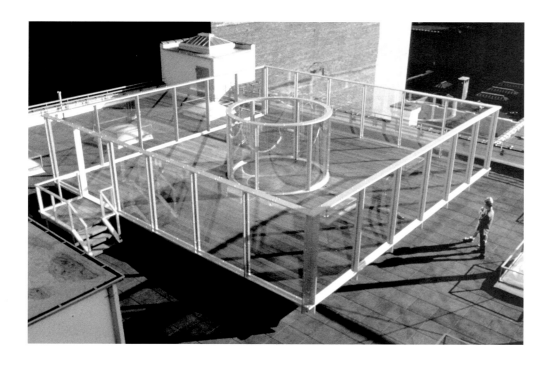

Aerial view from northwest

Bernard Tschumi Glass Video Gallery Groningen, the Netherlands, 1990

The Glass Video Gallery was commissioned by the city of Groningen and the Groninger Museum as a public pavilion for watching music videos. Situated in the center of a traffic roundabout, the rectangular volume of the gallery is seventy-one feet in length. Within the glass volume are six banks of video monitors. Tschumi's pellucid structure signifies the immaterial nature of video images as flickering patterns of colored light projected onto a glass screen.

The entire enclosure, including roof, sides, vertical supports, and horizontal beams, is made of toughened glass plates held together by metal clips, eliminating any substantial differentiation between structure and skin and minimizing the perceptive barrier between inside and outside. Glass plates divide the actual interior of the space, multiplying layers of reflection and dissolving the solid surfaces of the glass. The lucid and rational function of glass as a building material is ultimately denied by yanking the gallery out of the Cartesian grid in which it would otherwise seem to belong and tilting it on two axes.

An equivalence is set up between the glass volume of the gallery and the glass-screened video monitors, and video's function as an instrument of surveillance is inverted: the visitor to the gallery is not allowed the anonymous subjectivity of peering out of a darkened space, as in a movie theater, but is instead on view. In a transparent box, the spectator becomes spectacle, and the feasibility of private life in a media-suffused culture is questioned. At night, the architectural volume disappears altogether, supplanted by countless reflections and incorporeal video screen images. —A.D.

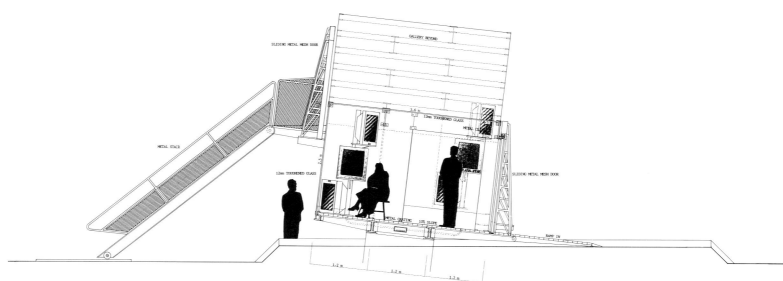

Transverse section

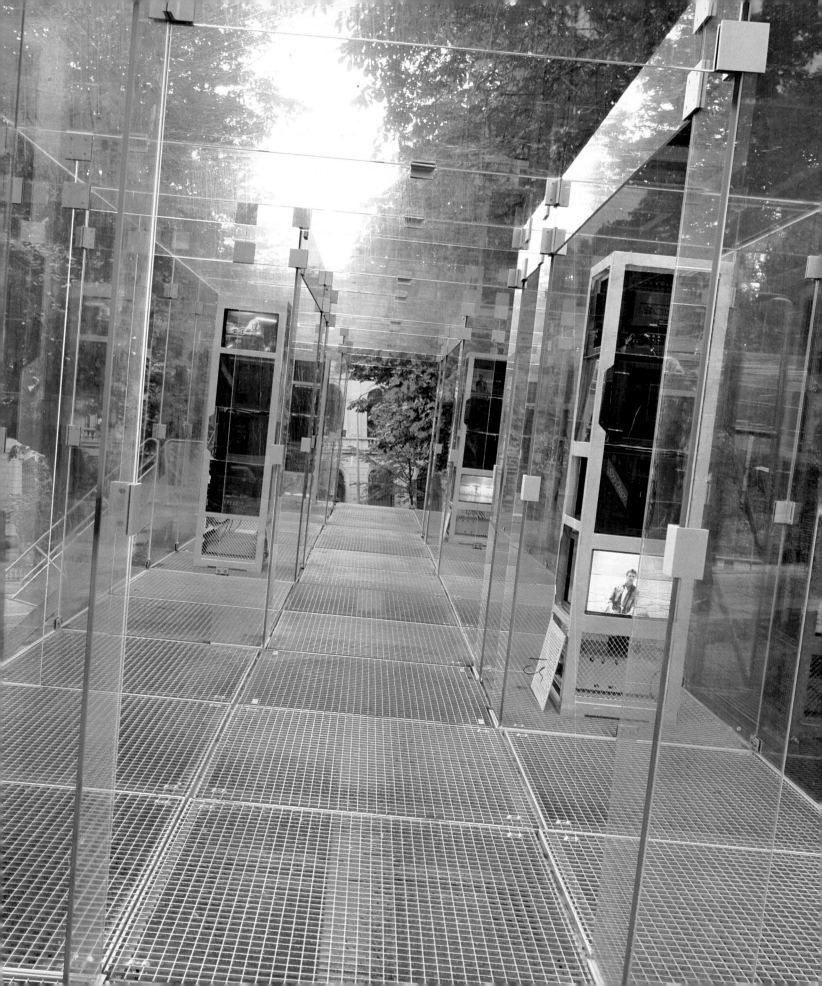

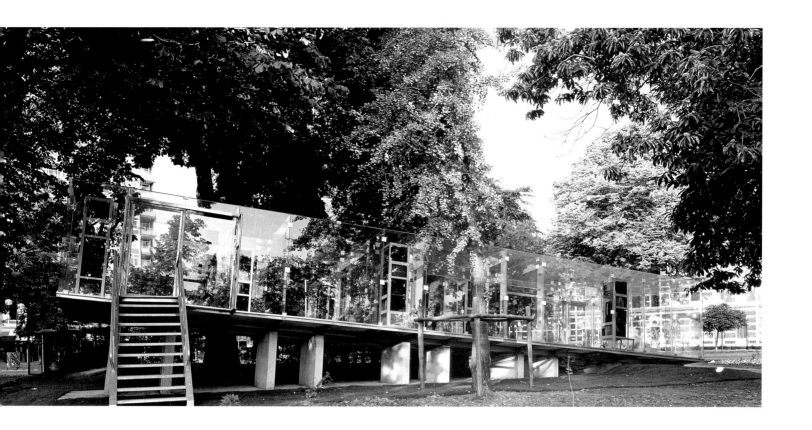

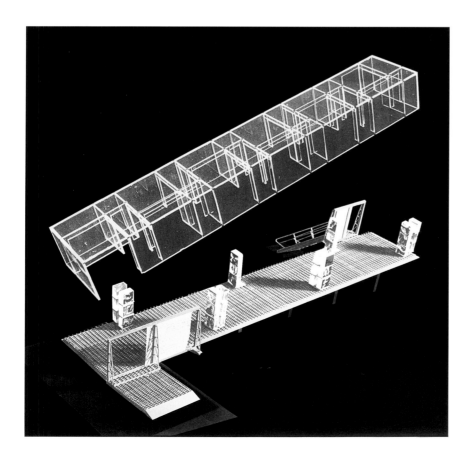

View of deck and video units with glass structure removed (photogram)

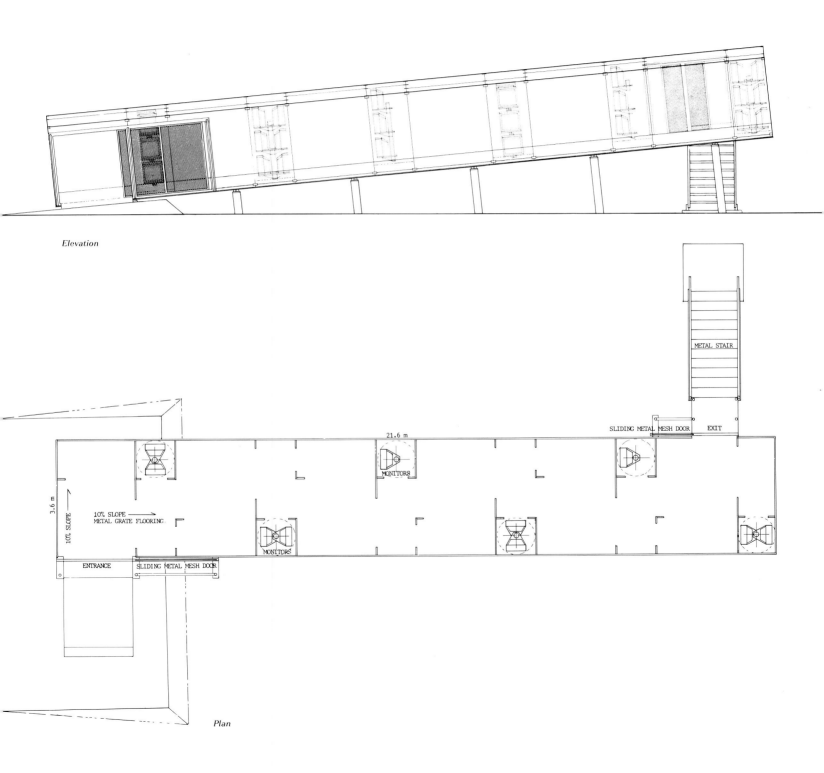

Elevation

METAL STAIR

SLIDING METAL MESH DOOR EXIT

21.6 m

MONITORS

3.6 m

10% SLOPE

10% SLOPE
METAL GRATE FLOORING

MONITORS

ENTRANCE SLIDING METAL MESH DOOR

Plan

Waterloo International Terminal

The international terminal grafted onto central London's Waterloo Station provides a direct link between the British Rail system and the French high speed train system through the recently completed Channel Tunnel. As part of a united Europe's evolving transportation infrastructure, the channel rail link is meant to compete directly with air service, reducing to three hours the journey from Waterloo Station to the Gare du Nord in Paris. Nicholas Grimshaw and Partners' design allows up to six thousand passengers per hour to pass through the station, whose length accommodates the 1,200-foot-long transcontinental trains.

The station's spectacular glazed train shed is reminiscent of the great engineering feats of nineteenth-century railway architecture, but the Waterloo International Terminal is in many respects more complex than its Victorian counterparts. Inserted into the dense fabric of central London, the station is only wide enough to accommodate the five rail lines dedicated to international arrivals and departures: roughly 164 feet at the railhead and

tapering to only 98 feet where the trains depart the station toward the south. Furthermore, there are only a few feet between the outer edge of the site and the westernmost rail bed, making it necessary for the structure to rise steeply at this point to clear the trains. The site's limits are equally restrictive in the vertical dimension: the three successive levels below Waterloo Station's existing platform level contain, respectively, a ticketing and departure area, an arrivals and customs hall, and a parking garage.

The 1,312-foot-long glass roof, designed in collaboration with YRM Anthony Hurt Associates, ingeniously reflects the site's constraints. The station is divided into thirty-six structural bays defined by arching supports, each consisting of two trusses of unequal length, connected by a pin joint. The shorter trusses rise sharply to clear the trains on the westernmost rail bed; the longer rise more shallowly and span the other four tracks. Each of the two interconnected trusses is stabilized by a tension rod, which runs under the longer truss, like a bowstring, and above the shorter truss,

pressing downward and counteracting the unequal distribution of the roof's weight. Along the eastern side, stainless steel panels bridge between the trusses, reducing the amount of direct sun and heat gain in the shed.

Despite its engineering marvels and its remarkable appearance, which makes it an appropriately grand gateway to Britain for arriving continental trains, the shed cost no more than ten percent of the project's total budget. Savings were achieved by exhaustive computer analysis of the shed's eccentric form to determine how the components could be standardized to the greatest extent. To achieve this, a complex "soft" construction system was used, which frames the west wall's glass panels with flexible neoprene gaskets that conform to the subtle changes in the structure's profile while allowing for movement of the structure in response to passing trains, wind, and heat. In the vertical direction, the glass panes lap over the ones below like shingles, allowing the panes to move independently, with another gasket maintaining a weather seal.

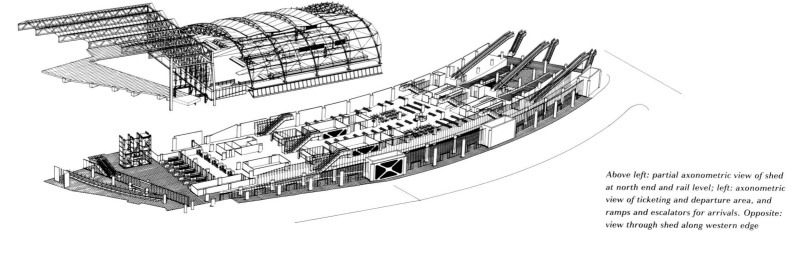

Above left: partial axonometric view of shed at north end and rail level; left: axonometric view of ticketing and departure area, and ramps and escalators for arrivals. Opposite: view through shed along western edge

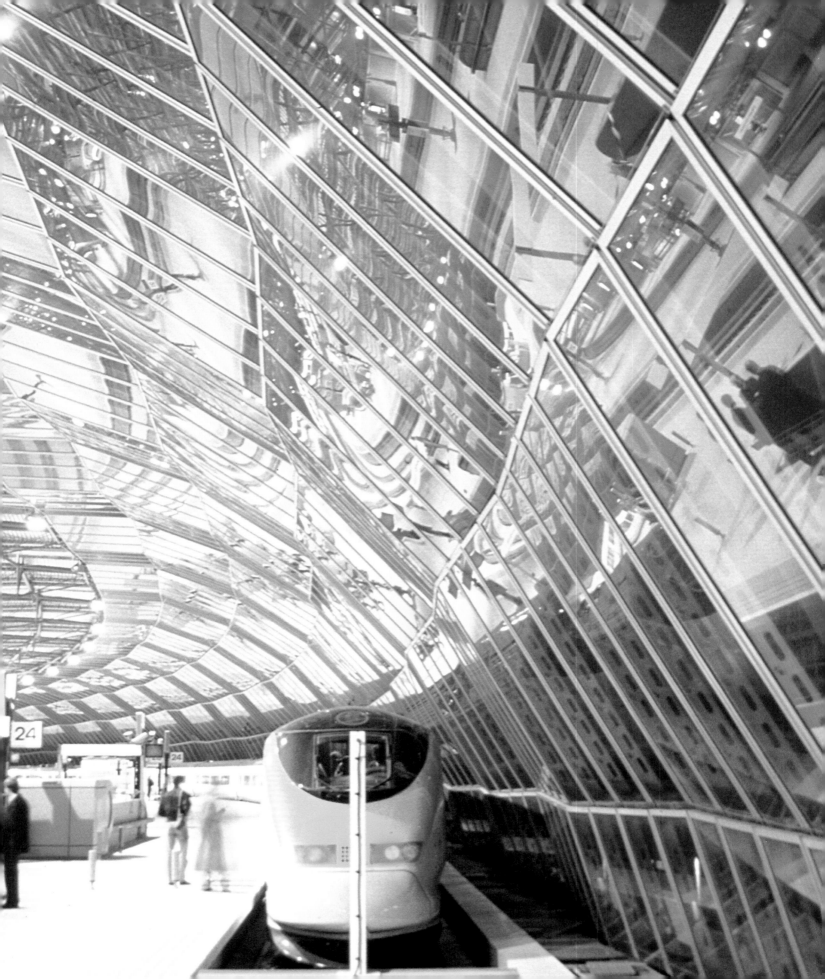

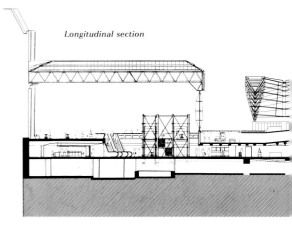

Departing passengers enter the structure one level below the railhead and progress linearly, as in an airport, through ticketing, check-in, and passport control to the departure hall. In section, across the departure level, the shape of the ceiling varies in height as it rises under the platforms and is depressed under the train tracks; escalators bring departing passengers to the rail level. Below the departure hall is the arrivals level, connected to the track level at the far end of the shed by a series of moving ramps and escalators. Passing through immigration services, arriving passengers move laterally into a double-height concourse, which runs along the west side of the structure at street level, providing access to taxi and subway stations and the central hall of Waterloo Station.

The Waterloo International Terminal begs comparisons with the great train sheds of London's Paddington, King's Cross, and St. Pancras Stations, yet it differs in a notable regard. The Victorians insisted on shielding their unadorned iron structures with monumental representational facades, while Grimshaw's design celebrates its technical aspects and reflects the renewed role of train travel in the twenty-first century. —*T.R.*

Below: view past rail head to old Waterloo Station; right: view from center platform through shed (looking south)

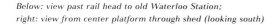

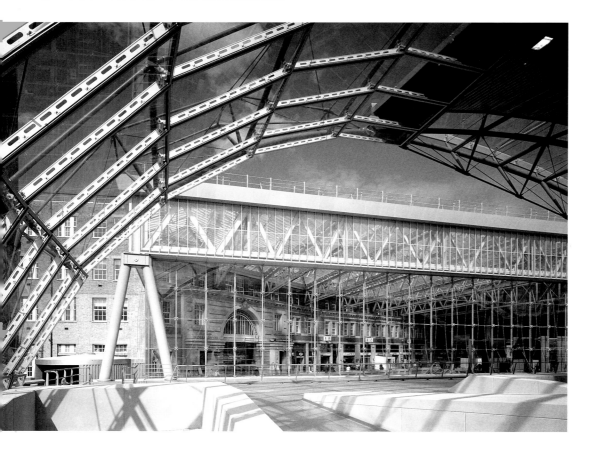

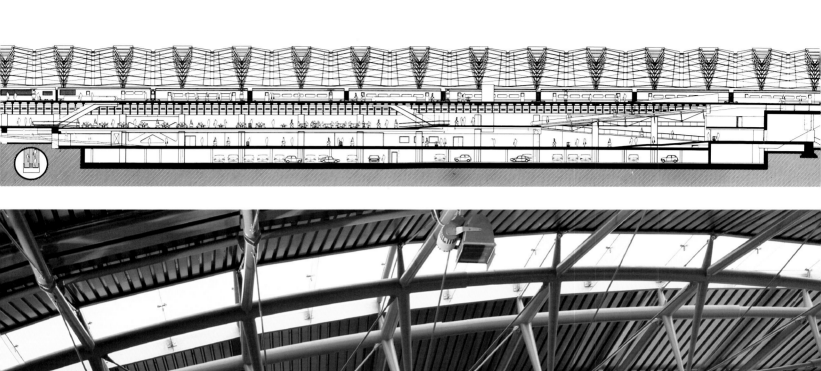

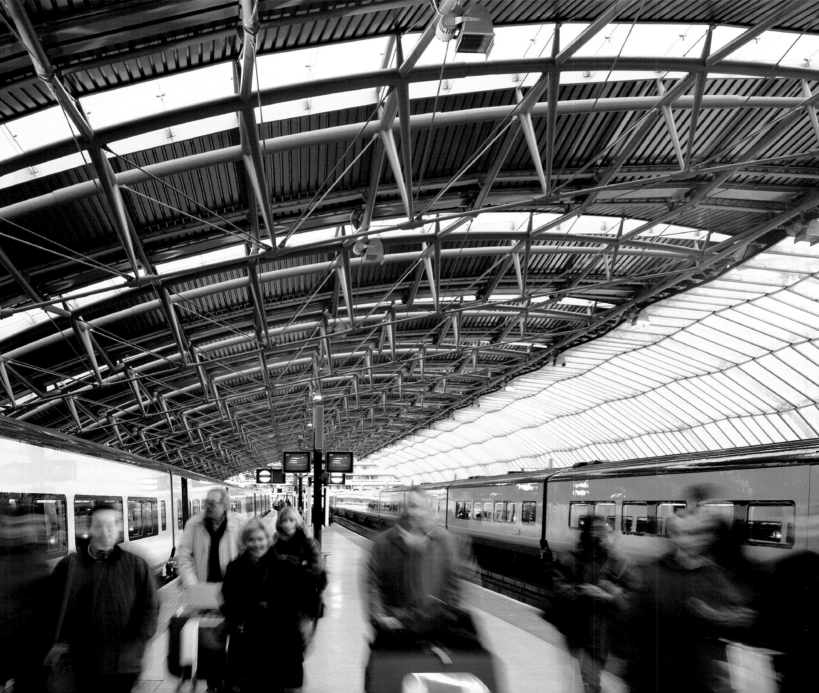

View from south

Abalos and Herreros Municipal Gymnasium Simancas, Spain, 1991

The municipal gymnasium designed by the Madrid architects Iñaki Abalos and Juan Herreros sits at the foot of the medieval hill town of Simancas in the province of Valladolid, facing the Pisuerga River. It serves not only as an athletic facility but, like an urban plaza, as a public space for dances, town meetings, and other activities.

The expression of the facade—concrete base, metal panel mid-section, and glass clerestory—emphasizes a horizontal reading of the structure, in keeping with the low-lying fields that surround the town and the predominantly horizontal architecture of the town's walled courtyards and cubic structures. The inexpensive but richly

proportioned gymnasium establishes an immediate relationship with the other principal buildings of the town, the castillo and the cathedral, which dominate its skyline.

The gymnasium is divided into six structural bays, the last of which has two levels, containing the entry, changing facilities, and showers above, and offices and storage below. The principal space is thirty feet high, spanned laterally by four lightweight trusses and lit during the day through clerestory glazing, which consists not of plate glass but interlocking cast glass planks. Like the state-subsidized housing project Abalos and Herreros designed for the outskirts of Madrid, the Simancas gymnasium displays a minimalist sensibility that originates in issues other than form, as they explain: "A criterion of minimum intervention was imposed, extending over all the project decisions. The construction elements become elements of signification." The dignified appearance of the modest structure is a result of the way in which the architects' minimal interventions contributed to a balance among aesthetic, functional, and structural concerns, "creating an effect of expanded scale, dematerialization, and lightness, reinforced in the interior space by the diffuse light." —*T.R.*

Gymnasium level with storage and offices at left

Principal elevation, upper level entry at left

Longitudinal section

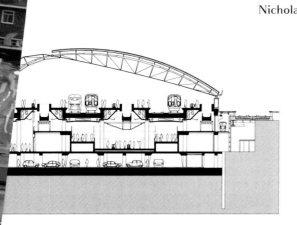

Transverse section (looking north)

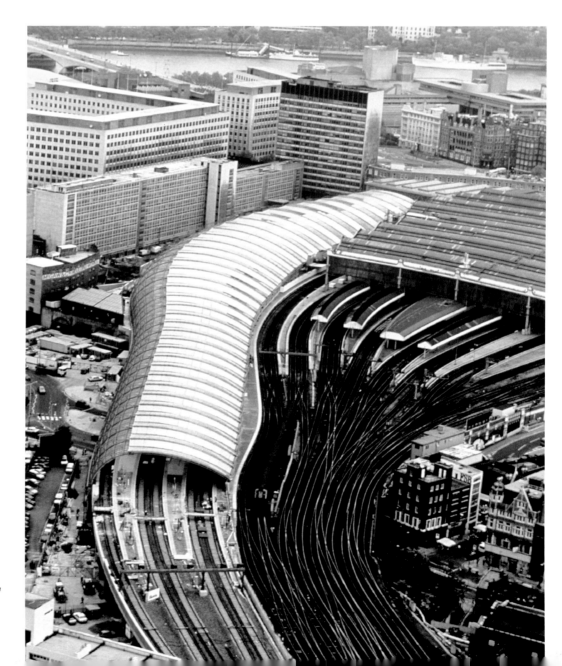

Aerial view from south

Facade

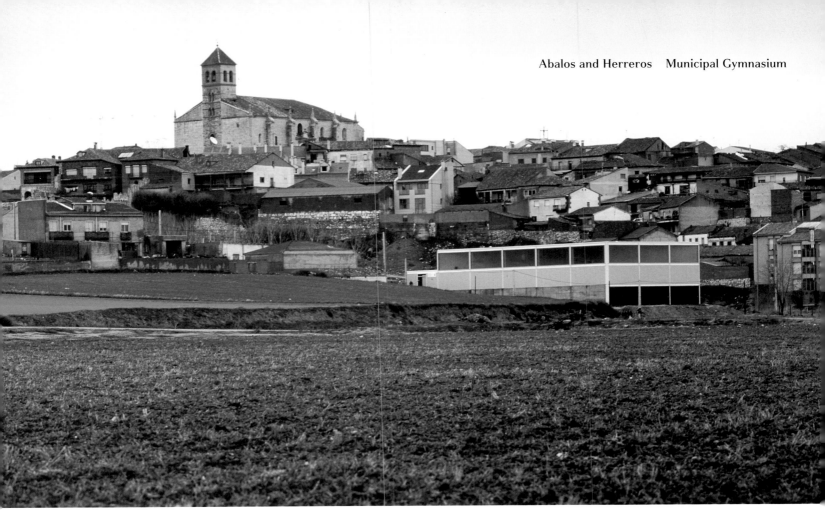

General view of Simancas, with
municipal gymnasium at right and
cathedral above

Left: shower room (upper level);
right: view of gymnasium interior
from upper level

101

Mehrdad Yazdani—Ellerbe Becket # CineMania Theatre Universal City, California, 1993

This small (fifty-seat) motion-based theater designed by Mehrdad Yazdani, formerly a design principal in the Los Angeles office of the architecture firm Ellerbe Becket, is part of the City Walk entertainment complex at Universal City, California, and it also was envisioned by its owner, the Showscan Corporation, as a prototype for similar projects. CineMania transforms traditional elements of the American movie house: a small box office projects in front of a curving facade rendered in luminescent Venetian plaster, along which ticketholders queue up under a sun screen before entering the lobby, a somewhat ovoid space whose smooth, computer-generated surfaces provide a transition from the Southern California glare outside to the Orphic enclosure of the media theater whose volume can be seen rising behind the rendered facade. CineMania departs from traditional movie houses by melding the patron's initial and concluding experiences: the transition from the actual world to one of simulated sounds and images is prefigured in the hovering folded scrim of fiberglass panels that float, cloudlike, above the queue line and in front of the theater volume. Replacing the traditional marquee, the scrim is a surface for projection, bringing the media world into daily experience; in the architect's words, "The intent of the design was to question the distinction between simulation and reality." —T.R.

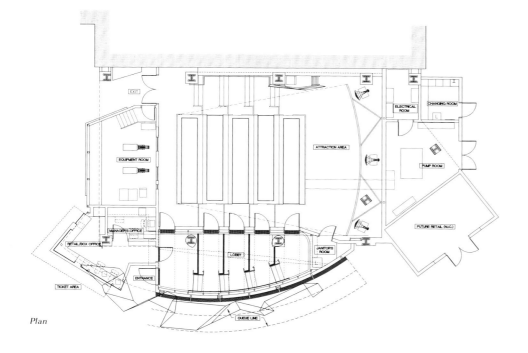

Plan

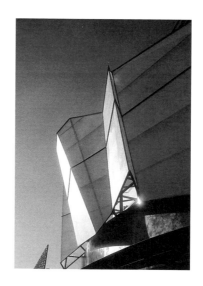

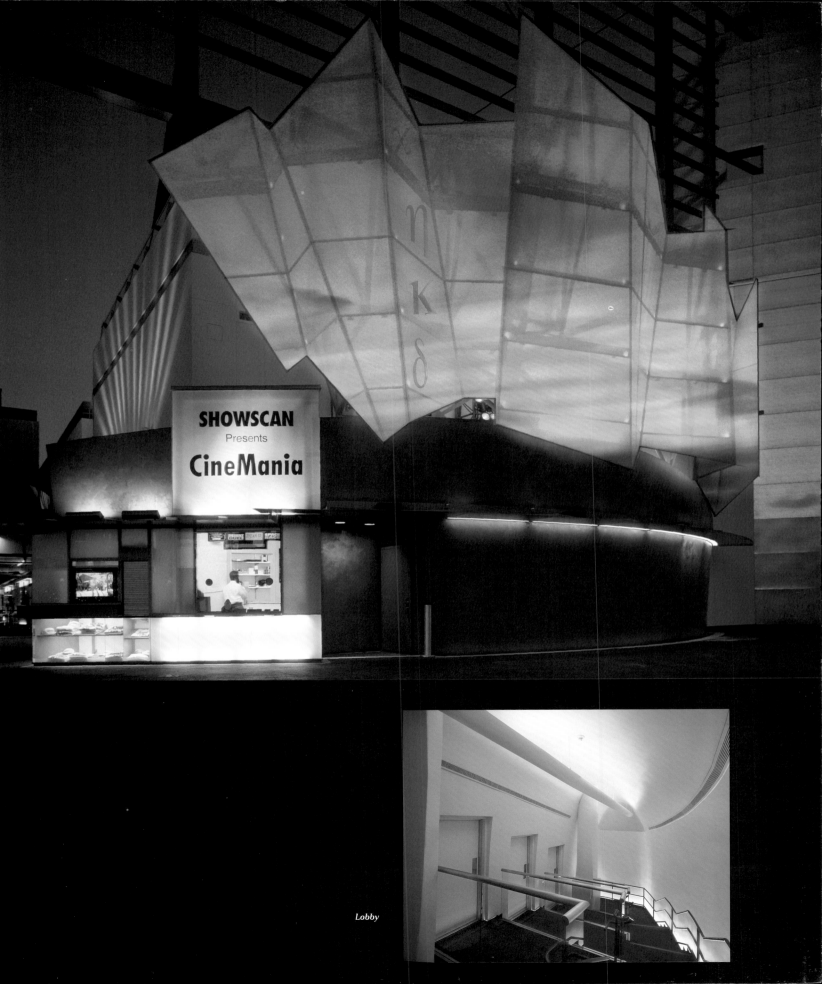

SHOWSCAN
Presents
CineMania

Lobby

The World Upside Down

Tod Williams and Billie Tsien and the composer Glenn Branca were invited by the choreographer Elisa Monte to collaborate on an original dance performance, *The World Upside Down*. The theme of Monte's piece was, in the architects' words, "the idea of rejuvenation through social reversal." When a social order is transformed, "the outcome is far from certain. That which is normally in the foreground retreats and its shadow emerges." To reflect this theme, the architects reconsidered the simplest of all sets, the traditional backdrop or scrim (a transparent drop of fine mesh cloth, often painted, which appears opaque when lit from the front, but seems to disappear when only the stage behind it is lit). They transformed it from a backdrop into an active participant, a translucent "canvas" stretched over an aluminum frame, braced and piano-hinged, on an undercarriage supported by casters. Heat-weldable

rear-projection-screen plastic was attached to the lightweight aluminum trusswork.

Using the architects' sketches and a model, Monte made the screen part of the choreography: emerging from the shadows, folding into a wedge, and coming to rest with its prow precariously cantilevered over the orchestra pit. Two versions of the screen were created: one fifteen feet high and sixty feet wide when fully extended, for the work's premiere in Amsterdam, and one twelve feet high and forty feet wide, for the subsequent showing on the somewhat smaller stage at New York's City Center. The set evoked ideas of reversal inherent in translucent and transparent materials. The audience simultaneously viewed dancers in front of the screen and ones behind it, whose figures were projected onto the scrim's surfaces by back-lighting. Backstage became onstage, figures

became silhouettes, and shadows danced. The theme of reversal also was realized in the costumes designed by Williams and Tsien: lightweight jerseys, interlined with fluorescent color, were worn as loose-fitting shirts and, inverted and reversed, as trousers. While the materials and the technology required to animate the screen are of the twentieth century, Tsien and Williams's designs recall a centuries-long fascination with lightness and transparency as metaphors for personal, spiritual, and social transformation. —*T.R.*

Design for reversible costume

Frederick R. Weisman Art Museum

The Frederick R. Weisman Art Museum, designed by Los Angeles architect Frank Gehry, is at the edge of the University of Minnesota campus, overlooking the Mississippi River at a point where a double-level bridge connects the campus with downtown Minneapolis. The lower levels of the museum, cut into the river bank, contain parking and service functions. A bookstore and a 1,500-square-foot black-box auditorium are adjacent to the main entrance at ground level. A double-height skylit exhibition area, which connects the entrance to the main galleries, is visible to passersby through large plate-glass windows on the north side of the building. To accommodate a wide range of contemporary art, the principal exhibition space, rectangular in plan, is designed for maximum flexibility:

it has few columns and its 4,000 square feet are divided into five galleries by nonstructural partitions.

While the galleries may seem quite regular in plan, they are exceptional in section. Above the exhibition area, free-form spaces, carved out of the level above, contain curatorial offices. These "voids," which, in the words of the critic M. Lindsay Bierman, "could have been the molds from Le Corbusier's biomorphic roof forms," create varying heights at key transition points in the main galleries, exposing the museum's truss structure in places and allowing natural light into the gallery through skylights.

The juxtaposition of the regular and the exceptional within is all the more evident without. The plainness of the nearly blank brick surfaces of the south and the east facades is

exaggerated by contrast with the sculptural quality of the north and west facades, which are sheathed in what might appear to be fragments of an airplane fuselage. On the north side, these fragments ostensibly serve as canopies hovering over the main pedestrian approach from the campus as well as the public entry. On the west side, the intention is plainly dramatic: the four-story facade, resembling a reflective three-dimensional cubist collage and comparable in scale to the nearby bridge, faces the main approach to the museum from downtown. It is regularly transformed by the setting sun into a multi-hued, shimmering apparition, which seems to refract as much as reflect light. Equally, the flat gray skies of the Minnesota winter seem to meld seamlessly with their reflection in the brushed stainless steel. —T.R.

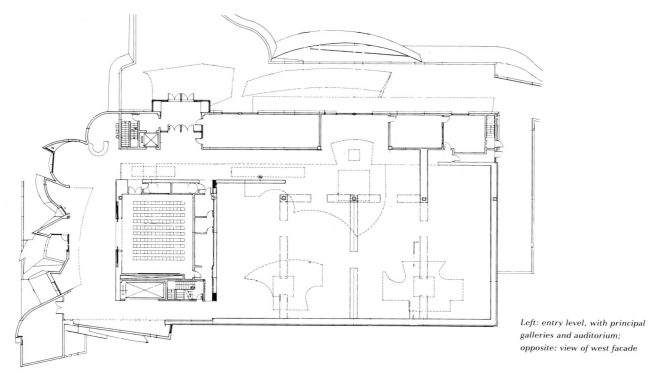

Left: entry level, with principal galleries and auditorium; opposite: view of west facade

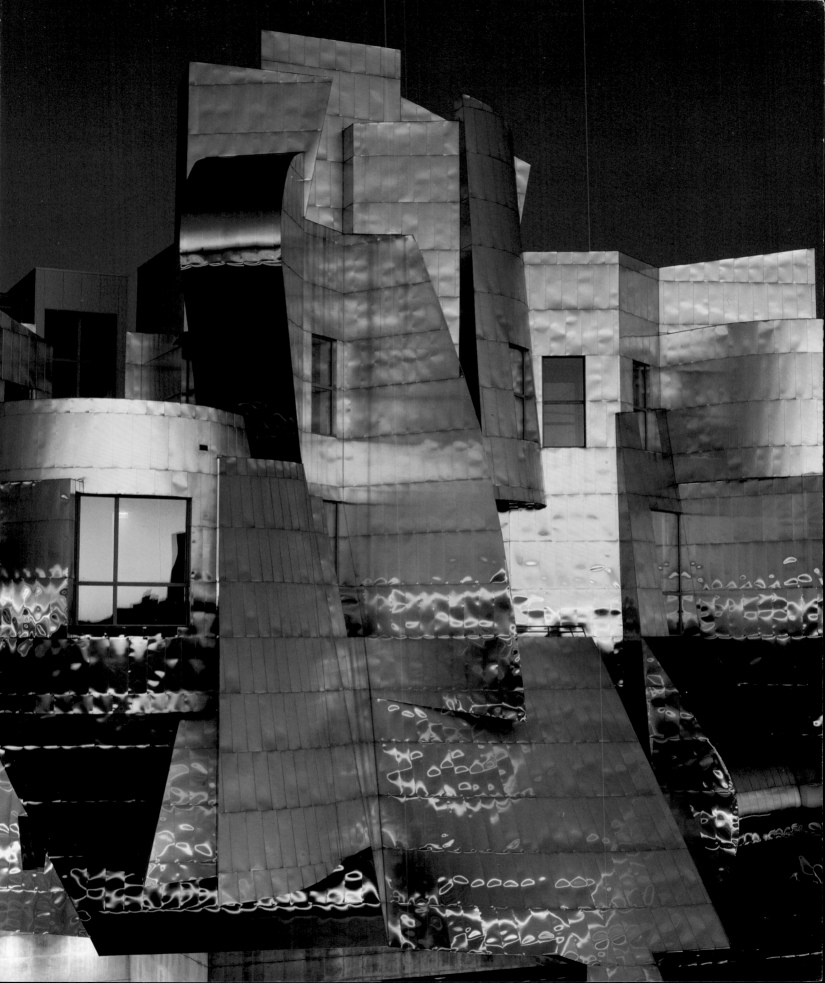

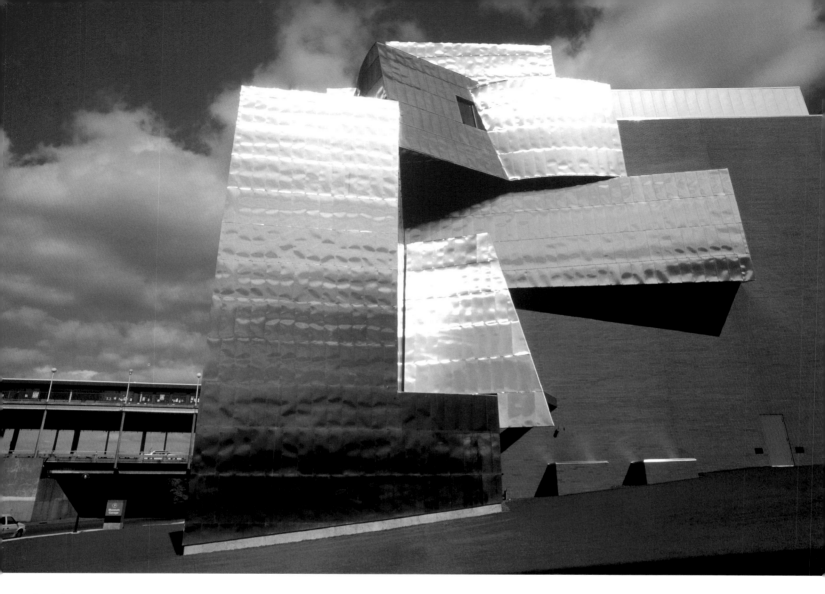

South facade

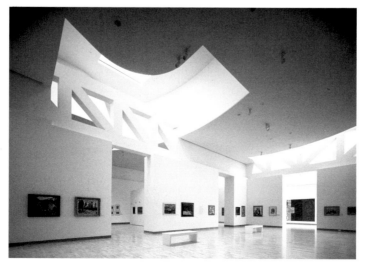

*Far left: auditorium lobby;
left: gallery view*

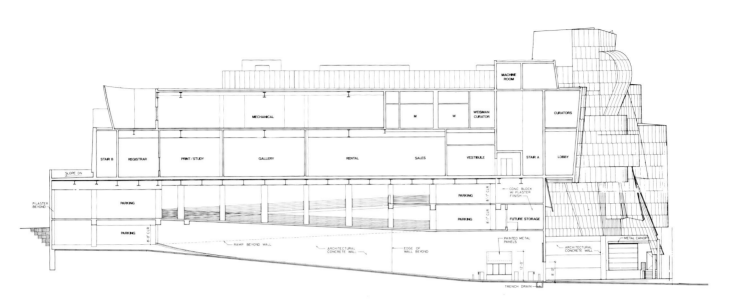

Labels visible in section drawing:

MACHINE ROOM

MECHANICAL M W WEISMAN CURATOR CURATORS

STAIR B REGISTRAR PRINT/STUDY GALLERY RENTAL SALES VESTIBULE STAIR A LOBBY

SLOPE DN

PILASTER BEYOND PARKING PARKING CONC. BLOCK W/ PLASTER FINISH

PARKING PARKING FUTURE STORAGE

RAMP BEYOND WALL ARCHITECTURAL CONCRETE WALL EDGE OF WALL BEYOND PAINTED METAL PANELS METAL CANOPY ARCHITECTURAL CONCRETE WALL

TRENCH DRAIN

Longitudinal section

North facade, entry canopy at right

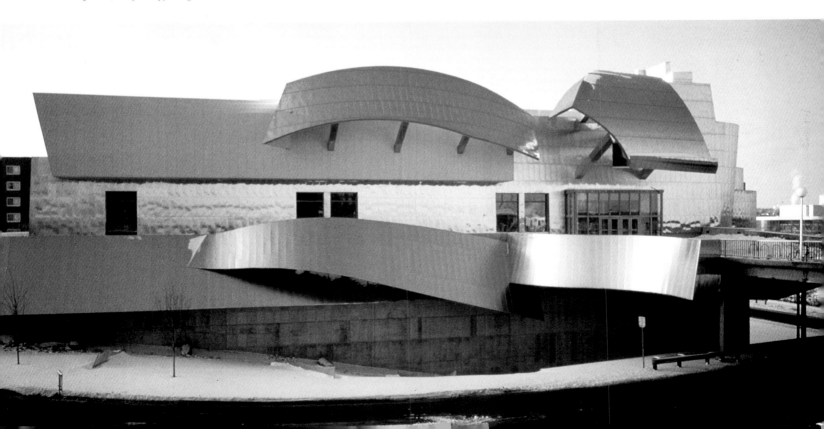

Kansai International Airport

The design for Kansai International Airport was selected in an international competition organized in 1988. The exceedingly complex project was, and perhaps only could have been, realized as a team effort; the lead architectural designers, Renzo Piano and Noriaki Okabe, collaborated with the engineer Peter Rice, of Ove Arup and Partners, and the architectural/engineering firm Nikken Sekkei, and they consulted with scores of other professionals including two facilities planners, Aeroport de Paris and Japan Airport Consultants. Situated on a manmade island in Osaka Bay, Kansai Airport was planned as Japan's second major gateway for international travelers, relieving congestion at Tokyo's Narita Airport and providing an alternate hub for national air routes. The facility can accommodate up to 160,000 arriving and departing jetliners per year.

The airport island represents a major achievement in technology and planning. Rather than selecting an outlying site in the suburbs of Osaka, large enough for passenger and freight terminals, a hotel, and related services, the airport authority undertook the construction of an eighteen-square-mile landfill island, linked by a causeway to Osaka's existing transportation infrastructure. The island is supported by over a million sixty-six-foot-long piles driven into the seabed. Jacks are installed under each of the terminal's columns, so that the building can be adjusted in response to the settling of the landfill, which is expected to sink up to ten feet from its level when construction began. The complexity and scale of the structure's engineering is suggested by the fact that the surveyors had to use gravity-based devices to determine floor levels rather than more sophisticated laser equipment, which could not account for the curvature of the earth over the structure's length of more than a mile.

Seen from the air, the airport's most distinctive feature is its undulating silvery skin of stainless-steel tiles. These cover about 108,000 square yards, including the surfaces of the main terminal building and its two tapered wings, each of which extends some 2,300 feet to accommodate forty-two arrival and departure gates. Treated to have a grayish luster, the tiles recall the metallic glazed *kawara* tiles of traditional Japanese construction. The overall relationship between roof and structure recalls the way Japanese temples are frequently dominated by the elaborate profiles of their complex roof forms.

On the "landside" of the building, there are three levels for public and private transportation running alongside a four-story atrium, which is just inside the main terminal. Elevators and escalators carry passengers through the atrium to and from arrivals and customs areas, on the lowest level, and domestic departures, concessions, and international departures on successively higher levels. As the atrium rises the full height of the building, all arriving and departing travelers pass through it, catching glimpses of the roof structure, whose wavelike form vaults over the upper level, as if to suggest movement toward the "airside" of the terminal. The roof rises to a "crest" sixty-six feet above the floor of the departure hall. The wavelike form

Opposite, above: lateral view into departure hall of main terminal building; below: view of roof profiles from "airside"

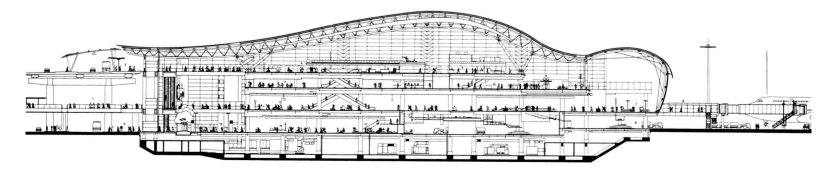

Above: section through main terminal building, from "landside" to "airside"

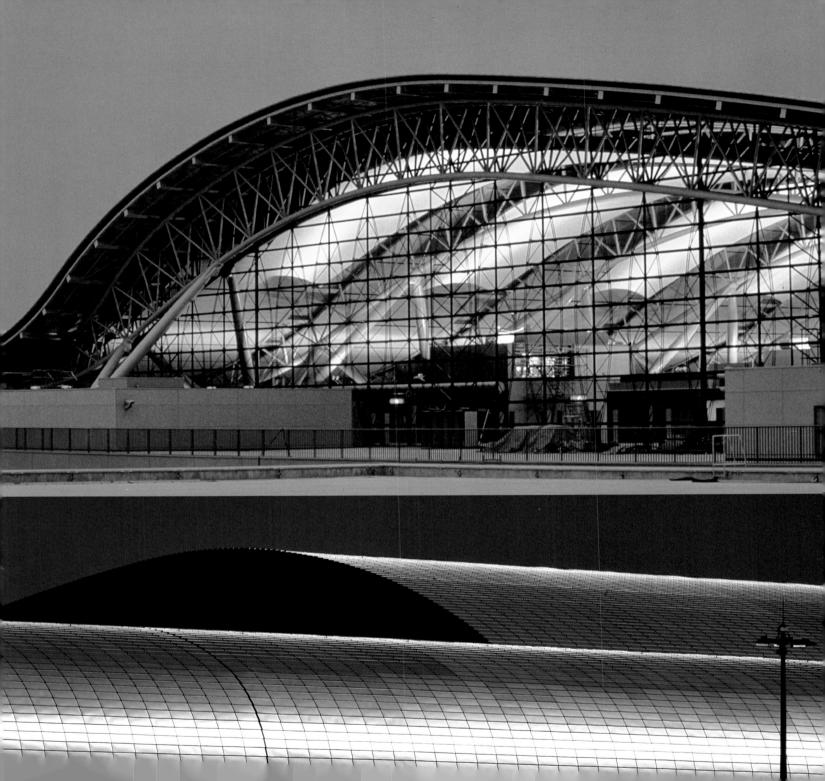

was derived from studies of the flow of air and is reflected in the shapes of the structure's twenty complexly articulated trusses, nearly five hundred feet long, the central portion of which span the entire international departures hall. Equally wavelike is the form of the teflon-coated membranes, suspended between the trusses, which guide heated or cooled air the length of the building without the use of enclosed air ducts. All the major elements of the structure, including the vertical trusses, which support the all-glass endwalls of the main building, are designed to successfully withstand the most severe effects of an earthquake.

To speak of the formidable technological aspects of the building alone would be to miss a good part of the significance of the accomplishment. The project represents Piano's remarkable skill at using technology

as an expressive and even metaphorical tool—a means to realize specific design goals rather than simply solve functional problems. Recalling the genesis of the design, Piano, an Italian architect based in Genoa, remarked that his first visit to the still-incomplete island suggested the metaphorical principal of "lightness," which would determine not only the technological approach to the work but the aesthetic and cultural implications as well: "This thought not only came about because we were floating in a boat, but also because it was clear to us that 'lightness' is what Japan is about. It's about temporality as well. . . . [I]t was clear that the building was going to be 1.7 kilometers long . . . immense. So we immediately thought about 'lightness,' and about breaking down the scale by the design of the fabric and texture." —T.R.

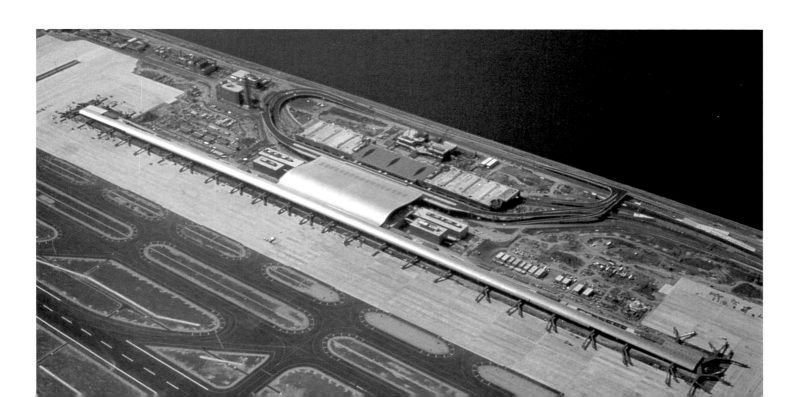

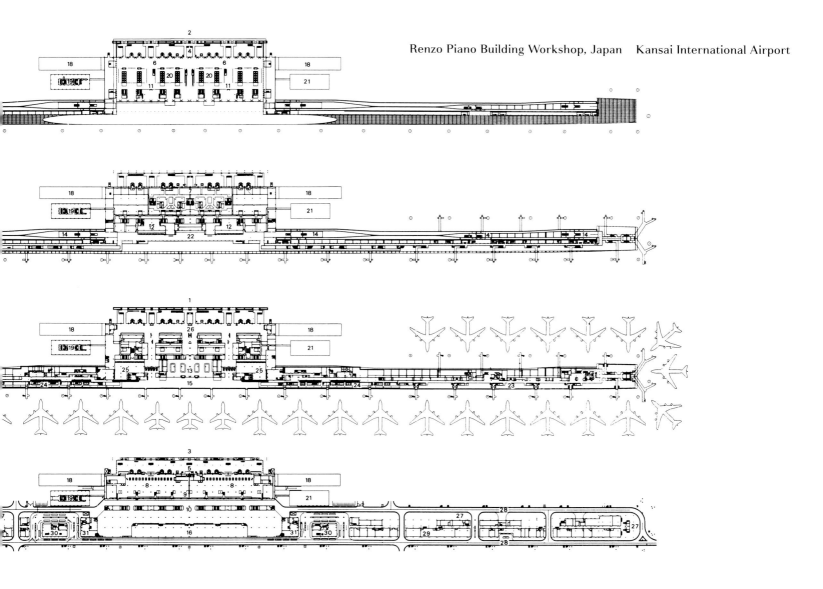

Renzo Piano Building Workshop, Japan Kansai International Airport

Above (top to bottom): fourth, third, second, and first floor plans

Key:
1. Concourse
2. Departure concourse
3. Arrival curbside
4. Canyon
5. Int. arrival lobby
6. Int. check-in lobby
7. Concession
8. Customs
9. Int. baggage claim
10. Int. baggage handling area
11. Security
12. Immigration
13. Dom. baggage claim
14. Wing shuttle station
15. Dom. gate lounge
16. Dom. baggage handling area
17. Passenger boarding bridge
18. Airlines admin. bldg.
19. CIQ admin. bldg.
20. Check-in island
21. Airport admin. bldg.
22. Transit lounge
23. Int. gate lounge
24. Swing gate lounge
25. Immigration
26. Dom. check-in lobby
27. GSE garage
28. GSE road area
29. Airlines offices
30. Int. business lounge
31. Dom. business lounge

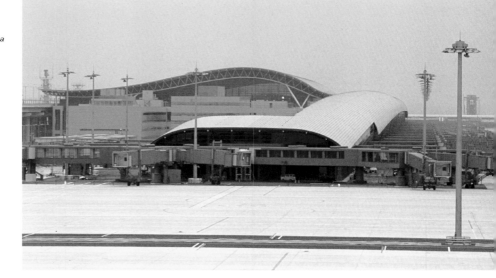

Lateral view from tarmac

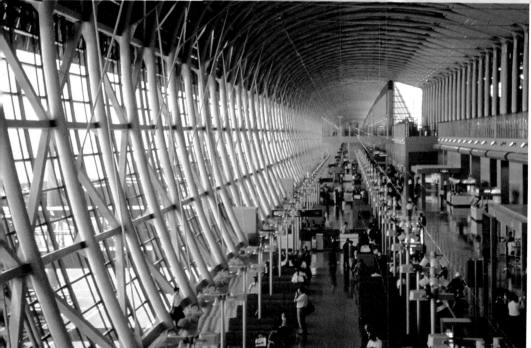

Top: transverse view through landside atrium; left: transverse view through departure/arrival wing; right: section through departure/arrival wing

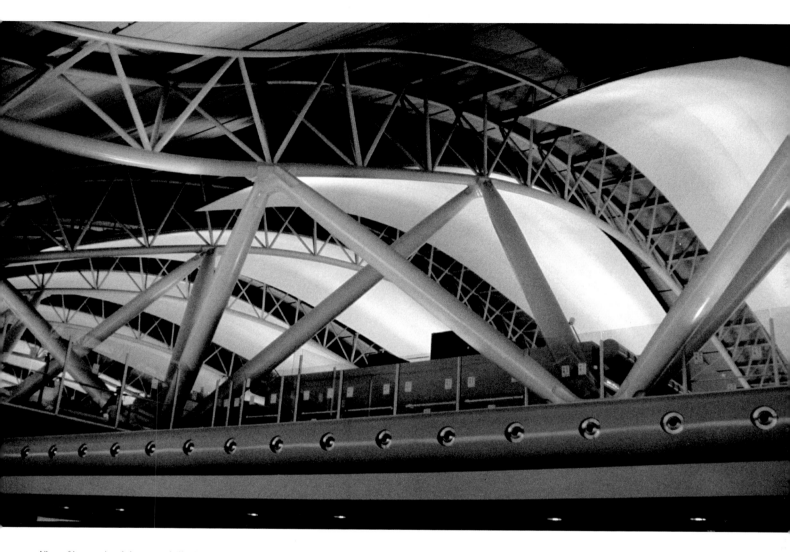

*View of international departure hall, showing
forced air channels between articulated trusses*

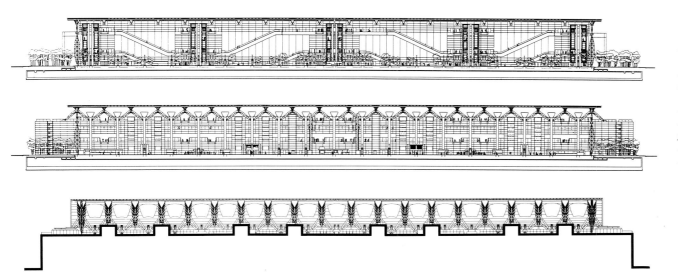

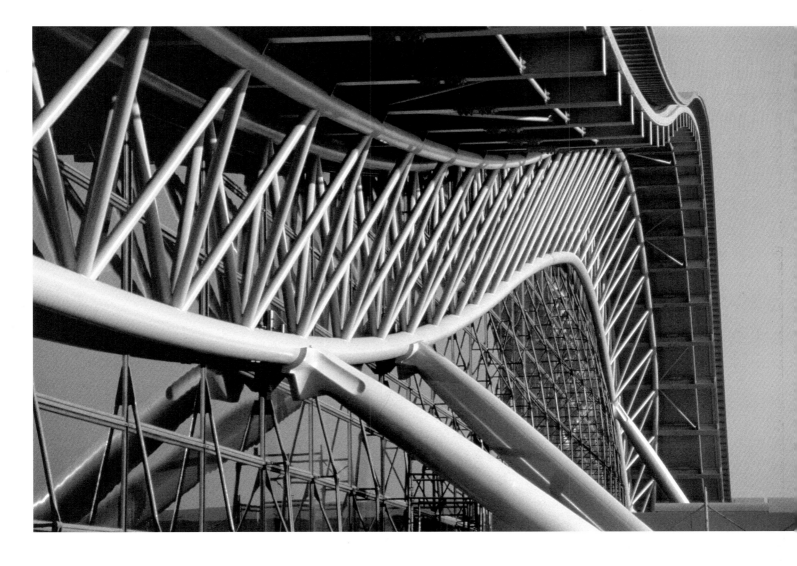

Shimosuwa Municipal Museum Shimosuwa, Japan, 1993

The Shimosuwa Municipal Museum was constructed in 1993 on the edge of Lake Suwa, a popular recreational site noted for its hot springs. Built for the centennial of the resort town's incorporation, from a design by Toyo Ito selected in a limited competition, the Museum houses permanent exhibitions of Shimosuwa's history and culture. The building arcs across the long, narrow site, reflecting the concentric edges of the park and motorway that ring the lake. From some vantage points, the form of the structure might recall the upturned hull of a boat or even a beached whale; the sculpted earth mounds surrounding the structure suggest roiling waters rather than terra firma. Ultimately, however, the museum's form is profoundly unfamiliar, pitched between ambiguity and precision. The building reflects the irregular shape of the site: at the front, on the lake side, a linear structure houses the principal exhibition spaces, on the upper level, and

offices, a small auditorium, and support functions on the ground level; behind, on the mountain side, a cubic volume contains double-height storage and gallery space. Connecting the two is a light-filled passageway, covered by a glass ceiling, looking onto a small, double-height court. Rising out of a shallow pool of water that recalls the lake's surface, the court brings light into the center of the structure and contains a freestanding, glass-enclosed elevator to the upper level.

The complexities of the museum's forms are many: the two arcing lines that define the plan of the linear structure are not concentric but converge toward its western end. The steel arches that span the width of the building at three-meter intervals are uniform but spring from different heights along the north (outer) wall of the linear structure, which tapers as it approaches both ends. In terms of Euclidean geometry, the museum's form is indefinably distorted, complex

beyond the capabilities of traditional drawing and building methods. The shape of each aluminum panel that sheathes the museum is necessarily unique, though computer modelling helped make the cost of the panels comparable to that of standardized ones. They form a permeable skin, which is only the outer layer of the series of membranes that comprise the roof system, which includes waterproofing, roof decking, and the wood slats that form the interior surface. Structural, electrical, and mechanical elements are woven into this roof system. Only a few inches thick, the roof seems like a tightly woven blanket draped over the museum's galleries. —*T.R.*

Above: site plan
Opposite: view of entrance

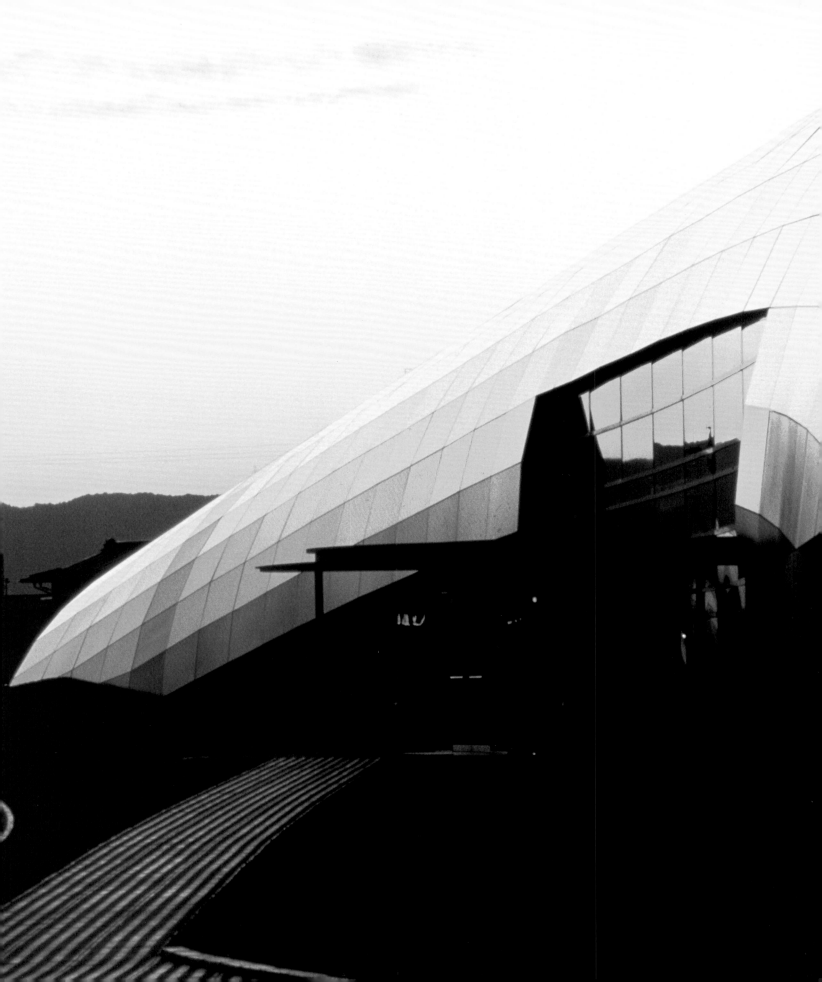

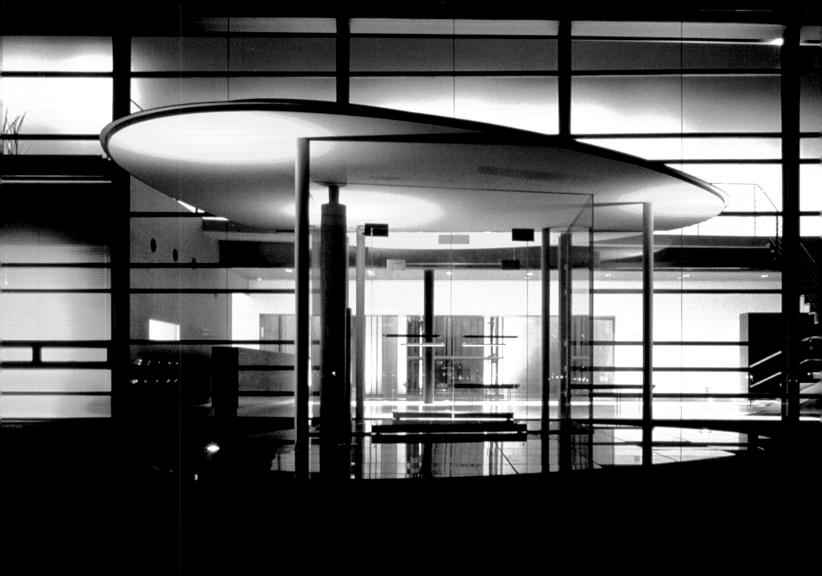

Transverse section

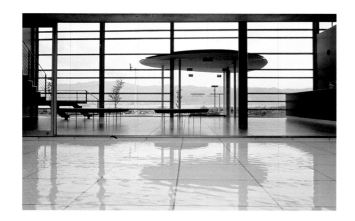

View from light court pool

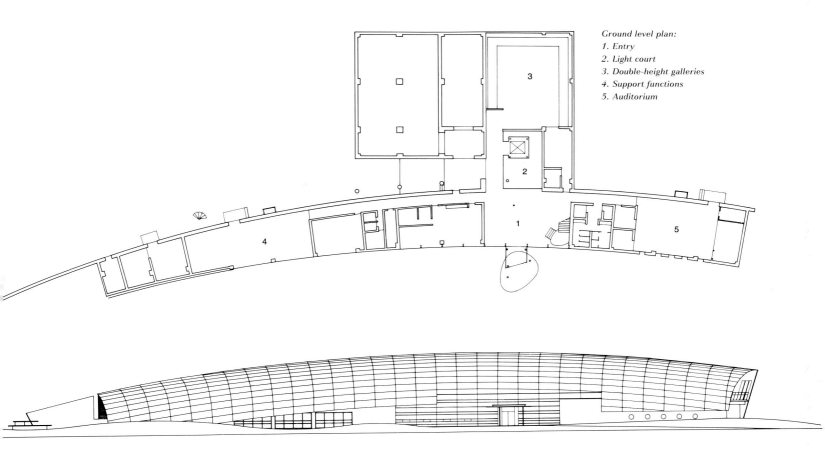

Ground level plan:
1. Entry
2. Light court
3. Double-height galleries
4. Support functions
5. Auditorium

South elevation

Principal galleries, upper level

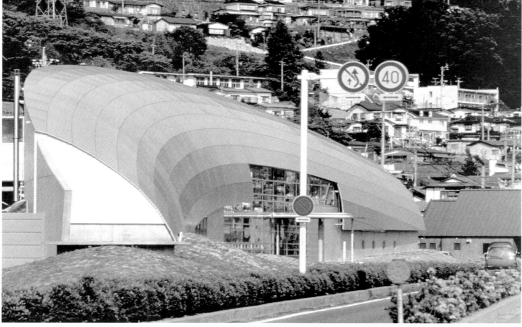

View from southwest

View from Lake Suwa

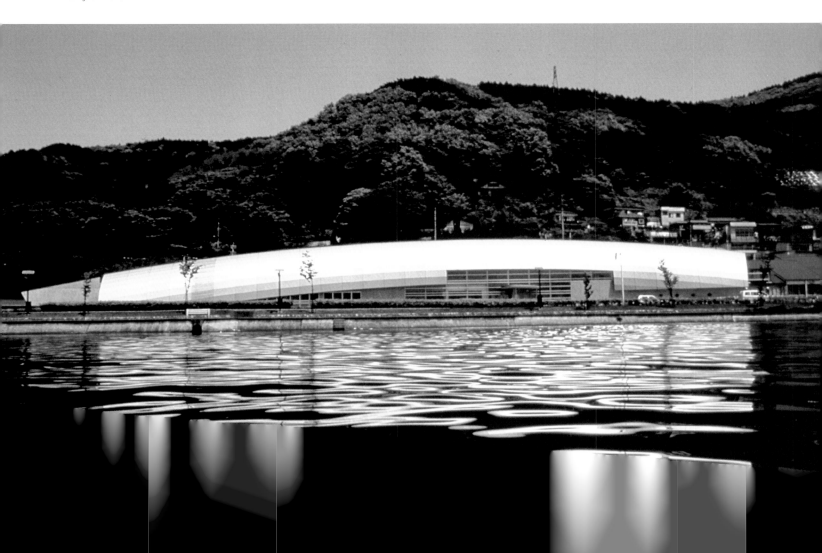

Joel Sanders **Kyle Residence** Houston, 1991 (project)

In this project for a house in a low-density Houston neighborhood, the New York–based architect Joel Sanders rethought the relationship between the archetypically modern glass house and the culture of the contemporary American suburb. The composite drawing opposite, showing multiple views from the main living room, recalls Mies van der Rohe's Resor House collages in which the structure frames distant views. In the Kyle Residence, the constraints of the suburban setting become a self-referenced horizon: the grass-covered roof of the lower-level master bedroom tilts up to obscure neighboring houses. Similarly, views to the south from the main living area are blocked by a reflective covering that shields a lap pool running along the edge of the site. In effect, the universal horizon of Mies is replaced by a localized one: the blue sky and green lawns of suburbia.

The house, whose floor plan reflects the property lines, is entered from a driveway to the north. A wedge-shaped "appliance wall" containing the functional spaces and mechanical elements of the house cuts diagonally across the Miesian volume, demarcating the public and private areas of the house. On the more public street side, a stairway rises from the entryway to a study on the upper level. Shielded from the street by the appliance wall are the more private living areas. This wall makes further reference to Mies's residential projects: it is a more linear and expressive version of the cluster of functional elements that Mies would typically place as a blind mass in the center of a house, leaving the glass-enclosed perimeter free of the more mundane aspects of residential life. Sanders's project displays those mundane functions more explicitly, and he includes banks of video monitors, which he regards as an "infiltration of the necessary equipment of modern life."

The ubiquitous presence of video monitors in the house suggests not only the necessities of modern life but its ironies, among them a competition between the pastoral ideal and the mediated reality of the American suburb. Sanders's intentions are even more explicitly evident in the placement of a pivoting screen in the courtyard between the lap pool and the lower level. Visible from various locations within the house, the screen with its projected images mingles with the artificial "horizons" to further confuse the distinction between actual and projected views. —*T.R.*

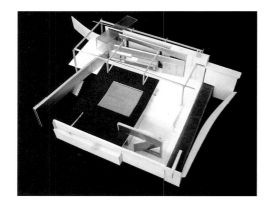

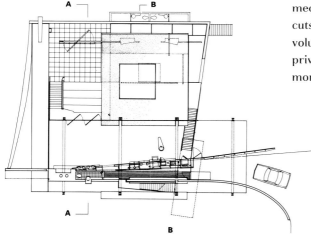

A B

A

B

Top: model; above: plan; below: section B—B

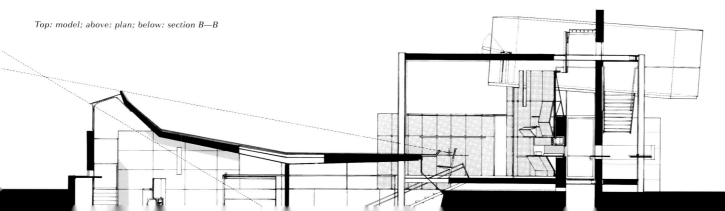

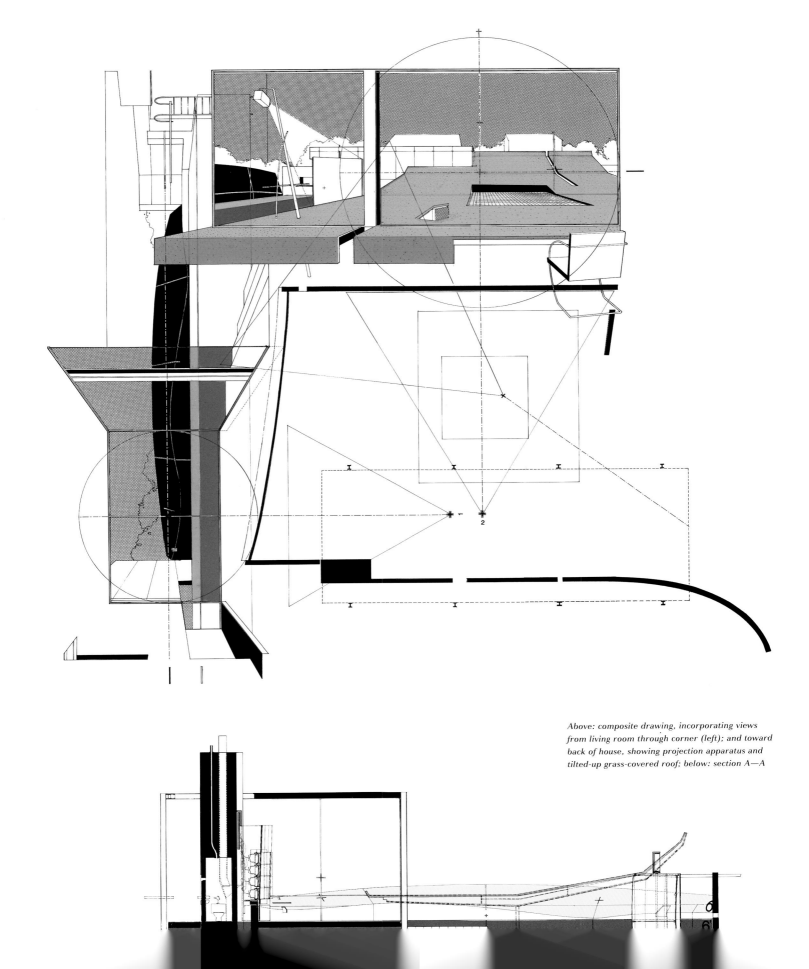

*Above: composite drawing, incorporating views
from living room through corner (left); and toward
back of house, showing projection apparatus and
tilted-up grass-covered roof; below: section A—A*

Gigon and Guyer **Kirchner Museum Davos** Davos, Switzerland, 1992

The first project built by the Swiss architectural team of Annette Gigon and Mike Guyer, the Kirchner Museum Davos is situated in the town of Davos, where Ernst Ludwig Kirchner settled in 1918 and lived until his suicide in 1938. Over four hundred of his paintings, drawings, and prints are contained in the two-story structure, which is set against a backdrop of tree-covered alpine peaks. It was constructed on a narrow site, on the edge of a sloping park. The lower level, exposed to the southeast as the site declines, contains the library, a book shop, and support functions. The main level, accessed by a slightly ascending ramp from the park's upper edge, consists of four prismatic galleries connected by a flowing circulation space.

The galleries are discreet concrete volumes with minimally detailed oak floors and plaster walls. A matte-glass ceiling hovers over each one, concealing and diffusing not only artificial light, but daylight as well, which enters a plenum, or airspace, above. In a climate where heavy snowfall makes skylights impractical, side-lighting from all four directions brings considerable natural light into the galleries. Seen from without, the building's volumetric components are easily distinguished: the "lanterns" above the galleries; the circulation spaces behind clear glass; and the galleries themselves, sheathed in frosted glass, which is used as a finishing surface to obscure insulating material.

The simply modulated prismatic forms of the Kirchner Museum might seem a rhetorical allusion to the starkly functional Neue Sachlichkeit architecture of the 1920s. Yet to be fully understood, the building should be viewed within a more specific cultural context, which the site suggests. In terms of organization, the structure's division into undercroft and main level, with an insulating air space above, is not unusual in alpine construction. Surfacing the roof with crushed glass, a "respondent gravel" in the architects' words, instead of crushed stone recalls Bruno Taut's association of crystalline architectural form with geologic formations, like the mountains that surround the site. The museum's flat roofs also have a historical dimension. In many quarters still an emblem of the architectural avant-garde, flat roofs were early and fervently embraced in Davos, to the extent that the town banned traditional peaked roofs from its central district. As if to prefigure the museum which would elegantly and self-confidently display his works, Kirchner wrote to a friend in 1931, "At present I am painting the flat roofs of Davos. The new buildings give the city an altogether different appearance and make the mountains high."* —T.R.

*Quoted in Wolfgang Henze, ed., *Kirchner Museum in Davos: Katalog der Sammlung*, vol.1 (Davos, Switzerland: Kirchner Verein Davos, 1992), 334.

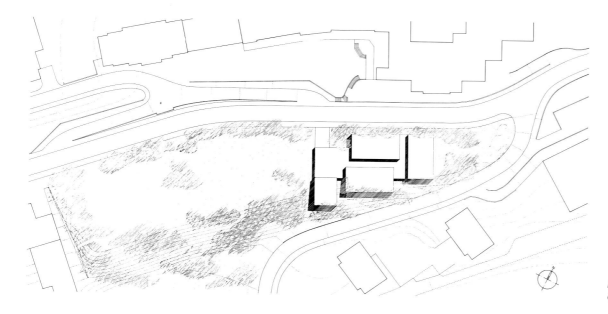

Left: site plan.
Opposite: view from east

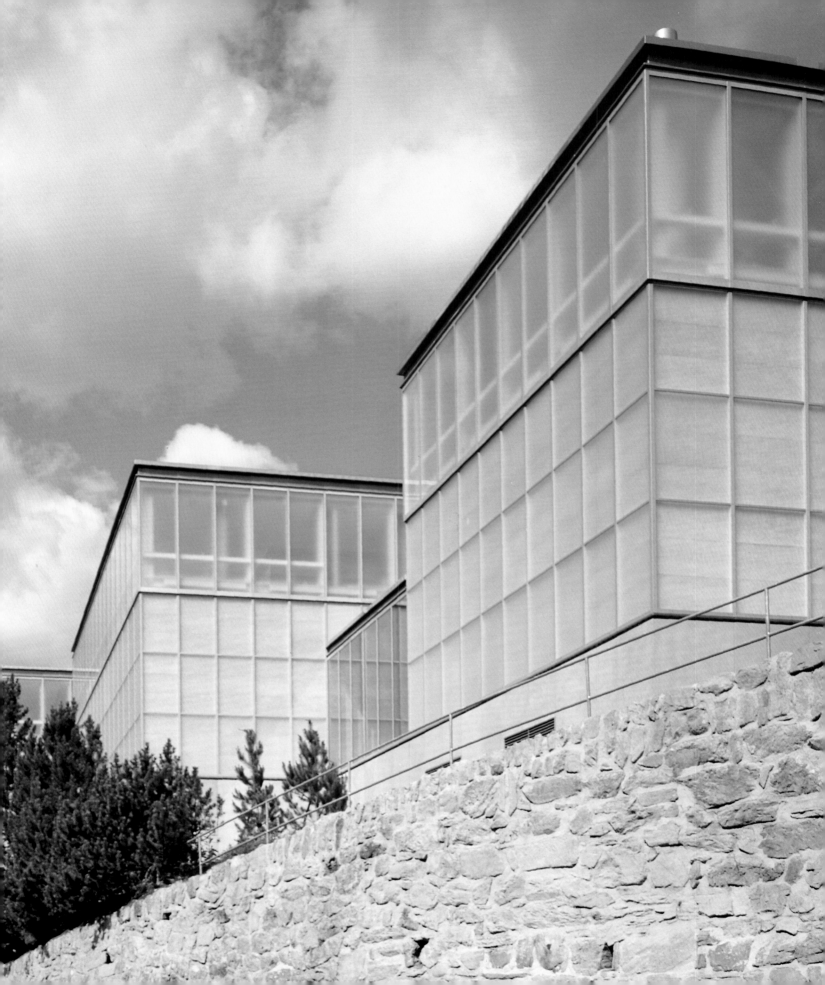

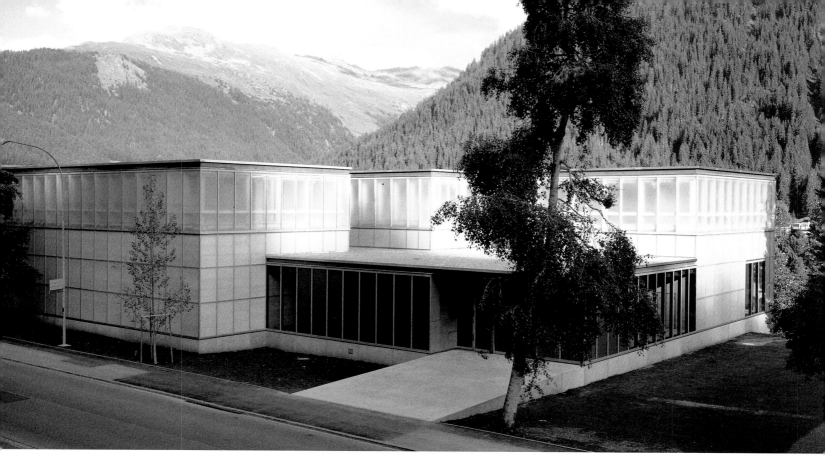

General view of street side, with entrance

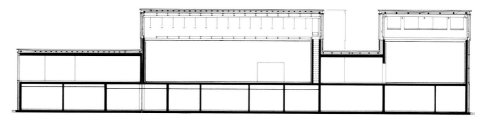

Transverse section through principal galleries, with lanterns above, support functions below

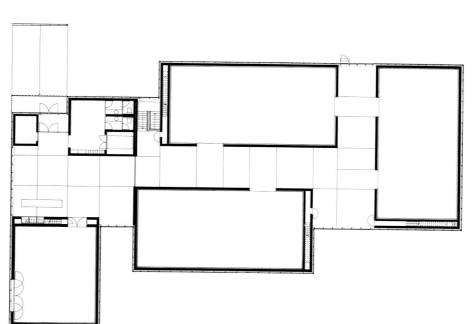

Ground level plan

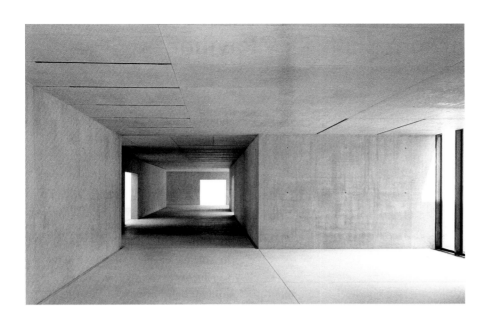

Above: circulation space; below: general gallery view

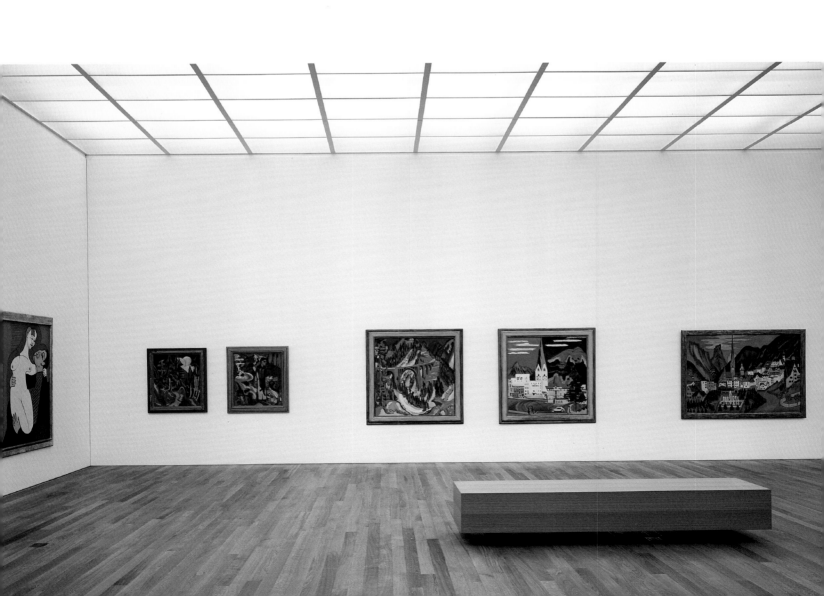

Williams and Tsien # Phoenix Art Museum Sculpture Pavilion Phoenix, Arizona, 1990

Slated for construction next year in the courtyard of the Phoenix Art Museum, this eighty-foot-tall open-air pavilion, designed in 1990 by Tod Williams and Billie Tsien of New York City, will be a shaded, cool place to view the museum's collection of sculpture. The shell-like structure rests upon a cast-in-place concrete ring, seventy-five feet in diameter, supported in three places so that it hovers seven feet above the ground. As the architects point out, the integral form of the domed pavilion recalls that of the Pantheon in Rome. Alluding fur-ther to its circular plan and the thermal effect of its form—hot air will rise and escape out of the eighteen-foot-diameter oculus like smoke from a chimney—the architects also compare the structure to the ceremonial kiva of Native Americans in the Southwest. This thermal effect will be enhanced by a fine mist of cool water emitted by dozens of stainless steel atomizing nozzles located about twenty feet above ground level. The heat exchange that takes place as the water evaporates in the dry desert climate will create a cushion of air, cooled by ten to twenty degrees without using a mechanical system, in the lower part of the pavilion.

Perhaps the most distinctive element of the design is the shell-like dome, rising above the surrounding structures of the Phoenix Art Museum. Made of fiberglass resin, the surface of the structure will be translucent, evoking the changing ambient light of the desert while filtering its harsher effects. Early schemes for the pavilion included a steel frame structure to support the panels, but the architects' research indicated that the panels, bolted together with stainless steel fasteners, could be self-supporting, like the monocoque design of an airplane fuselage. With no intermediate structural members, the voluminous envelope of space will appear both light and light-filled. —T.R.

Top left: section; bottom left: plan; right: site view

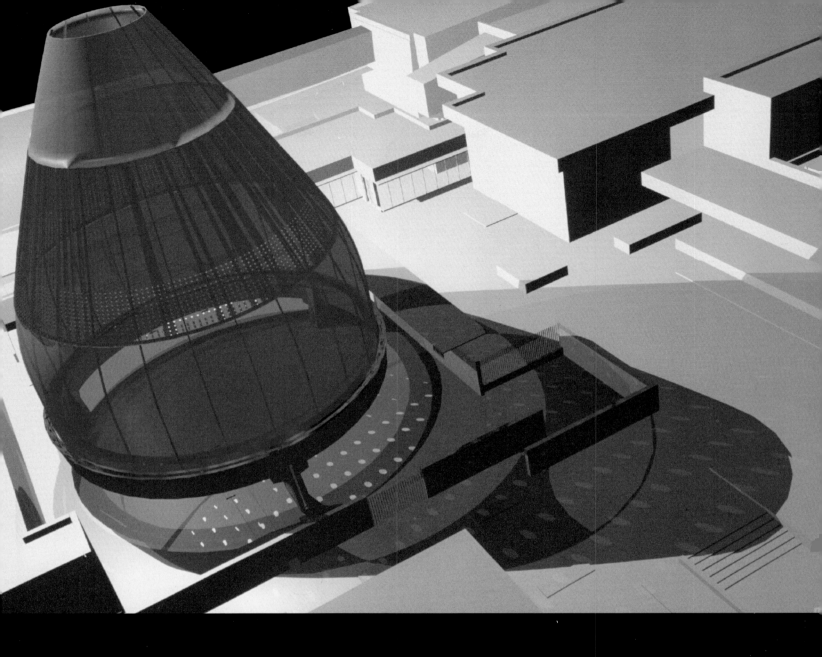

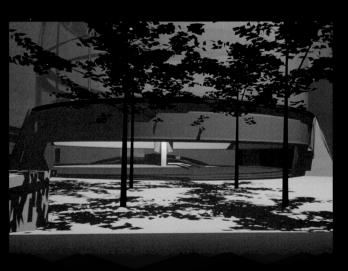

Far left: view from courtyard; left: interior view

Toyo Ito **Tower of the Winds** Yokohama, 1986 (dismantled 1995)

Plan

Section

The Tower of the Winds was located in the square in front of Yokohoma's central train station. It was built in 1986 to a winning competition design submitted by the Tokyo-based architect Toyo Ito and it was taken down this year. The seventy-foot tower was constructed around a preexisting concrete structure, which functions as a water tank and ventilation stack for the shopping concourse below the square. The existing structure was covered with mirror-finish acrylic panels, and then a steel frame, elliptical in plan, was built around it and sheathed in perforated aluminum panels, which were semitransparent during the day.

After sundown the tower underwent a metamorphosis, dematerializing and becoming an expression of what the architect calls the "phenomenal city of lights, sounds and images [that is] superimposed on the tangible urban space of buildings and civil engineering." Behind the perforated surface were 1,280 small lamps, twenty-four floodlights, and twelve neon rings. Controlled by a computer program, the lights were synchronized to provide "environmental music": the neon was activated to mark the passing of an hour, the flood lights responded to changes in wind velocity and direction, and the small lights were stimulated by noise. Ito's poetic, ephemeral architecture used transient artificial light to evoke the same themes that motivate his more substantial work—delicately defined volumes, lustrous surfaces, and a formidable sensitivity to the specific, and often subtle, qualities of a site. —*T.R.*

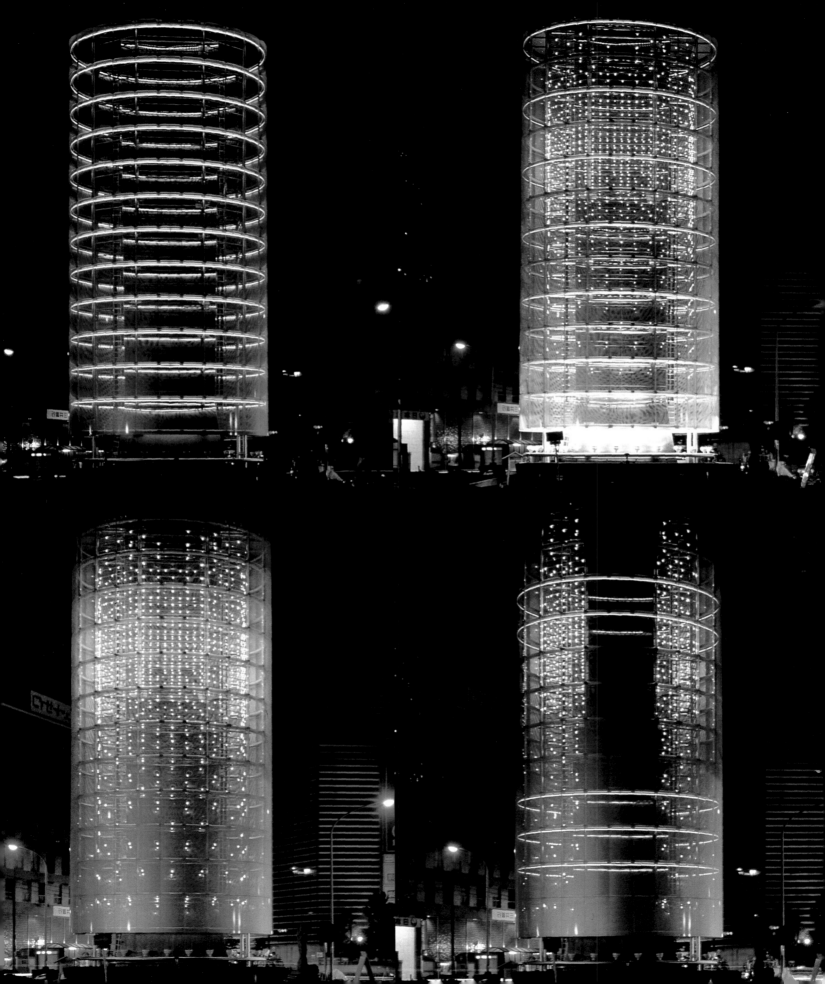

Dennis Adams **Bus Shelter IV** Münster, Germany, 1987 (installation)

Bus Shelter IV, one of a series of Bus Shelter projects Dennis Adams began in 1983, was realized as part of *Skulptur Projekte in Münster*, an international exhibition of temporary outdoor sculpture projects. This public art work transforms the most mundane of architectural spaces into a political realm. The structure is modeled on a generic bus shelter, but the geometry is skewed. The partially rotated plan and the acute angularity of the double-sided structure subtly counter expectations of municipal street furniture. Instead of maps or advertisements, the panels of the shelter hold two-way mirrors and back-lit images of ambiguous intent.

The images are enlargements of a photograph taken during the trial of the Nazi Klaus Barbie, nicknamed the "Butcher of Lyons," which was under way in that city at the time of the exhibition. Several versions of the photograph are displayed. Facing outward from the bus shelter in each of the two light boxes is a version of the picture that shows Barbie in a glass-enclosed (presumably bulletproof) defendant's box above and behind his lawyer, Jacques Vergès. The photograph is cropped so as to confuse and flatten spatial relationships, and the space it describes is echoed by the space of the bus shelter, which is defined by angled, shatterproof panes of glass. One of these two otherwise identical images is further cropped at the roof line of the bus shelter, cutting through Barbie's head. On the opposite sides of the light boxes, visible through and reflected by the two-way mirrors, is a drastically enlarged detail of the trial picture, an image of an unidentified man standing in the background.

Adams shifts emphasis from the perpetrator, Barbie, to his associates, by hire or by chance, the advocate and the bystander. An indeterminate link is established, which culminates with the blown-up and multiply reflected image of the unidentified man. This heretofore incidental, inconsequential figure in the background is mirrored by bus riders who happen to be waiting in the structure, raising such issues as accountability and the erratic course of justice, and the implication of collective guilt. —A.D.

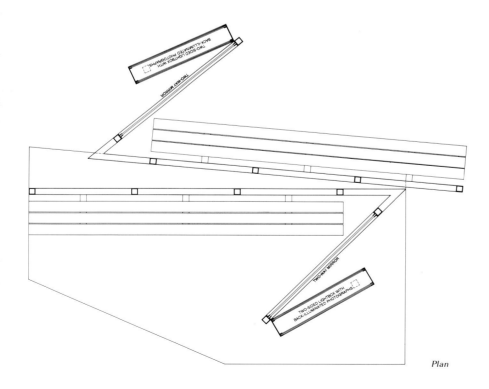

Plan

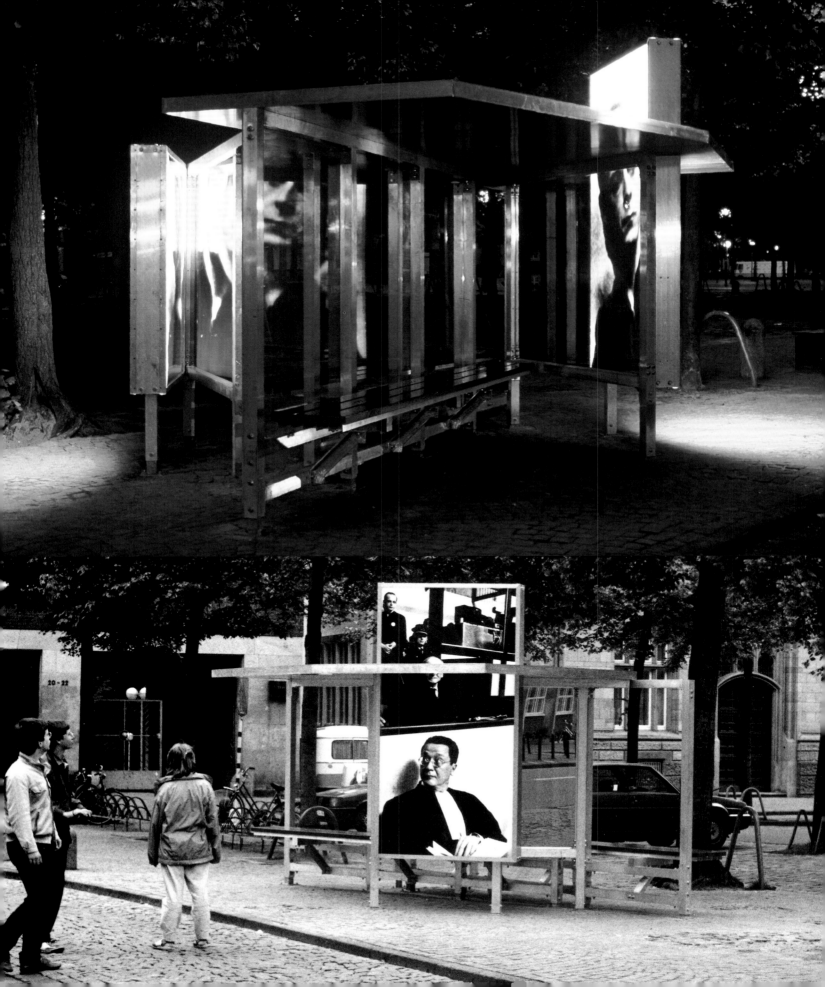

In 1991 Melissa Gould's *Floor Plan* was installed for four days in a park on the bank of the Danube River in Linz, Austria. Meant to be viewed after sundown, it rendered in light and at full scale the floor plan of the Neue Gotteshaus, a nineteenth-century Reform synagogue that was situated in the Johanisstrasse in Berlin. It was damaged during Kristallnacht, the night in November 1938 when Jews were attacked and their property vandalized by German mobs, and it was destroyed by bombing during World War II. The building's outline, created by 110 fluorescent light tubes placed in shallow trenches, suggested, in the words of the New York–based artist,

"the dynamics of real space and, at the same time…a phantom building, at once present and absent, real and surreal."

An audio installation by Alvin Curran, "Notes from the Underground," was deployed around the periphery of the illuminated plan, creating "sonic walls" to reinforce the presence of the phantom temple. Presented as part of this conceptual Holocaust memorial, the audio installation consisted of "dense clouds of taped sounds representing multitudes of voices" emitted from sixty-four hidden speakers.

Working with light, which the artist frequently does, had special sig-

nificance for this project. She intended it to recall Kristallnacht and the flames which engulfed entire populations of European Jews during the war, as well as the *ne'er tamid*, the eternal light that burns in all synagogues. Finally, she intended the work to have a more universal significance as, in her words, "a strong metaphor for life itself." The memorial is as dependent on darkness, both literally and figuratively, as on light: the one heightens the other. In the resulting "dramatic contrast between the blinding brightness and surrounding pitch of darkness, spectators appeared to wander in the disorienting field of light as if in a dream." —*T.R.*

Plan, Neue Gotteshaus, Berlin, designed by Gustav Stier (1854, destroyed)

Helsinki Museum of Contemporary Art

Steven Holl's design for a Museum of Contemporary Art in Helsinki was selected in a 1993 competition. Slated to be built in 1996, the museum is located on a triangular site that is both pivotal and expansive: with the national Parliament to the west, Alvar Aalto's Finlandia Hall to the north, and Eliel Saarinen's Helsinki Station to the east, it opens toward Töölo Bay. The New York–based architect's proposal calls for the construction of a canal extending the waters of the bay, the dominant feature of Helsinki's landscape, past Finlandia Hall to the museum. It would be channeled through the structure alongside a public passageway to a reflecting pool on the west side. The pool also serves to reflect and enhance the low levels of light in the far northern latitude. Borrowing a detail from Saarinen, Holl designed the western pool so that it may be allowed to freeze, rather than being drained, in the winter, precisely when glints of light from the sun, low in the sky, would be most comforting.

While the introduction of such water elements is not unusual, the architect's intention is notable: he means to intertwine the urban and natural landscapes. In selecting an anonymous code name for his competition submission, as all four of the invited architects were required to do, Holl used Chiasma, borrowing a term with various applications in modern Latin and English adapted from same word in Greek, which means an arrangement of two lines crossed like the letter X (*chi*). Holl means this to refer not only to the intertwining of the urban and natural landscape but the forms and spaces of the building itself: of the building's two principal linear volumes, the larger volume to the east folds over a smaller block of sky-lit permanent collection galleries like one finger crossing another. The larger volume contains the museum's principal temporary exhibition galleries.

The zinc-plated eastern facade has a complex surface, curving inward in plan and folding over to become the structure's roof, which is supported by a series of unequal arched trusses. The curvature of the roof/facade allows for skylighting not only in the upper story but the level below as well. Instead of a traditional axial arrangement of galleries, the museum will have a flowing sequence of column-free spaces, mainly orthogonal but inflected by the curving surfaces of the roof/facade. Looking from the west, one will see a wall of glass, cast in planks and frosted to diffuse light, which reaches from ground level to the apex of the curving roof and, following the curved lines of the building, becomes a clerestory, allowing western light into the upper level. Public entry is from the south, between the two "fingers." Ticketing and information, a bookshop, and a cafeteria all cluster around an atrium whose ramp and stairs connect the levels of the museum. The skylit atrium is also, in the words of the architect, a "light-catching section," bringing natural light into the lower levels of the building. —T.R.

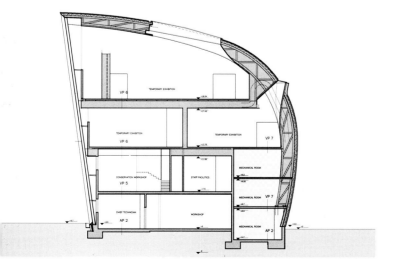

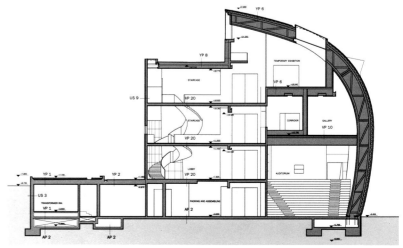

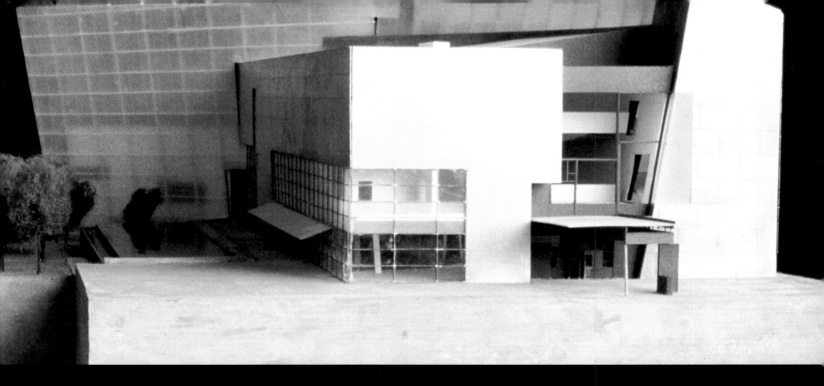

View from south toward entry

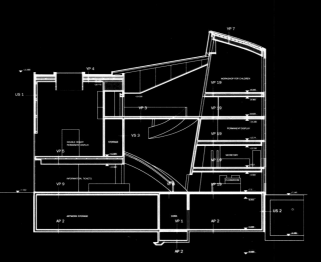

*Left to right: section through
temporary exhibition galleries;
section through auditorium;
section through atrium*

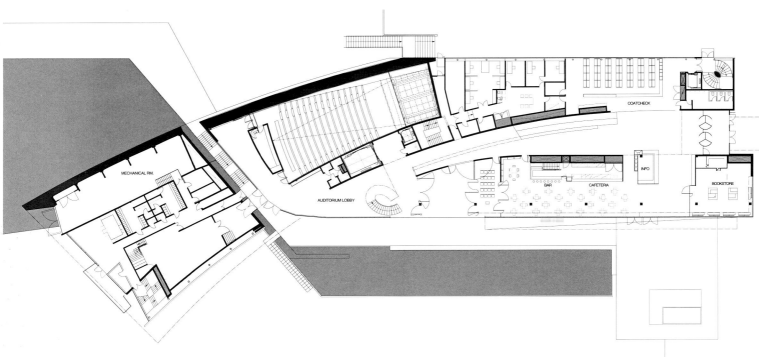

*Ground-level plan, entry at right;
dark areas left and center represent reflecting pools*

140

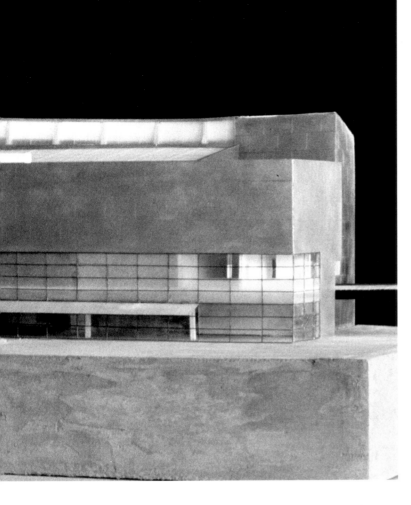

View from west

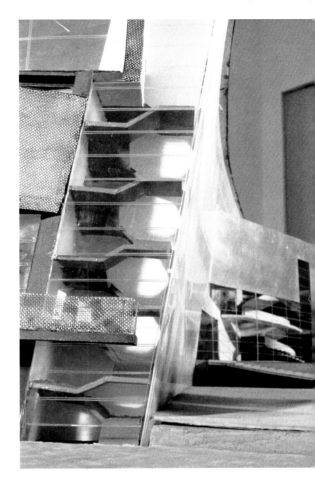

North stair detail

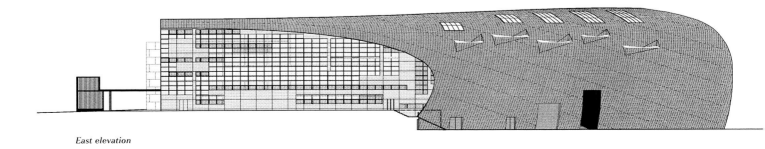

East elevation

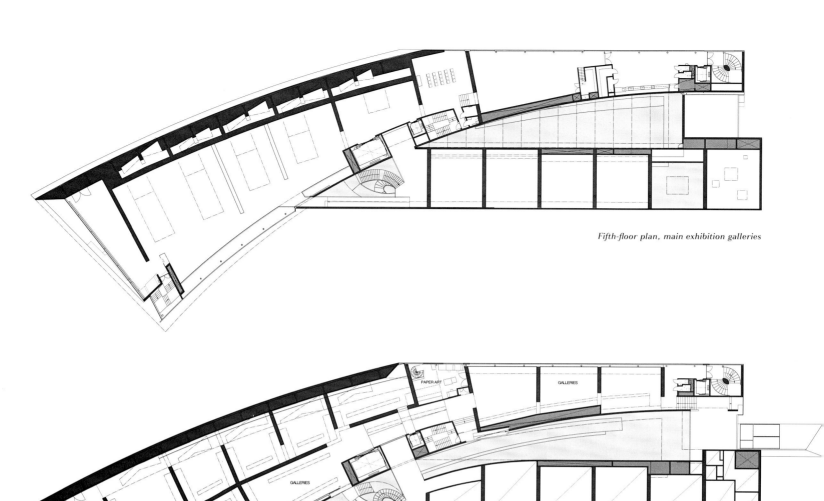

Fifth-floor plan, main exhibition galleries

Third-floor plan, main exhibition galleries

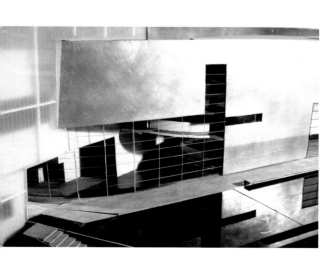

Detail, west facade

142

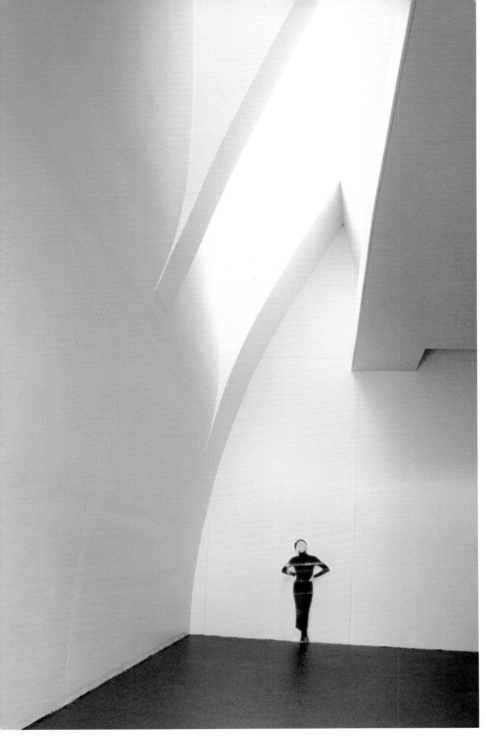

Above and right: views of model: light studies

Business Promotion Center Duisburg, Germany, 1993

The new headquarters of the city of Duisburg's Department of Business Promotion is intended to be a flagship for the planned revitalization of Germany's Ruhr region. Designed to encourage the use of advanced energy systems, it was one of the first structures to be realized as part of Foster and Partners' master plan for Microelectronic Park, a commercial development located in the city's center. It is conceived as a workplace geared for directing future development of high-technology industries. The construction of Foster's transparent, pristinely detailed seven-story Business Promotion Center, marquise-shaped in plan, with a sloped and curved roof plane, announces the region's transition from the long-dominant coal and steel industries to the clean technology of microelectronics.

The concrete and steel structure's glass cladding is suspended from a ring beam at the edge of the roof and is attached to the floor slabs by movable joints. Within the layers of glazing are vertical dividers that create air cavities, which act as chimneys, drawing warm air from the building in summer and insulating it in winter. Within the cavities, computer-controlled blinds can block direct sunlight from the inner insulated double layer of glass to prevent the interior from being heated.

Instead of air, the heating and cooling system uses water, which has a higher thermal capacity, more efficiently conveying heat and cold. Solar panels, supplemented by a conventional gas generator, heat water, which is piped into an absorption cooler. The absorption process utilizes the cooling effect of evaporation to produce cold water, which is then circulated through a configuration of pipes concealed in the dropped ceilings. The chilled air cools the room below and is led through narrow ducts to the floor of the room above. In winter, a gas-fired electricity generator heats water for the building as well. Photovoltaic solar cells on the roof, separate from the panels used to heat water, also provide electricity. These systems not only reduce energy usage but increase comfort. Radiant water heating and cooling helps to eliminate drafts and the noise of conventional air conditioning systems. Occupants are able to modify their immediate areas: the temperature and window blinds in each room can be adjusted by manual controls, which override the computer settings, and windows in the internal glazing layer can be opened to increase air circulation.

Foster often exploits technology—particularly structural engineering—for its formal expressiveness, for example in the bracing of the Hong Kong and Shanghai Bank. The technology incorporated into the design of the Business Promotion Center is slower to reveal itself, just as the full range of its external appearance can only be seen over time in different light conditions. When viewed at night with the louvers fully open, the glass curtain wall reads as a minimal material. In bright daylight, the slickly encased shutters cause the facade to be reflective and opaque. Foster's is a refined, systemic, and transmutative modernism, as if the ante of what is modern had been raised. —A.D.

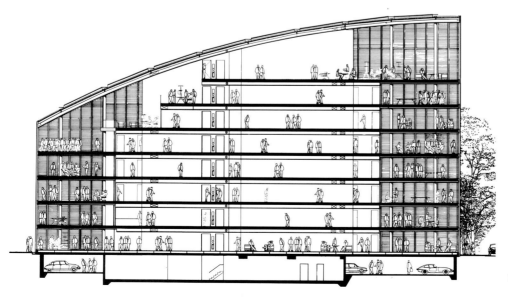

Longitudinal section

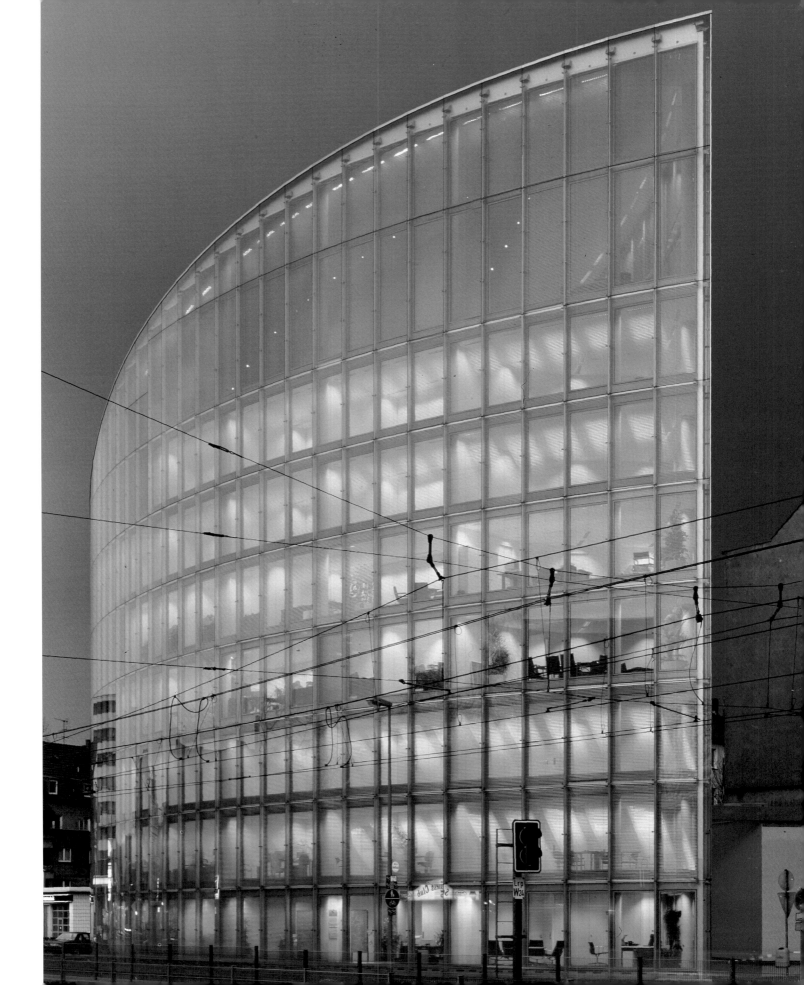

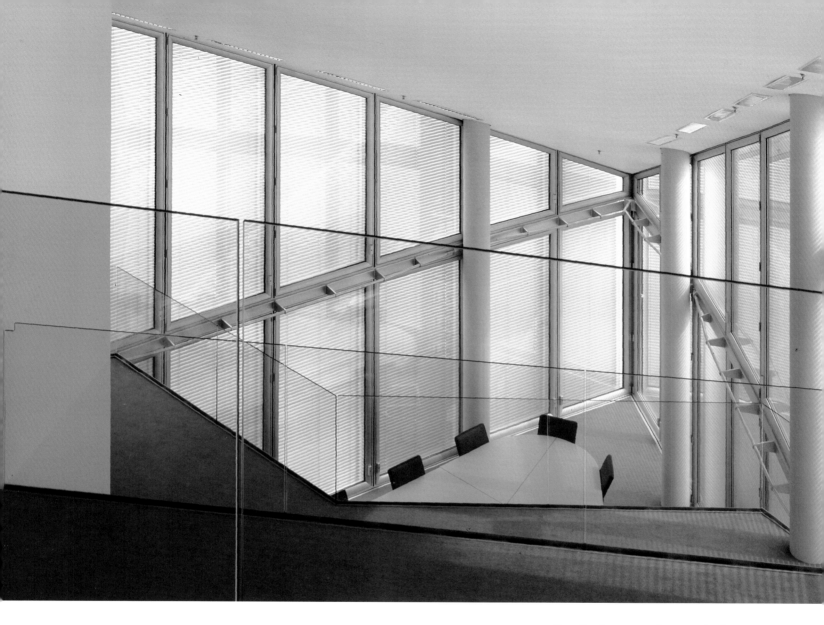

View of conference room from upper level

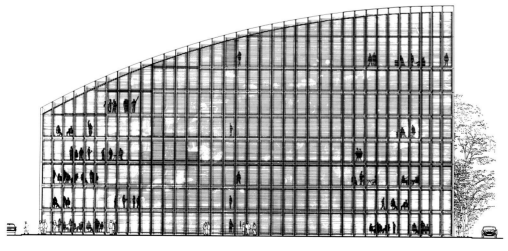

North elevation

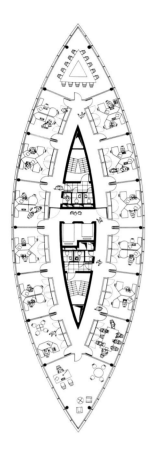

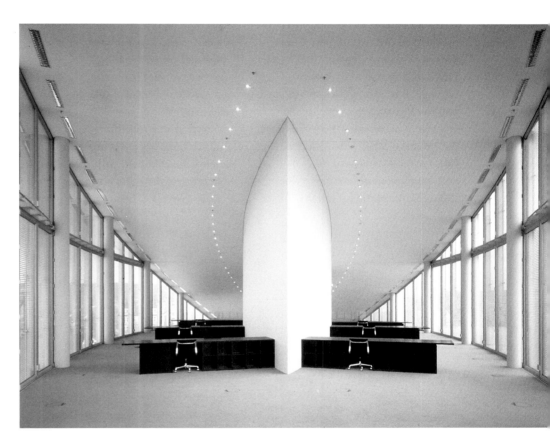

Upper level office area

Above: west elevation; top: typical office level plan

Museum of Modern Art Museumsquartier Vienna, 1990 (competition proposal)

The Museum of Modern Art by Austrian architects Manfred and Laurids Ortner is part of a large (53,000 yd²) contemporary art and cultural complex to be built in Vienna adjacent to the twin Imperial museums of art history and natural history (1872–82) designed by Gottfried Semper. Intended to link the modern and the historic, the new Museum Quarter incorporates the buildings of the Imperial Stables designed by Bernhard Fischer von Erlach in 1720 and the nineteenth-century Winter Riding Hall, refitting them for use as galleries and as a central foyer.

In addition to the Museum of Modern Art, new buildings will include a Kunsthalle for temporary exhibitions; a performance hall for music, dance, and theater; and an information and reading tower to serve as a resource center for printed and electronic media related to art and culture. The overall layout of the quarter is derived from a convergence of the transverse axis of central Vienna's radial plan with the network of residential streets on the other side of the quarter. The architects have described the site plan as "the result of the pattern of the monarchic monumental order intersecting with a democratic one."

The Austrian Republic's collections of twentieth-century art, which are currently scattered among several facilities, will be housed in the new Museum of Modern Art, which will also contain galleries for temporary exhibitions. The interior spaces and functions of the museum, conceived as distinct blocks, include a daylit pavilion, a domed cube containing artificially lit galleries, and slab-shaped volumes for audiovisual media, staircases, and offices. These units will be consolidated beneath a round-edged cubic glass-and-steel skin. The facade shell fits into a well at the perimeter of the building, continuing seamlessly below grade level. The transparency of the structure, revealing the conglomerate interior organization, contrasts with the opaqueness of the Imperial era's monumental buildings. Rising from behind the low facade of the Baroque stables, the new buildings of the Museum Quarter will seem like a futuristic model city, recalling one of the aphorisms written by Paul Scheerbart as inscriptions for Bruno Taut's Glass Pavilion of 1914: "Glass opens up a new age." —A.D.

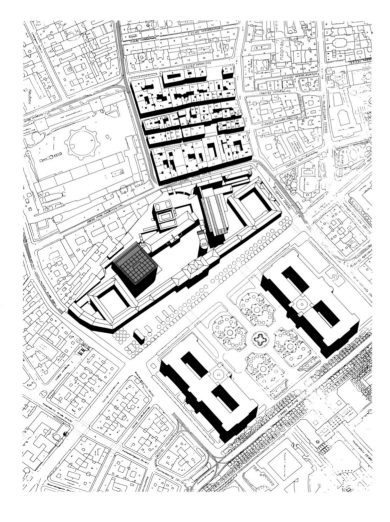

Left: site plan (north is to the right)
Opposite: view of model of Museum of Modern Art with Imperial Stables in foreground

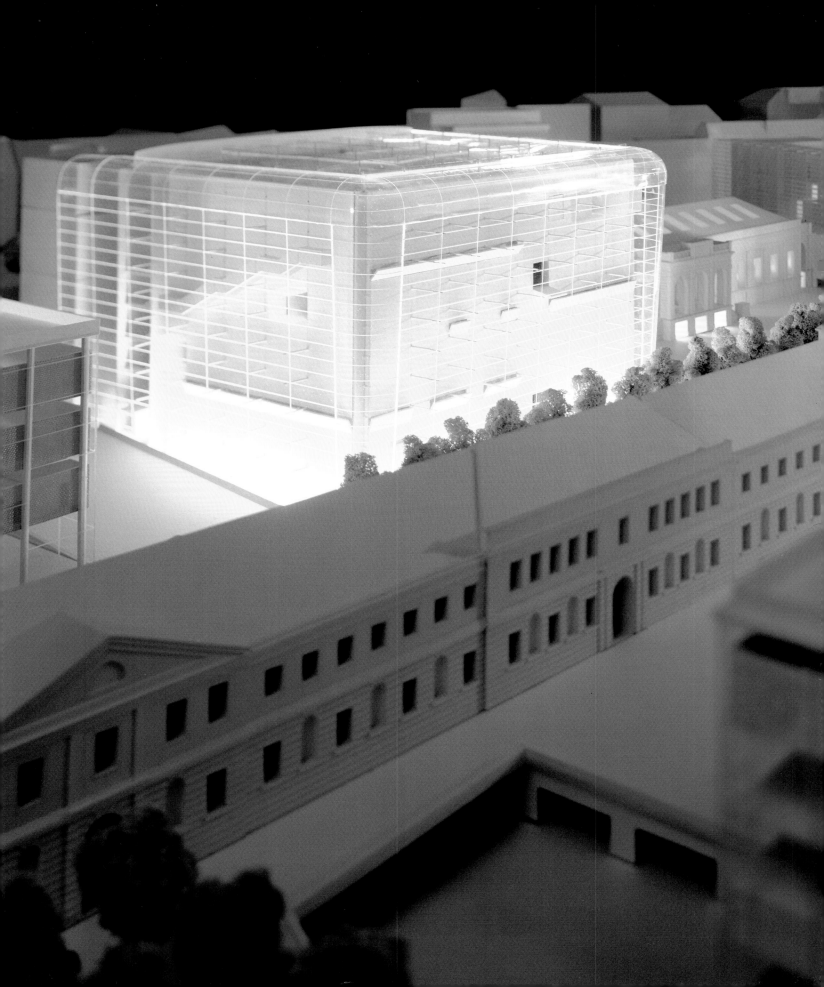

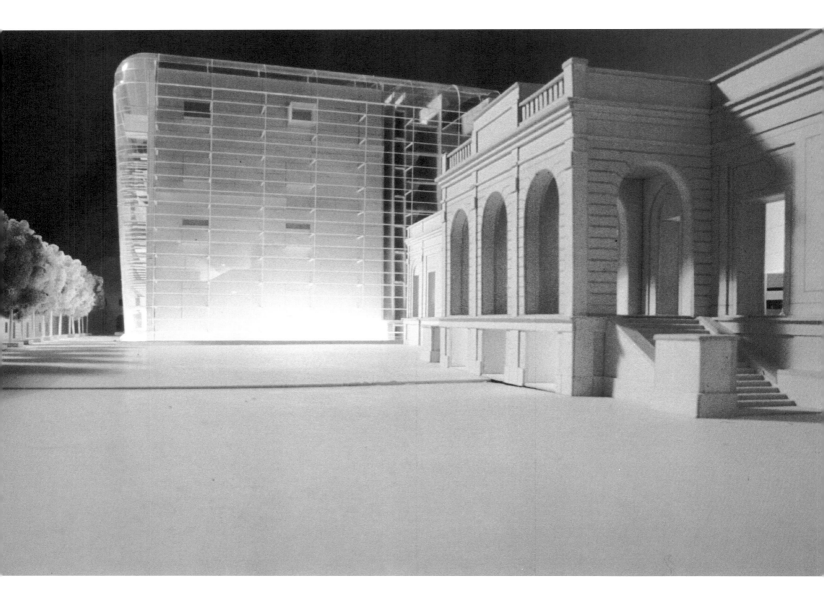

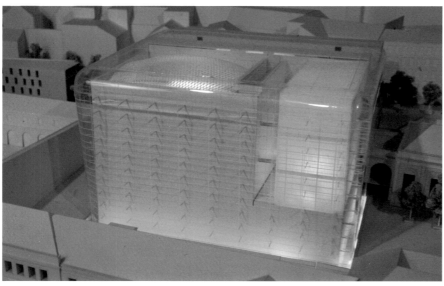

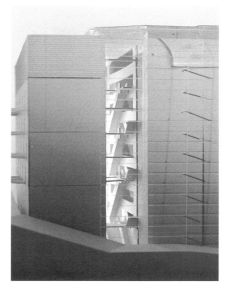

Views of model

150

Opposite: view of model of
Museum of Modern Art with
Winder Riding Hall at right

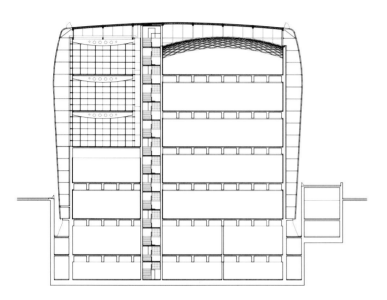

South-north section

West-east section

Ground floor plan

Rem Koolhaas—O.M.A. **Two Patio Villas** Rotterdam, 1991

For his Two Patio Villas, Rem Koolhaas draws on a Miesian modernist vocabulary but confounds implications of clarity by layering volumes and surfaces that are reflective, transparent, and opaque. The double villa is constructed on an embankment created for a highway that was never realized, and it comprises two levels: a lower, where one enters, and the main living areas above. Also known as A House for Two Friends, the building contains two adjacent but unconnected living spaces, one ultimately built with a conventional plan and the other with an open plan and interior patio as Koolhaas had originally intended. This internal court, in combination with a freestanding wall, defines the living spaces of the house: living room to the south, dining room to the north, kitchen to the east, and,

on the other side of the wall, bedroom, bathroom, and office. A glass plate floor illuminates the windowless exercise room below.

The street-side elevation of the double villa is unified by an emphasis on its horizontality; a band of windows runs the length of the upper level of the facade, contrasting with the opaque stucco surface below (which is arbitrarily demarcated by diagonal-edged areas of color). Retaining side walls, forming a stairway to the east and a clerestory facade to the west, project beyond the building, penetrating the embankment and defining the exterior space, both at the street level and into the garden. The single-story garden facade is almost completely glazed. The four different types of glass—clear, frosted, green-tinted, and wired—are

intended to create, as Koolhaas has explained, "effects of transparency, 'view,' reflection, and different degrees of blockage." These potential effects are vastly compounded by the insertion of a glass-enclosed patio at the center of the open-plan space.

The patio, which functions as a well of light, bringing the outdoors into the house, suggests a displaced, inside-out modernist glass box; where Mies would place a solid service core, Koolhaas has inserted a void. The court's transparency (two of the walls slide open, to further disappear), grid geometry (the patio's unitary fenestration pattern), and corrugated aluminum wall with slot window augment the subtle diversity in the double villa's facades—the combination of glazing materials in the garden facade and the varied configurations of opacity and transparency in the other facades. This accumulation of discrete patterns culminates in an optic complexity whereby reflections on the surfaces of the glazed facade and the prismatic patio are multiplied, deflected, or abruptly blocked. Interior and exterior are commingled, both actually and perceptually. To further this point, a boardwalk leads from the house to the canal beyond the garden, continuing the paint-striped vector at the entrance of the house as if speeding the path in, through, and out. —*A.D.*

Above: axonometric view
Opposite: view from garden
of internal court

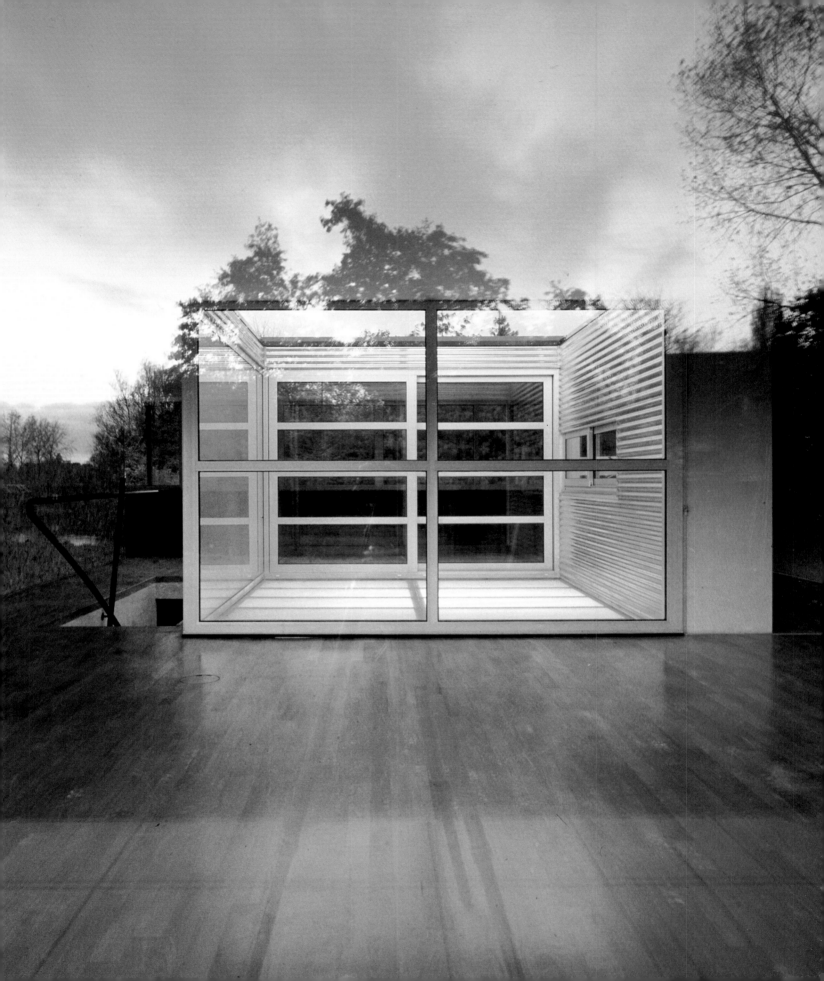

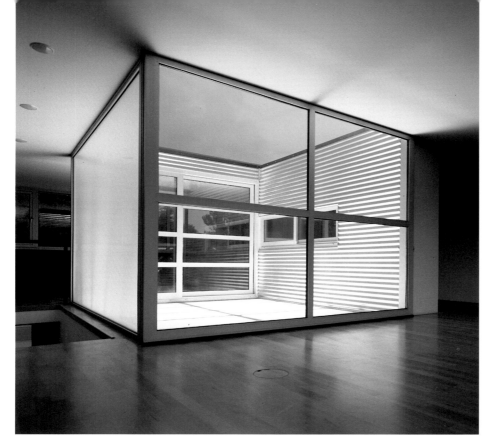

Above: internal court;
right: views of garden facade

Street facade

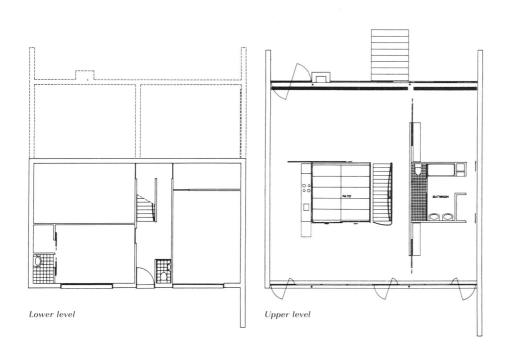

Lower level Upper level

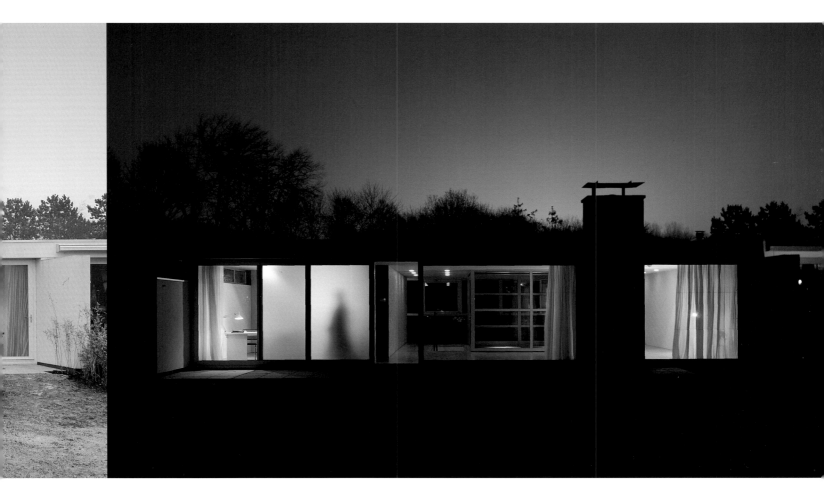

Project Information

ABN-AMRO Head Office Building

Location: Amsterdam
Date: 1992 (competition proposal)
Client/owner: ABN-AMRO Bank, Amsterdam
Principal structural system: precast, post-tensioned concrete
Principal materials: concrete, glass
Status: unbuilt

Architect: Harry C. Wolf
Design team: Harry C. Wolf; Brit Billeaud, Katheryn Coe, Regina Dorsching, Steve Dumez, John Dutton, John Frishman, John Hersey, Thomas Hoos, Melanie Kao, Alla Kozovski, David LeClerc, Hugh Lee, Toni Lewis, Karin Mahle, Carol Reese, Dan Rosenfeld, Rob Rothblatt, Mayee Salgado, Patricia Takanashi
Structural engineer: Guy Nordenson
Parking and traffic engineer: Gregory Hodkinson
Mechanical, electrical, and elevator engineer: Mahadev Raman
Electrical engineer: Jacob Chan
Daylighting: Andrew Sedgwick
Landscape architecture: Office of Dan Urban Kiley
Cost consultants: Andrew Matthewman, Anthony Vallance—Hanscomb Associates

ACOM Office Building

Location: Amersfoort, the Netherlands
Date of design: August 1992
Date of completion: January 1993
Client/owner: SCW, Amersfoort
Contractor/builder: Van Hoogevest bv. Amersfoortse aannemingsmaatschappij
Size: 39.3 x 65.6 x 39.3 ft. (12 x 20 x 12m)
Structural system: existing concrete structure
Principal materials: aluminum, frosted toughened glass, iroko wooden frames

Budget: f. 475,000, excluding VAT
Architect: Ben van Berkel—Van Berkel & Bos
Design team: Aad Krom (project coordinator); Paul van der Erve, Jeff Till
Structural engineers: Bekker & Stroband, Amsterdam
HVAC engineers: Fa. Visser, Baarn
Electrical engineers: Fa. Koning Electrotechniek bv., Amersfoort
Other consultant: Fa. Racon Gevelbouw, Apeldoorn

Bus Shelter IV

Location: Domplatz, Münster, Germany
Date of completion: 1987
Client: *Skulptur Projekte in Münster* (international exhibition of temporary outdoor public projects organized by Klaus Bussmann and Kasper König)
Builder: Dennis Adams
Size: 10 x 16.8 x 13 ft. (3 x 5.1 x 4m)
Principal materials: aluminum, stainless steel hardware, wood, fluorescent lights, plexiglass, photographic transparencies

Artist: Dennis Adams

Business Promotion Center

Location: Duisburg, Germany
Date of completion: March 1993
Client/owner: GTT (Gesellschaft für Technologieförderung und Technologieberatung Duisburg mbH) and Kaiser Bautechnik
Contractor/builder: Hochtief/Wiemer & Trachte
Size (office space): 43,056 ft.2 (4,000m^2)
Principal structural system: concrete core and floor slabs with glass curtain wall
Principal materials: concrete, glass, steel

Budget: £5 million
Architects: Sir Norman Foster and Partners
Design team: David Nelson, Norbert Kaiser, Norman Foster (concept and design); Stefan Behling (project director); Sandy Bailey, Mary Bowman, Georg Gewers, Serina Hijjas, André Poitier
Structural engineers: Ingenieur Büro Dr. Meyer
HVAC and electrical engineers: J. Roger Preston & Partners/Kaiser Bautechnik
Surveyor: Lothar Schwarz
Acoustics: ITA GmbH
Lighting: Claude A. Engle

Cartier Foundation for Contemporary Art

Location: Paris
Date of design: March 1991–October 1992
Date of completion: May 1994
Client/owner: Gan Vie (building); Cartier SA (interiors and furniture)
Principal structural system: steel frame
Principal materials: steel, glass, aluminum
Budget: F 125 million

Architects: Jean Nouvel, Didier Brault (assistant architect)
Design team: Pierre André Bohnet, Laurence Ininguez, Philippe Mathieu, Viviane Morteau, Guillaume Potel, Massimo Quendolo, Steeve Ray, Stephane Robert, Arnaud Villard
Structural engineer: Paul Nuttall—Ove Arup & Partners
HVAC engineers: Reidweg and Gendre; Sefca
Electrical engineers: Integral Ingenierie
Facade engineers: Arnaud de Bussiere and Associates
Landscape engineers: Ingenieur et Paysage
Landscape design: Lothar Baumgarten

CineMania Theatre

Location: City Walk, Universal City,
 California
Date of completion: November 1993
Owner: Showscan Corporation
General contractor: Cal-Pac Construction
 Size: 3,000 ft.2
Principal structural system: steel frame
Principal materials: Venetian plaster, clear
 and translucent glass, fiberglass, painted
 and perforated steel
Budget: US$3 million

Architect: Mehrdad Yazdani—Ellerbe Becket
Design team: Mehrdad Yazdani (design prin-
 cipal); Katherine Demetriou, John Frane,
 Matt Ralsten, David Woo, Terence Young
Project director: Jon Pugh
Project manager: Tom Goffigon
Structural engineer: Brian L. Cochran
Mechanical engineers: Harold T. Kushner
 and Associates
Electrical engineers: Lucci Associates

Congress Center

Location: Salzburg, Austria
Date: June–October 1992 (competition
 proposal)
Client: City of Salzburg
Size (site area): 25,834 ft.2 (2,400m^2); (build-
 ing area): 24,897 ft.2 (2,313m^2); (total
 floor area): 188,521 ft.2 (17,514m^2)
Principal structural system: concrete and
 steel frame
Principal materials: glass, perforated metal,
 metal screens and louvers
Status: unbuilt (second prize in competition)

Architect: Fumihiko Maki—Maki &
 Associates
Design team: Kei Mizui; Fabian Berthold,
 Paul Harney, Masaaki Kurihara, Lox
 Loidolt, Naomi Maki, Atsushi Tokushige
Structural engineer: Kunio Watanabe—
 Structural Design Group

Definitions Fitness Center 2

Location: New York City
Date of completion: July 1993
Client/owner: Definitions Management
 Services
Contractor/builder: Artech Construction
Size: 5,000 ft.2 (465m^2)
Principal structural system: metal studs, alu-
 minum storefront sections
Principal materials: burnished copper at
 curved wall, burnished aluminum
 cladding, etched glass and aluminum win-
 dow grid at cubicles, plastic laminate at
 walls, maple and cherry wall panels at spa

Architects: Charles Thanhauser, Jack
 Esterson (principals); Kenneth Levenson
 (project architect)
Mechanical engineer: Clive Webster
Electrical engineer: Walter Mehl
Plumbing engineer: Tim Allinson

Floor Plan

Location: Linz, Austria
Date: September 1991
Client: Ars Electronica Festival (Gottfried
 Hattinger and Peter Weibel, producers)
Builders: Ars Electronica Festival staff; City
 of Linz, Austria, Parks Dept. staff
Size: 57 x 80 ft. (17.4 x 24.4m)
Principal materials: 110 fluorescent light
 tubes, neutral-colored opaque corrugated
 fiberglass roofing material, wood, electric
 cables
Status: dismantled after four-day festival

Artist: Melissa Gould

Ghost House

Location: New Canaan, Connecticut
Date of design: November 1984
Date of completion: November 1985
Client/owner: Philip Johnson
Contractor/builder: Louis Lee Co.
Principal structural system/materials:
 Galvanized steel tubes on existing barn
 foundation of field stone

Architect: Philip Johnson

Glass Video Gallery

Location: Groningen, the Netherlands
Date of completion: October 1990
Client/owner: Groningen Department of
 City Planning with Groningen
 Museum
Size (dimensions): 11.8 x 8.5 x 70.9 ft.
 (3.6 x 2.6 x 21.6m); (usable area):
 697.5 ft.2 (64.8m^2)
Principal structural system: structural
 glass (glass beams and fins) and
 steel clips
Principal materials: glass, steel floor
 grating

Architect: Bernard Tschumi
Associate architects: Karlse van der
 Meer Architekten, Groningen
Design team: Bernard Tschumi; Mark
 Haukos, Robert Young (model)
Glass contractor: Vermco Abeln,
 Groningen

Goetz Collection

Location: Munich
Date of design: 1989–90
Date of completion: 1992
Client/owner: Ingvild Goetz
Contractor/builder: Marcel Dittrich,
 Munich
Size (upper level): 26.2 x 79.4 ft.
 (8 x 24.2m); (lower level): 26.2 x 41.8
 ft. (8 x 12.7m)
Principal structural system: concrete and
 wood
Principal materials: birch plywood,
 sandblasted glass, concrete, aluminum
Budget: DM 3 million

Architects: Jacques Herzog, Pierre de
 Meuron—Herzog and de Meuron
Local Munich architect: J. P. Meier-
 Scupin
Structural engineers: Behringer Muller,
 Munich
HVAC engineers: Waldhauser AG, Basel
Electrical engineers: Nelhiebel, Munich
Carpenters: Holzbau Schmid, Trostburg
Glass constructions: Glassbau Hahn,
 Frankfurt; Uhlmann, Munich

Helsinki Museum of Contemporary Art

Location: Helsinki
Date of design: 1993 (competition proposal)
Client/owner: Ministry of Education
Contractor: Helsinki City Public Works Dept.
Size (net floor area): 129,000 ft.2 (12,000m^2)
Principal structural system: steel trusses and reinforced concrete
Principal materials: zinc, aluminum, u-glass
Budget: US$30 million
Status: construction scheduled for early 1996

Architect: Steven Holl—Steven Holl Architects
Design team: Steven Holl; Janet Cross, Justin Rüssli, Juhani Pallasmaa
Structural engineers: Insinoontoimisto OY, M. Ollila & Co.
Consulting engineers: Matti Ollila; Tero Aaltonen (project manager); Markku Aalto, Seppo Kykkanen
HVAC engineers: Reijo Hanninen; Markku Jokela (project manager); Kari Hyykky—Insinoontoimisto Olof Granlund OY
Electrical engineers: Juha Maljanen; Erkki Finni (project manager)—Tauno Nissinen OY Consulting Engineering
Structural and mechanical consultants: Guy Nordenson, Mahadev Raman—Ove Arup & Partners
Other consultants: Herve Descottes—L'Observatoire International (lighting); Markku Kauriala, Ari Kujala (project manager)—Markku Kauriala Ltd. (fire); Aulis Bertin—Engineering Office Aulis Bertin Ltd. (glass); Timo Tuovila, Reijo Hammar—Teatek (theater); Alpo Halme—Arkkitehtitoimisto Alpo Halme (acoustics)

ITM Building

Location: Matsuyama, Ehime Prefecture, Japan
Date of design : May 1991–January 1992
Date of completion: January 1993
Client/owner: ITM Group
Contractor/builder: Obayashi Corporation
Size (building area): 5,235.6 ft.2 (486.4m^2); (total floor area): 18,898 ft.2 (1,756m^2)
Principal structural system: steel frame

Principal materials (exterior wall): steel, aluminum, frosted and tempered glass, perforated metal panels, frosted and liquid-crystal-laminated glass, transparent float glass plus opalescent film
Budget (total construction cost): ¥ 500 million

Architects: Toyo Ito—Toyo Ito & Asssociates, Architects
Structural engineers: Toshihiko Kimura and Oak Architects Co., Ltd.
HVAC engineers: Kawaguchi Mechanical Engineering
Electrical engineers: Yamazaki Electric Engineering

Kansai International Airport

Location: Izumisano and Sennan, Osaka, Japan
Date of design: 1988 (competition)
Date of completion (open to the public): September 1994
Client/owner: Kansai International Airport Co., Ltd.
Contractors/builders: North Passenger Terminal and South Passenger Terminal Joint Ventures (20 companies)
Size (overall length): 1.1 mi. (1.7km); site area): 4,886,791 ft.2 (453,994m^2); (building area): 1,225,794 ft.2 (113,879m^2); (total floor area): 3,135,230 ft.2 (291,270m^2)
Principal structural system: rigid steel frame, partly steel frame and reinforced structure, steel truss (main terminal building roof); steel frame shell; spread foundation
Principal materials: steel, cement, extruded aluminum curtain wall (airside and landside glazing), steel curtain wall (endwall glazing)
Budget: ¥1.5 trillion

Basic design and detail design consortium:
Design leader/representative: Renzo Piano Building Workshop, Japan
Architectural and engineering design: Renzo Piano, Noriaki Okabe (Renzo Piano Building Workshop, Japan) in collaboration with Peter Rice (Ove Arup & Partners) and Kimiaki Minai (Nikken Sekkei)

Basic concept, functional aspect, and design of moving elements: Paul Andreu—Aéroports de Paris
Negotiation with and design for government agencies, and airside planning: Misao Matsumoto—Japan Airport Consultants

Architects: Renzo Piano, Noriaki Okabe (associate architect)—Renzo Piano Building Workshop, Japan
Design team: S. Ishida (associate architect); J. F. Blassel, A. Chavela, I. Corte (CAD), K. Fraser, R. S. Garlipp, M. Goerdt, G. Hall, K. Hirano, A. Ikegami, A. Johnson, C. Kelly, T. Kimura, S. Larsen, J. Lelay, K. McBryde, T. Miyazaki, S. Nakaya, N. Takata, T. Tomuro, O. Touraine, M. Turpin, M. Yamada, M. Yamaguchi, T. Yamaguchi
Architecture and engineering: Nikken Sekkei Design team: M. Asahi, T. Daito, M. Goto, S. Hada, T. Inokura, R. Iwasaki, K. Kurita, H. Miyakawa, H. Morimoto, K. Muramoto, K. Nakamoto, T. Nakatsu, A. Oyama, H. Sasaki, S. Shitamukai, K. Sugawara, Y. Sugimoto, N. Tomatsu, T. Watanabe
Facilities consultants: Paul Andreu, J. M. Chevallier (project leaders)—Aéroports de Paris; T. Kirio, Y. Niina (project leaders)—Japan Airport Consultants
Structural and mechanical engineers: P. Dilley, A. Guthrie, P. Rice, T. Stevens, (project leaders)—Ove Arup & Partners

Kirchner Museum Davos

Location: Davos, Switzerland
Date of design: 1989 (competition)
Date of completion: 1992
Client/owner: Kirchner Stiftung Davos (the museum is a gift from the collector Roman Norbert Ketterer and his wife Rosemarie Ketterer to the Kirchner Stiftung Davos)
Contractor/builder: several, coordinated by the architect
Size: 39.4 ft. (12m) max. height (incl. basement); 165.4 ft. (50.4m) max. length; 86.6 ft. (26.4m) max. breadth; (building area): 21,097 ft.2 (1,960m^2)
Principal structural system: concrete floors and walls; steel frames for skylight

Principal materials (exhibition rooms): wooden floors, plaster panel walls, steel and etched glass ceiling; (entrance hall): concrete; (facade): etched, profiled, and clear glass

Budget (building costs): SwF 9.77 million

Architects: Annette Gigon and Mike Guyer
Design team: Annette Gigon, Mike Guyer; Judith Brändle, Urs Schneider
Structural engineer: DIAG–Davos Ingenieure AG, Davos
HVAC engineer: Drei-Plan Ingenieurbüro, Winterthur
Electrical engineer: K. Frischknecht AG, Chur
Daylighting: H. Freymuth, Institut für Tageslichttechnik, Stuttgart
Artifical lighting: A. Zitnik, Ingenieurbüro für Kunstlicht, Frankfurt

Kunsthaus Bregenz

Location: Bregenz, Austria
Date: 1991 (competition proposal)
Client/owner: Land Vorarlberg
Size: 85 x 85 x 98 ft. (26 x 26 x 30m)
Principal structural system (inner structure): poured concrete; (facade): structurally autonomous steel frame
Principal materials: concrete, steel, glass
Budget: ATS 245 million (US$24 million)
Status: under construction; completion scheduled for 1997

Architect: Peter Zumthor—Atelier Peter Zumthor, CH–Haldenstein
Collaborators: Daniel Bosshard, Thomas Durisch
HVAC engineers: Meierhans & Partner AG, CH-Fällanden
Daylighting: Dr. Ing. H. Freymuth—Institut für Tageslichttechnik, Stuttgart

Kyle Residence

Location: Houston
Date of design: Summer 1991
Client/owner: Jerry van Kyle
Size: 24 x 77 x 77 ft. (7.3 x 23.5 x 23.5m); 5,929 ft.² (551.4m²)

Principal structural system: steel frame, load-bearing concrete perimeter walls
Principal materials: glass, steel, reinforced concrete, steel panels, Astroturf
Architect: Joel Sanders
Design team: Joel Sanders (design principal), Marc Tsurumaki (project architect); Ernest Guenzburger, Sean Keller, Dillon Kyle, Cary Siress
HVAC and electrical engineers: Hardie & Associates

Leisure Studio

Location: Puolarmaari, Espoo, Finland
Date of design: 1990–91
Date of completion: June 1992
Client/owner and contractor/builder: Group: Juha Kaakko, Ilkka Laine, Kimmo Liimatainen, Jari Tirkkonen
Size (area): 488 ft.² (50m²)
Principal structural system: wood frame with triple-wall hollow polycarbonate sheet glazing
Principal materials: wood, polycarbonate sheet, brick, plaster
Budget (materials): approximately FIM 180,000

Architects and design team: Group: Juha Kaakko, Ilkka Laine, Kimmo Liimatainen, Jari Tirkkonen
Structural engineer: Jouni Järvenpää
HVAC engineer: Timo Sarpila—Insinöörikeskus OY
Electrical engineer: Heikki Teittinen—Insinöörikeskus OY

Municipal Gymnasium

Location: Simancas, Spain
Date of design: 1990
Date of completion: 1991
Client/owner: Consejo Superior de Deportes, Ministerio de Educacion y Ciencia, Comunidad de Castilla y Leon, Ayuntamiento de Simancas
Contractor/builder: Construcciones Alcala
Size: 29.5 x 65.6 x 131.2 ft. (9 x 20 x 40m)

Principal structural system: 5.2 ft.–high trusswork beams on double-H columns (no bracing)
Principal materials: panel-sandwich steel, glass, wood
Budget: Ptas 55,718,231
Architects: Iñaki Abalos, Juan Herreros
Design team: Carlos Brugarolas, Juan Manuel Fernandez, Javier Herreros, Maria Lamas

Museum of Modern Art (Vienna)

Location: Museumsquartier Vienna
Date of design: 1990 (competition proposal); revised 1990–94
Client/owner: Federal Ministry for Science and Research, Republic of Austria, and the City of Vienna
Size (floor area): 226,000 ft.² (21,000m²)
Principal materials: Steel, glass, ferro-concrete
Budget: approximately ATS 1 billion
Status: construction to begin 1996

Architects: Laurids and Manfred Ortner
Design team: Dietmar Lenz, Christian Lichtenwagner, Sven Sokolay, Hanns-Peter Wulf
Structural engineers: Fritsch-Chiari, Pospischek
HVAC and electrical engineers: Austroconsult
Lighting: Licht-Design, Köln

Phoenix Art Museum Sculpture Pavilion

Location: Phoenix, Arizona
Date of design: 1990–95
Client/owner: Phoenix Art Museum
Contractor/builder: Johnson Carlier, Phoenix (general contractor); Merrifield Roberts, Bristol, Rhode Island (pavilion fabricator)
Size: 80 x 75 ft. (24.4 x 22.9m)
Principal structural system/materials: fiber-glass panels, stainless steel fittings, concrete ring beam
Status: awaiting funding

Architects: Tod Williams and Billie Tsien—Tod Williams Billie Tsien and Associates
Design team: Tod Williams, Billie Tsien; Marwan Al-Sayed, Martin Finio

Structural engineers: Robin Parke and
 Associates, Phoenix (concrete ring beam);
 M3 Engineering and Technology, Tucson
 (fiberglass pavilion)
Mechanical engineers: Ambrosino, de Pinto
 & Schmeider, New York
Lighting design: Richard Renfro

Radcliffe Ice Walls
Location: Harvard University, Cambridge
Date: 1988 (installation)
Client: Harvard Office for the Arts
Builders: Harvard University Graduate
 School of Design student team led by
 Brian Avilles and Ed Hamm
Size (each wall): 7 x 45 ft. (2.1 x 13.7m)
Principal structural system: two-inch-diame-
 ter galvanized steel pipe frame; wire mesh
 grids attached to both sides of frames,
 providing surfaces for ice accretion; water
 emitted as mist from plastic pipes
 strapped to top rail (walls were iced six
 times in a fifteen-day period)
Principal materials: two-inch-diameter galva-
 nized steel pipe, welded wire mesh, water,
 plastic pipe
Budget: US$35,000
Status: dismantled
Landscape architect: Michael Van
 Valkenburgh—Michael Van Valkenburgh
 Associates, Cambridge, Mass.

Saishunkan Seiyaku
Women's Dormitory
Location: Kumamoto City, Japan
Date of design: April–October 1990
Date of completion: August 1991
Client/owner: Saishunkan Seiyaku Co., Ltd.
Contractor/builder: Iwanaga-gumi
Size: 9,160.2 ft.2 (851m^2)
Principal structural system/materials: rein-
 forced concrete and steel
Budget: ¥500 million

Architect: Kazuyo Sejima—Kazuyo Sejima &
 Associates
Structural engineers: Gengo Mutsumi and
 O.R.S.
HVAC engineers: System Design Laboratory
Electrical engineer: Matsumi Sekkei

D. E. Shaw and Company Offices
Location: New York City
Date of design: 1991
Date of completion: 1991
Client/owner: D. E. Shaw & Company
 Holdings, L.P.
Contractor/builder: Clark Construction
Size (total floor area): 16,000 ft.2 (1,488m^2)
Principal materials: drywall, fluorescent-
 painted surfaces
Budget: US$707,570

Architect: Steven Holl—Steven Holl
 Architects
Design team: Steven Holl, Thomas Jenkinson
 (project architect); Hideaki Ariizumi,
 Scott Enge, Todd Fouser, Annette
 Goderbauer, Adam Yarinsky
Structural and electrical engineers: Robert
 Derector Associates
Technologies consultant: Scott Fenton

Shimosuwa Municipal Museum
Location: Shimosuwa-machi, Nagano
 Prefecture, Japan
Date of design: April 1990–October 1991
Date of completion: March 1993
Client/owner: Shimosuwa Municipality
Contractors/builders: JV of Shimizu and
 Shibusaki Construction
Size (building area): 14,747 ft.2 (1,370m^2);
 (total floor area): 21,345 ft.2 (1,983m^2)
Principal materials: reinforced concrete, steel
Budget (total construction cost):
 ¥1,250 million

Architect: Toyo Ito—Toyo Ito & Associates,
 Architects
Structural engineers and planners: Toshihiko
 Kimura and Oak Architects Co., Ltd.
HVAC engineers: Tetens Engineering Co., Ltd.
Electrical engineers: Setsubi Keikaku Co., Ltd.

Signal Box auf dem Wolf
Location: Basel
Date of design: 1989–92
Date of completion: 1995
Client/owner: SBB Kreis 2, Swiss Federal
 Railway
Size: 78.7 x 39.4 x 72.2 ft. (24 x 12 x 22m)
Principal structural system: reinforced con-
 crete
Principal materials: concrete, copper
Budget: SwF 6 million

Architects: Jacques Herzog, Pierre de
 Meuron, Harry Gugger (principal-in-
 charge)—Herzog and de Meuron
Project management: Proplan Ing. AG, Basel
HVAC engineers: SEC-AG, Liestal/Basel
Electrical engineers: Selmoni AG, Basel
Facade consultants: Tecton AG, Pratteln/
 Basel

Tower of the Winds
Location: Yokohama, Kanagawa Prefecture,
 Japan
Date of design: March–July 1986
Date of completion: November 1986
Client/owner: Committee for the Thirtieth
 Anniversary of the Yokohama Station
 West Unit
Contractor/builder: Obayashi Corporation
Size (height): 69.2 ft. (21.1m); (area): 142.6
 ft.2 (43.45m^2)
Principal materials: perforated aluminum,
 acrylic mirror plates, 2,000-3,000 electric
 bulbs
Budget (cost of construction): ¥100 million
Status: dismantled 1995

Architect: Toyo Ito—Toyo Ito & Associates,
 Architects
Structural engineers: Gengo Mutsumi and
 O.R.S.
Electrical engineers: Kandenko Co., Ltd.
Lighting: TL Yemagiwa Laboratory

Two Patio Villas

Location: Kralingen, Rotterdam,
the Netherlands
Date of design: 1984–88
Date of completion: 1988
Client/owner: Joop Linthorst
Developer: Geerlings Vastgoed, Deventer
Contractor/builder: OBM, Holland
Size: 42.7 x 85.3 ft. (13 x 26m)
Principal structural system: concrete,
steel, wood
Principal materials: concrete, steel, wood,
glass, corrugated aluminum
Budget (per house): f. 300,000

Architect: Rem Koolhaas—O.M.A. (Office
for Metropolitan Architecture)
Design team: Rem Koolhaas; Thijs de Haan,
Georges Heintz, Götz Keller, Jo Schippers,
Jeroen Thomas
Structural engineer: Jr. Krans—D3BN
Landscape designers: Petra Blaisse,
Yves Brunier

Two-Way Mirror Cylinder
inside Cube

Location: The Rooftop Urban Park Project,
Dia Center for the Arts, New York City
Date: 1991
Client: Dia Center for the Arts
Owner: Dan Graham
Contractor/builder: Mison Concepts
Size: 8.5 x 36 x 36 ft. (2.6 x 11 x 11m)
Principal materials: two-way mirror glass,
steel, wood

Artist: Dan Graham
Design team: Dan Graham; Clifton Balch,
Moji Baratloo
Structural engineer: Ross Dallard

Waterloo International Terminal

Location: London
Date of completion: May 1993
Client/owner: British Railways Board
Contractor/builder: Bovis Construction Ltd.
Size (roof): 1,312.3 x 98.4–164 ft. (400 x
30–50m)

Principal structural system: concrete frame
with lightweight steel and glass canopy roof
Principal materials: concrete, steel, glass
Budget: £130 million

Architects: Nicholas Grimshaw and Partners
Design team: Nicholas Grimshaw, Neven
Sidor (directors); Andrew Whalley (asso-
ciate in charge); Rowena Bate, Ingrid
Bille, Conal Campbell, Garry Colligan,
Geoff Crowe, Florian Eames, Paul Fear,
Alex Fergusson, Sarah Hare, Eric Jaffres,
Ursula Heinemann, Doug Keys, David
Kirkland, Chris Lee, Colin Leisk, Jan
Mackie, Julian Maynard, Steve McGuckin,
Ulriche Seifutz, Will Stevens, George
Stowell, Robert Wood, Sara Yabsley,
Richard Walker, Dean Wyllie
Structural engineers: YRM Anthony Hunt
Associates (roofing and glazing); Cass
Hayward & Partners with Tony Gee &
Partners (terminal viaduct); British Railway
Network Civil Engineer (approaches
viaduct); Sir Alexander Gibb & Partners
(basement and external works)
Mechanical and electrical engineers: J. Roger
Preston & Partners
Other consultants: Davis Langdon & Everest
(quantity surveyor); Sir Alexander Gibb
and Partners (flow planning); Ove Arup
and Partners (fire); Sean Billings
(cladding); Lighting Design Partnership
(lighting); Henrion Ludlow Schmidt (sig-
nage); Montagu Evans (planning)

Frederick R. Weisman Art Museum

Location: Minneapolis
Date of design: April 1990
Date of completion: November 1993
Client/owner: University of Minnesota Art
and Teaching Museum
Contractor/builder: Sheehy Construction,
St. Paul
Size: 41,000 ft.2 (3,813m^2)
Principal structural system: concrete post-
and-beam (parking), steel
(galleries/administration)
Principal materials: stainless steel facade,
brick, painted metal
Budget: US$10.5 million

Architect: Frank O. Gehry—Frank O. Gehry
& Associates
Design team (Frank O. Gehry & Associates):
Frank O. Gehry (design principal); Robert
Hale (project principal); Matt Fineout,
Victoria Jenkins (project architects);
Edwin Chan (project designer); David
Gastrau, Richard Rosa (project team)
Associate architects: Jeff Scherer (project
manager), John Cook (project architect)—
Meyer, Scherer & Rockcastle
Structural engineers: Rollie Johnson, Bob
Kuntz—Meyer, Borgman & Johnson
Mechanical and electrical engineers: Leif
Ericksen, Jim Art, Greg Neva, Tim
Rabbitts—Ericksen, Ellison & Associates
Civil engineers: Dan Allmaras, Jim Eulberg,
Naeem Qureshi—Progressive Consulting
Engineers
Landscape architects: Damon Farber, Joan
MacLeod—Damon Farber & Associates
Lighting: Paul Helms, Chris Bowsher—PHA
Lighting Design Inc.

The World Upside Down
(stage set [two versions])

Locations: Amsterdam and New York City
Dates: in Amsterdam, December 1990; in
New York City, February 1991
Date of design: summer 1990
Client/owner: Elisa Monte—Elisa Monte
Dance Co.
Builders: Het Muziektheater, Amsterdam;
J. Paterson Scenic Studios; South Kearny,
New Jersey
Size (screen): 15 x 60 ft. (4.6 x 18.3m)
(Amsterdam version); 12 x 40 ft. (3.7 x
12.2m) (New York version)
Principal structural system/materials: painted
aluminum; piano hinges at the center;
Gerriets scenographic scrim over alu-
minum frame
Budget: US$10,000

Architects: Tod Williams and Billie Tsien
Design team: Tod Williams, Billie Tsien,
David van Handel, Vivian Wang, Erika
Hinrichs
Structural engineer: Guy Nordenson
Lighting: Craig Miller

Photograph Credits

Trustees of The Museum of Modern Art